THE LAST DAYS OF
THE CORK DOCKLANDS

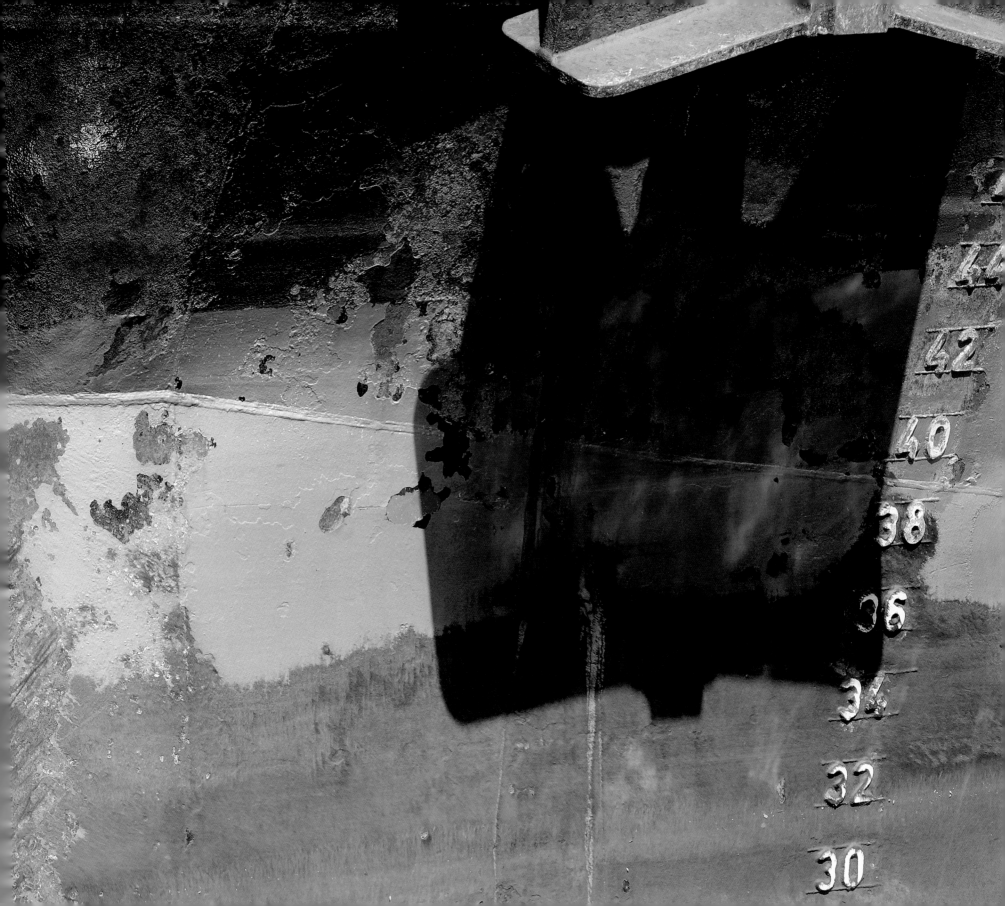

THE LAST DAYS OF THE CORK DOCKLANDS

PATRICK CUMMINS

ATRIUM

For Cherie, my Swiss-army wife; it couldn't have been done without you

First published in 2008 by Atrium
Atrium is an imprint of Cork University Press
Youngline Industrial Estate, Pouladuff Road, Togher, Cork, Ireland

British Library Cataloguing in Publication Data

A CIP catalogue record for this book is available from the British Library.

ISBN 978-0-9552261-5-1

Book design and typesetting, Anú Design, Tara
Printed by Gutenberg Press, Malta

For all Atrium books visit www.corkuniversitypress.com

Contents

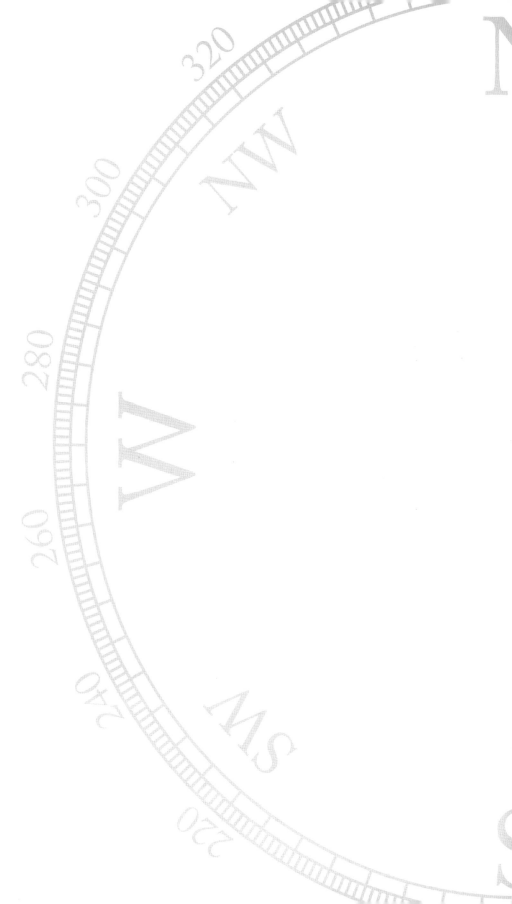

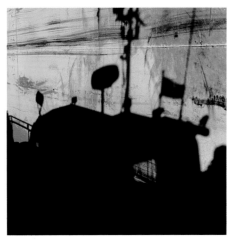

Introduction

In August 2007 the *Irish Examiner* carried a notice inviting artists to attend a tour of the Cork Docklands to learn about the proposed €2 billion redevelopment of the area. 'Our aim is to bring the Docklands area alive for all Cork-based artists', the notice read. 'To make the docklands a success, Cork needs to be ambitious and supportive.' The tour would begin at the Port of Cork Customs House and, weather permitting, would take place in October. Participants should wear flat shoes and warm clothes. I cut out the slip of newspaper and stuck it to the fridge.

Like many people from Cork, the Docklands had played a part in my life. My parents, Laurence and Mary Cummins, spent their early married years living in No 1 Marina View on Victoria Road before moving to Togher to raise a family. Growing up, my friends and I would ride our bikes down to the wharfs to watch the banana boats come in from South America. We would stand with our backs to the warehouse wall, hoping that we might get a free bunch of bananas, and we would make up stories about the exotic spiders that lurked in their yellow hides. Later, as a student at Crawford Art School, my work in sculpture was inspired by the soaring towers of the R & H Hall silos and the curved galvanised roofs of the Warehouse Companies premises. As a sideline at the Crawford I enrolled in photography and took my first pictures, ironically, of the hoppers and the overhanging conveyers at the docks. I didn't know then that photography would become my career, taking me halfway around the world shooting for newspapers and magazines, and, in 2007, bringing me back to the shores of the River Lee.

In the month that the *Irish Examiner* carried the notice about the artists' tour, I had returned to live in Cork after nearly twenty years as part of the Irish diaspora in Sydney. I soon grasped that I had arrived at a poignant moment in the city's history, when the docks' role as the centre of commerce was about to change for ever. Of course, this wasn't the first time that the area had been transformed. Several hundred years ago it would have been a sleepy bank on a slow-moving river. Then the Navigation Wall (now the Marina) was built and the wharfs and warehouses were constructed. Soon, manufacturers like Fords and Dunlops moved in and the workers came. By the 1960s, the Cork Docklands was a bustling hub of trade and commerce, producing tractors, motor cars and rubber boots. In its shipping heyday, roughly 500 dockers worked the wharfs, and several hundred vessels entered the port each year. In the 1980s manufacturing slowed as the big factories closed and, with the invention of the shipping container, international trade was revolutionised, with much of the cargo activity moved further downriver to Tivoli.

Now things were about to change again. As I found out what was happening – by reading newspaper articles about proposed thirty-storey residential towers and speaking to people whose jobs would be affected – it became clear that, for history's sake, there needed to be a record of the people and places that formed the fabric of the Docklands in its last days. Only a historian could tell the full story of the docks in a chronological manner, but as a photographer I would be able to convey what was in front of my camera at the time – to tell a living history through the lens.

Over the next twelve months I would visit the area almost daily, focusing my attentions on the South Dock. If I hadn't been down to take photographs on a particular day, I would make it a point to pass

by on my evening walk, to see how the light would be playing on the water and the contours of the buildings. The seasons brought variety and fresh activities: in autumn, the street sweepers gathered the fallen lime leaves on Centre Park Road into rust-coloured mounds; in winter, families bought Christmas trees from the men in the used-car yards; in spring, joggers and walkers used the longer daylight hours to stride along the Marina; and in summer, the erection of big show tents heralded the arrival of festival season. And, all the while, out on the river, the ships and tankers would come and go, bringing fuel for our stoves, food for our tables and supplies for our farmers.

The area covered by the proposed redevelopment on the South Docks occupied a triangle with a total land area of 131 hectares. The triangle started at the Idle Hour on the corner of Albert Quay and Victoria Road in the west, and stretched along the water's edge to Pairc Uí Chaoimh in the east, along the Marina to Church Avenue in Blackrock. Monahan's Road formed the other two sides of the triangle, with Centre Park Road cutting through the middle like cupid's arrow. In 2006, more than 2,200 people worked in the area. At the time of going to print, the fate of many of these workers was still to be determined. Some would be relocated and others would be made redundant. The dock workers themselves, mostly working on casual employment terms, were in the process of negotiating severance packages. The fate of many of the buildings, however, had already been sealed: the iconic MIAG silos were to come down, and two of the Seveso sites on Centre Park Road (the Topaz and Goulding buildings) would also be demolished.

With so many people and places affected by the redevelopment, there was never a shortage of photographs to take. I found that even the more desolate pockets – the areas already abandoned and waiting silently for change to bring them a new purpose – held their own beauty and significance. I would always be drawn back to the water's edge, though; back to the wharfs where the ships' pilots, the dock workers, the crane operators and the truck drivers kept the cargo ticking over. In November, some dockers invited me to an early-morning meeting at the offices of Doyle Shipping Group, where men would be hand-picked to work a shift. This time-honoured selection process had been part of docker life for decades and Cork was probably one of the only ports in Europe where the practice remained. At 8am, about two dozen men gathered in Doyle's stores on Connell's Street, as the foreman stood on a raised wooden platform and read through the list of ship movements, detailing the cargo and tonnage. The men were divided into shifts and, on that day, there was more than enough work to go around. The selection process was designed to be egalitarian, but the meetings didn't always end satisfactorily; when things were slow, men got turned home.

People often condemn the dockers' labour practices and pass judgement on their work ethic. But the dockers I met had an enormous sense of pride in their vocation. Unlike a lot of white-collar jobs, the work is casual and there are no perks; productivity is easily measured by the speed at which ships are loaded and unloaded. I met crane drivers who were paid by the tonne of cargo they lifted. Over the years, the dockers have been adaptable, welcoming new technologies that have improved their working conditions. And they have an intuitive sense that appealed to me – reading the Irish weather like a map and knowing when to pull the hatches over the cargo within seconds of a rain shower. I also marvelled at their exposure to different cultures, having been in contact with crewmen from Spain and Eastern Europe for decades, long before budget airlines opened these destinations to common folk.

As winter set in, I had become a regular on the South Docks and had formed relationships with people who took an interest in my project. Andy Breen, the security guard who previously trained in the Irish Military Police and had a preference for reading classic novels translated from Russian and French, was always good for a chat. One day I found him engrossed in a book about elephants. Simon Quilligan, a docker for forty-seven years, was a mine of information on the workings of the docks and drove me around in his van to point out various buildings, his dog Max riding dutifully in the back. Later, when the salmon were running, Simon took me fishing. Brian Holland showed me around the R & H Hall mill and grain store, while Paul O'Regan, deputy harbour commissioner at the Port of Cork, arranged for me to travel with the

ships' pilots and board a tanker. I also met artists who, like me, were hoping to capture the essence of the Docklands before the redevelopment. Willie Redmond, a Dublin artist, had painted a number of scenes from Éamon de Valera Bridge, while John Adams, another Dublin man, who studied at Crawford around the same time as me, was finishing off a series of paintings about the harbour – one of which was hung on the wall outside the office of Joe Gavin, the City Manager. John occupied a studio with a handful of other artists in the old Ford plant at the eastern end of the quays.

In photographing these gentle, everyday people, a trend emerged. It became clear that the lower a person figured in the hierarchy, the easier they were to approach. Access was more difficult in the higher echelons, where company representatives required me to make repeated phone calls and fill in forms before they would grant access to their buildings and workers. In some cases, the doors to these establishments remained closed and these premises are conspicuously absent from the book. I began to wonder, in this post-9/11 world of heightened security, when the ribbons are cut on the glass towers and residential complexes in the new development, whether the Docklands would remain a place of the people? Would it retain its unguarded charm and be open and accessible to all, or would it be restricted to those with coded swipe cards? And, I wondered, when the cargo activity is moved southeast to the new high-tech docks in Ringaskiddy, would it be possible to walk up to the side of a freighter and touch the metal plates of its hull?

It was the current spirit of openness and candour that spurred me on. By Christmas I had amassed a stock of pictures and the book was beginning to take shape. It wasn't difficult to find people who had a connection with the docks, and often one photograph would lead to the next, as people shared their stories. At times, the web that linked acquaintances and friends was intricate. I met John Carroll, who worked in port operations directing ships in and out of the harbour. It turned out he was the nephew of the people who owned my parents' rented house in Marina View. At my daughter's school in Ballinlough I met Mary Morley, who grew up on the docks, where her father, Sean O'Flynn, was the proprietor of the Silo Bar on Victoria Road (now the Idle Hour). Mary introduced me to some friends of her father's who still meet every Monday night for a drink on the docks. One of them, Noel Browne, upholstered my mother's sofa in the 1990s. Another girl in my daughter's class is one of Ken Carey's children, the family behind Carey Tool and Plant Hire, which occupies the old Passage Railway terminal. In some cases, people could recall in great detail a person's address and their line of work, or how many children they had and what kind of car they drove. In other cases, their memories were patchy. When it came to the dockers, it didn't help that many were known only by their nicknames. One dock worker told me that the first time he learned the real name of a man he had worked with for twenty years was when he read it in the man's obituary.

In February, Cork City Council adopted the South Docks Local Area Plan. The approval gave the green light to the rezoning of the South Docks area, classifying it as a high-density urban area and setting clear residential and employment targets. A few weeks later, Howard Holdings held a cocktail reception to unveil plans for its proposed Atlantic Quarter development, the single largest development project ever undertaken in Cork. The Atlantic Quarter would include 564 residential units, 555,000 square feet of office and commercial space, an events arena and conference centre, a four-star hotel, cafés, restaurants and bars. The chief executive of Howard Holdings, Greg Coughlan, posed with a mountain of boxes containing the paperwork for the development application. Laid end-to-end, the A4-sized documents were said to stretch for hundreds of kilometres.

Back on the River Lee, the arrival of warmer spring weather showed on the faces of the rowers as they moved silently back and forth. Stefan Wulff, a German who lives in Cork, took me out on a traditional currach, with its black ribbed hull and heavy oars. The currach rowers of Naomhóga Chorcaí trained every Saturday at midday, regardless of the weather, in preparation for various race meetings around the country and for the popular annual fifteen-mile Ocean to City race from Crosshaven to Lapp's Quay. Stefan and his crew were among many people I met who used the docks area for exercise and

recreation. There were the American footballers in Kennedy Park, and the travellers who trained their horses along the straights at the Marina. And, of course, there were the Don card players in The Sextant Bar, one of a few iconic pubs on the waterfront including the Idle Hour and the Port Bar. By 2007, these establishments had already adapted to change. Years ago, lunch hour would have been their busiest trading time, but drink-driving laws and a new attitude to alcohol on the job had brought an end to that. Now they opened only in the evenings and, instead of attracting dock workers, the regulars were students and residents living in and around Monerea Terrace, Eastville and Kingston Avenue.

In June 2008, the demolition crews moved in to tear down the Art Deco MIAG silos. Men stood in baskets hanging from cranes nine storeys up and used cutting torches to dismantle the silos piece by piece. Around the same time, the county's fishing trawlers held a protest to draw attention to the crisis in the fishing industry – a crisis brought on by restrictive quotas, cheap imports and a major rise in fuel prices. Over one weekend dozens of boats moved up the river to berth at Penrose Quay, rafting side-by-side in defiant formation. The following day they orchestrated a blockade of Cork Harbour to force the government into negotiations over taxes and new management regulations for fishing vessels. The plight of the Irish fishermen was a reminder to me that a lot of working men and their families depend on the sea for their income, and that often these people work under very difficult conditions. This is frequently the case for the crew working on ships from developing countries. Twice during the year I heard about boats that had been held in port because the sailors onboard hadn't received a salary in months. In support of these men, the Cork dockers refused to unload the ships until the owners of the vessels had paid up.

In July, I took my last photographs. I visited Mrs Eileen Campbell, who had just celebrated her eighty-sixth birthday and had been living in Marina View since 1948. The house had been in her husband's family for four generations and, as a couple, they had raised four children there. She said she couldn't think of a better place to live. Then I went along to the Marquee, a summer performance venue near the Show Grounds, where artists like Eric Clapton, Dolly Parton, Neil Young and Lou Reed were playing. It was clear to me that the docks area was not only a place of work and industry, but a place where people lived and came together to socialise and interact. It would be a pity, I thought, if the new development ignored this history. Such mistakes had been made before. In Sydney, where an inner-city area called Darling Harbour was transformed from a working dock into a high-density urban area, the redevelopment failed in its first form. The town planners ignored the fact that people wanted more than just shops and restaurants, and places to spend their money. They wanted atmosphere and tranquillity and a connection with the past – a place where they could gather with their friends and families.

It seems incongruous to those of us living in Cork in the first decade of the twenty-first century that, one day, people would reminisce about the docks in the city centre like we remembered the outdoor markets on the Coal Quay, or the tin mines on the Beara Peninsula. But that's how history works; it lives in the memories of the people. The stories told and retold over a pot of tea or a pint of beer carry the weight of years behind them. I have my story: the one about the South American banana boats and the dangerous spiders. In my quiet moments, I often wonder whether it was the sight of these foreign vessels tied up to Kennedy Quay that ignited wanderlust in my heart and inspired me to seek out the exotic destinations from whence they came. Maybe. One thing was certain, however; after a year of photographing *The Last Days of the Cork Docklands*, there would be several memories that would live on in my mind – the smiling face of Mrs Campbell, the welcoming handshakes from Simon and Andy, the smell of the cargo, the hum of the ESB Building and the screeching of the greaseless rollers on the overhead conveyers.

Patrick Cummins and Cherie Marriott

Acknowledgements

Without the help of a legion of strangers and friends, this book would not be. I would like to thank all the people who kindly allowed me to take their photographs: those who opened the doors to their homes, shared with me their history and experiences, and delighted me with humorous stories relating to the Docklands. A special thanks to a few individual people who showed a particular interest in the project and went out of their way to assist: Mary Morley, who shared her childhood memories of growing up on the quays; the docker Simon Quilligan who taught me about the passage of salmon up the river; Brian Holland of Halls who led me through the towering silos; and Paul O'Regan of the Port of Cork Company who smoothed the way for me to travel on the ships and pilot boats.

I thank the people at Atrium – Mike Collins, Maria O'Donovan and Karen Carty at Anú Design – for having the vision and bravery to publish a contemporary photographic essay of Cork when most other books focus on the city's history.

I thank the Port of Cork Company for their contribution towards the printing costs. It is important that organisations get behind local projects that record the living history of the city and provide an insight into the present day for generations to come.

And, of course, to my three girls – Cherie, Asha and Genevieve – who watched their husband and father pedal off to the docks each day with a camera over his shoulder. I am eternally grateful for their constant love and support.

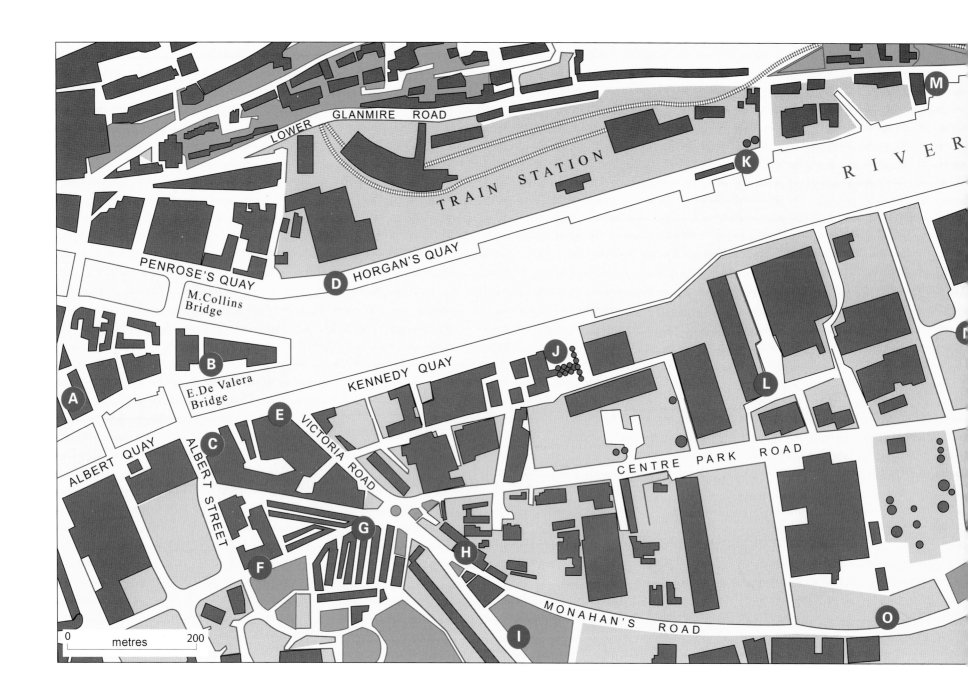

LOWER GLANMIRE ROAD

TRAIN STATION

RIVER

PENROSE'S QUAY

HORGAN'S QUAY

M.Collins Bridge

E.De Valera Bridge

KENNEDY QUAY

ALBERT QUAY

ALBERT STREET

VICTORIA ROAD

CENTRE PARK ROAD

MONAHAN'S ROAD

A
B
C
D
E
F
G
H
I
J
K
L
M
O

0 metres 200

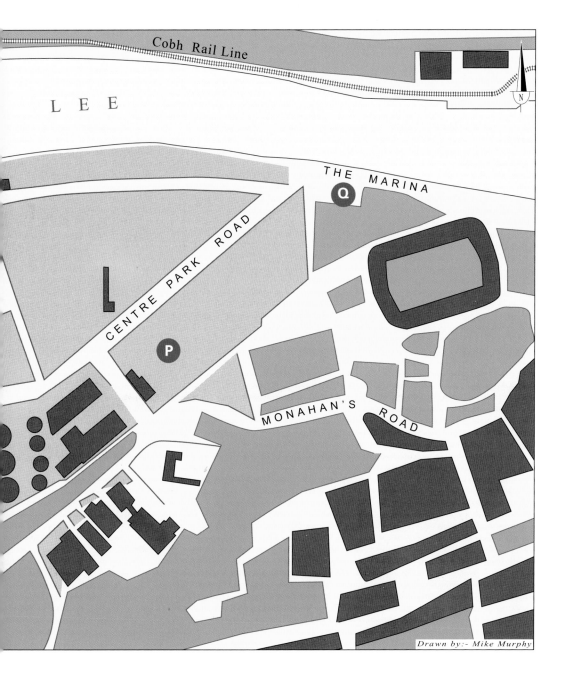

Drawn by:- Mike Murphy

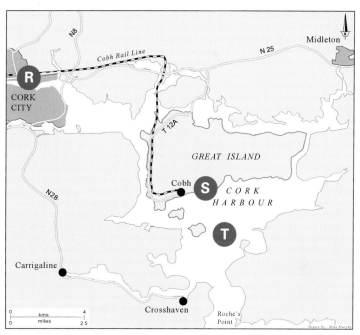

Drawn by:- Mike Murphy

Main map

A Doyle's Stores, Connell's Street (pages 172-174)
B Customs House, Customs House Quay (pages 4-7, 15-17, 19)
C Sextant Pub, corner of Albert Street and Kennedy Quay (pages 181-185)
D View of South Jetties from Horgan's Quay (pages 9, 12-13, 20, 23)
E Silo Bar/Idle Hour, corner of Kennedy Quay and Victoria Road
 (pages 72-73, 78-79, 178-179)
F Monerea Terrace (pages 75, 76-77, 88)
G Albert Road residents (pages 68-69, 74-75, 81-91, 95)
H Pentecostal Church, Monahan's Road (pages 70-71)
I Kennedy Park, Victoria Road (pages 80, 85, 92-93)
J South Jetties (pages 9, 20, 28-29, 32-39, 42-43, 50-51, 58-59, 64-67)
K North Jetties (pages 2-3, 8, 10, 12-13, 18, 21-23, 26, 30)
L Ford Plant, Centre Park Road (pages 134, 136-139)
M Ferry boat crossing, Lower Glanmire Road (pages 23-25, 100-103)
N ESB Building, Centre Park Road (pages 21, 24, 130-131,137)
O Rehab Recycling Centre, Monahan's Road (page 45)
P The Marquee, Centre Park Road (pages 122-123, 142-145, 147, 149-150)
Q The Marina (pages 96, 104-109, 124-125, 140-141)

Insert map

R Upper River Lee (page 114)
S Port Operations, Cobh (pages 113, 115)
T Lower Cork Harbour (pages 112, 116-118)

NORTH

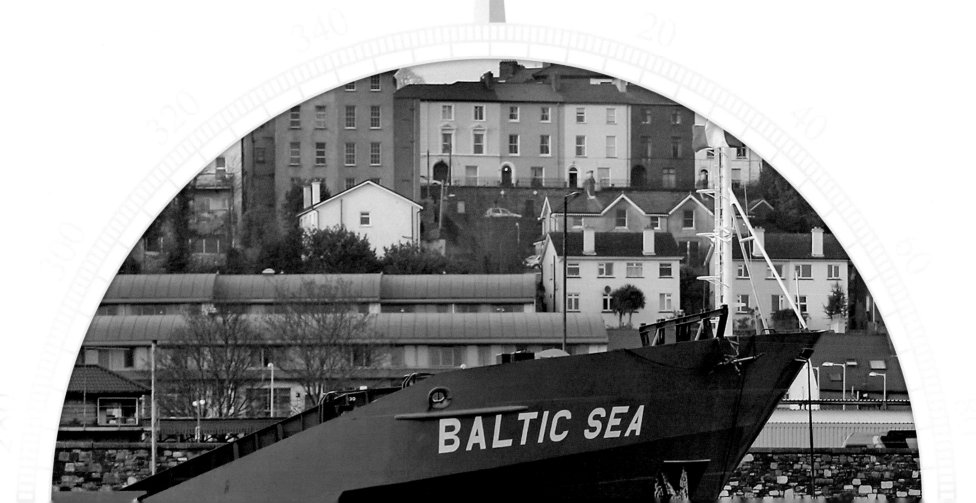

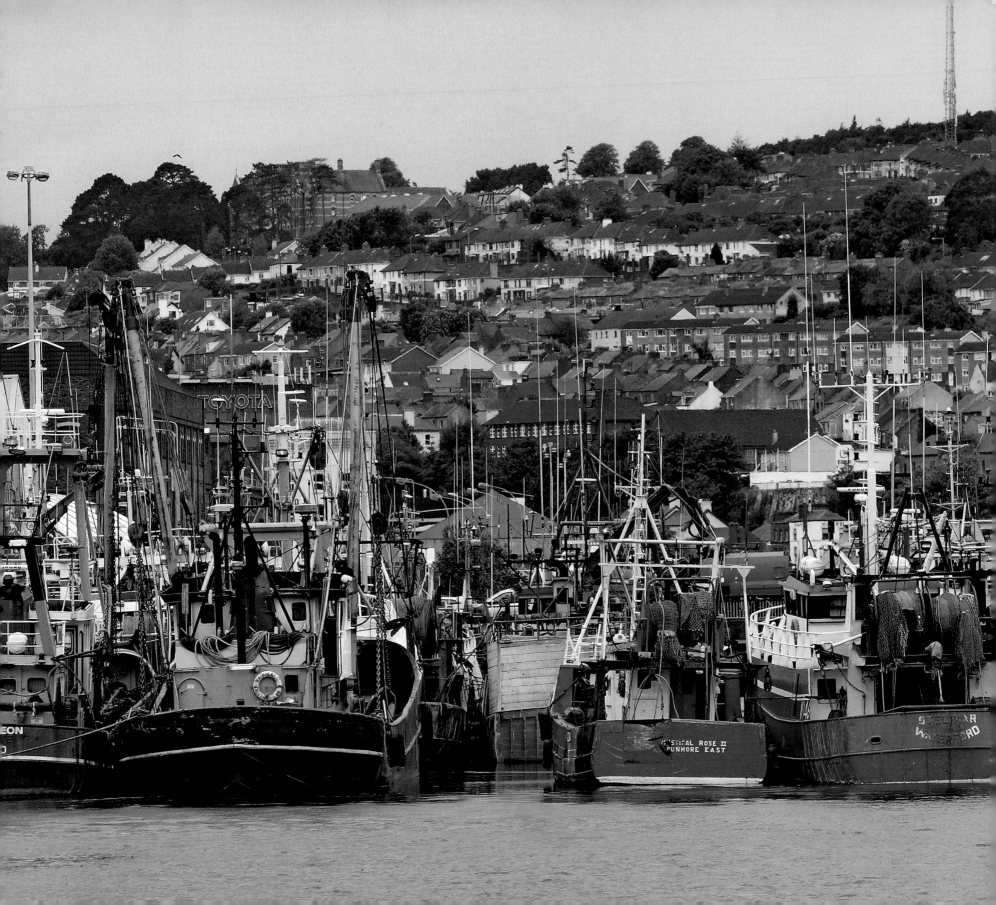

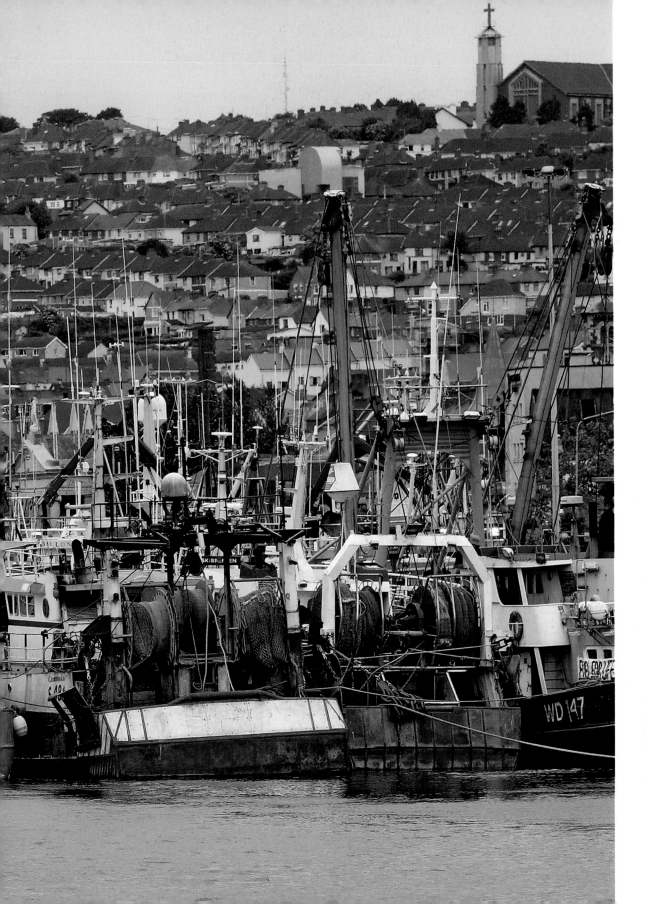

In June 2008, Irish fishermen
blockade Cork Harbour in
protest at rising fuel costs
and restrictive fish quotas.

3

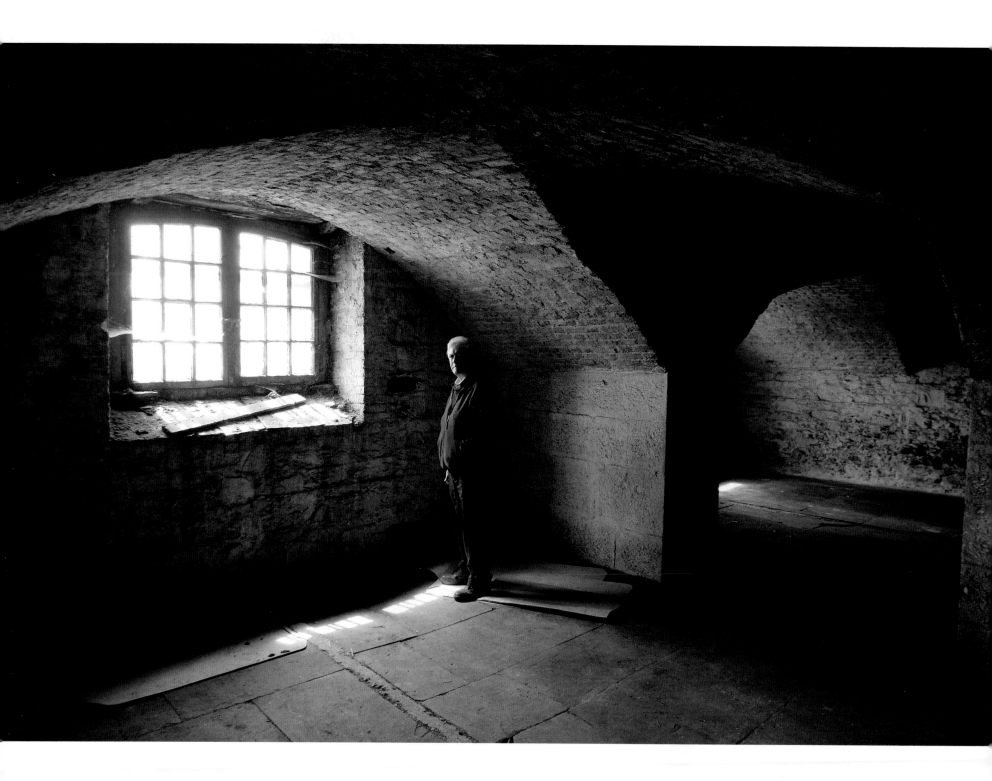

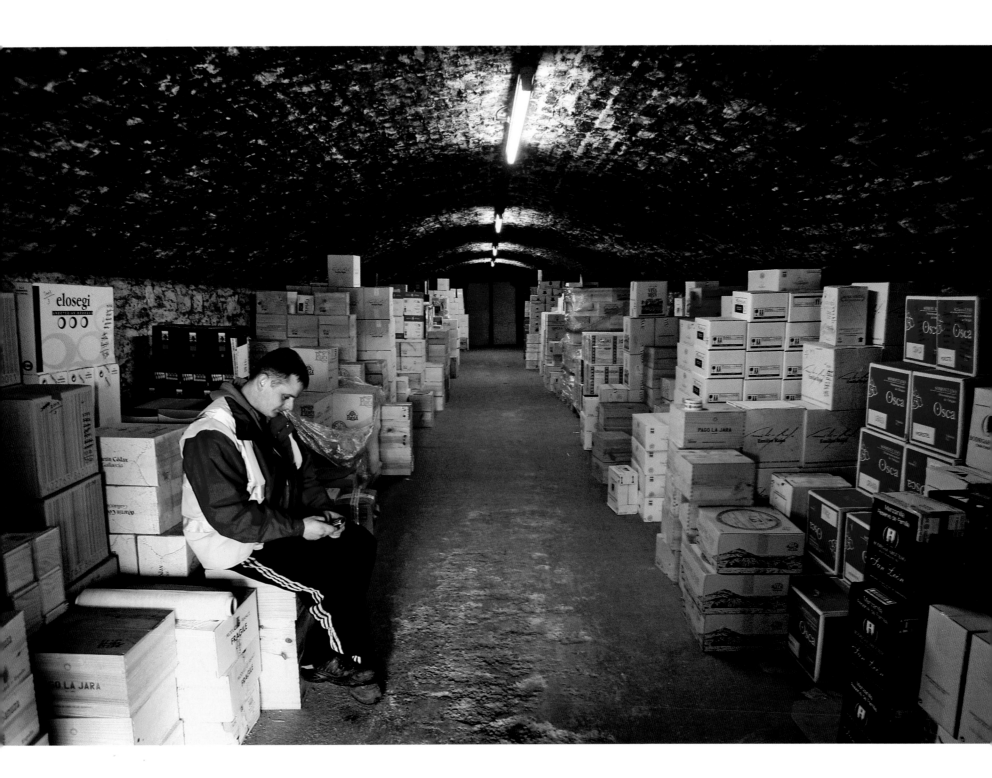

Previous: (left) Pat Harrington, storeman, Bonded Warehouse; (right) 'I think they held convicts in these caverns before they were sent overseas,' David Luxford, storeman, Bonded Warehouse.

Right: (top, l to r) Pat Harrington, Tom Coogan and John Nolan, storemen, Bonded Warehouse; (bottom) The arched roofs and heavy walls keep the Bonded Warehouse at an even temperature all year round.

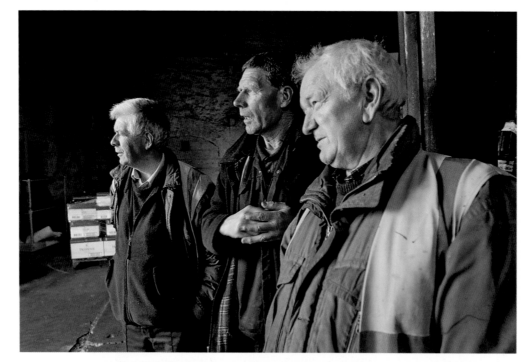

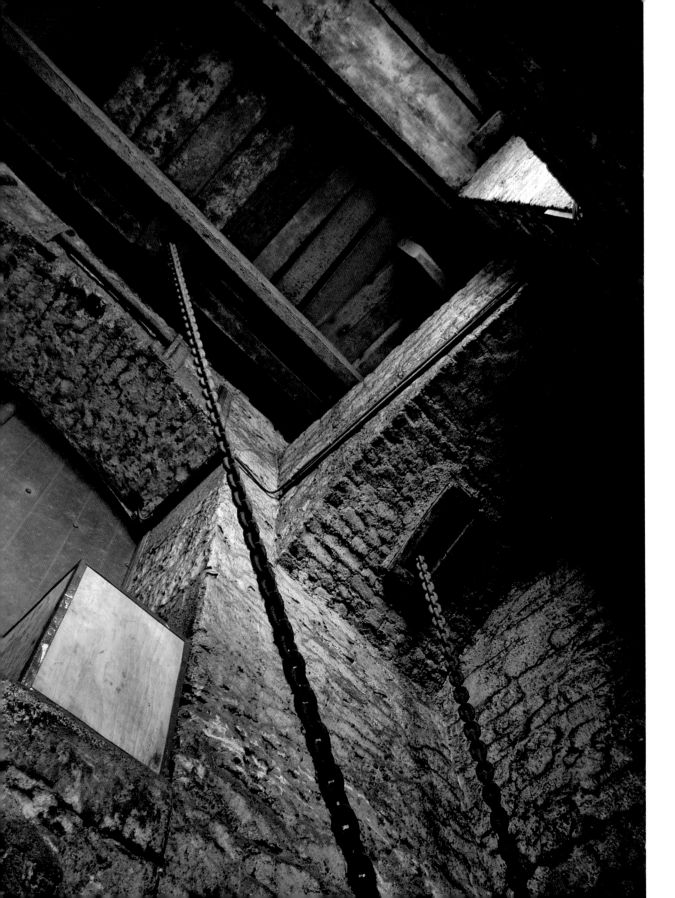

Pulleys and chains used
to shift cargo around the
warehouses prior to the
arrival of fork-lifts.

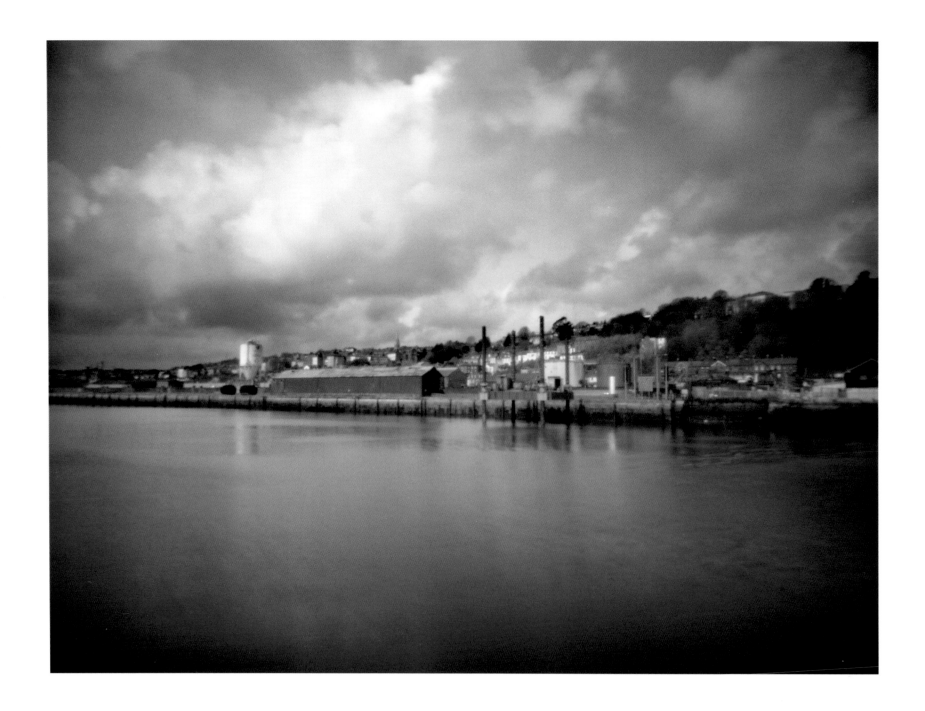

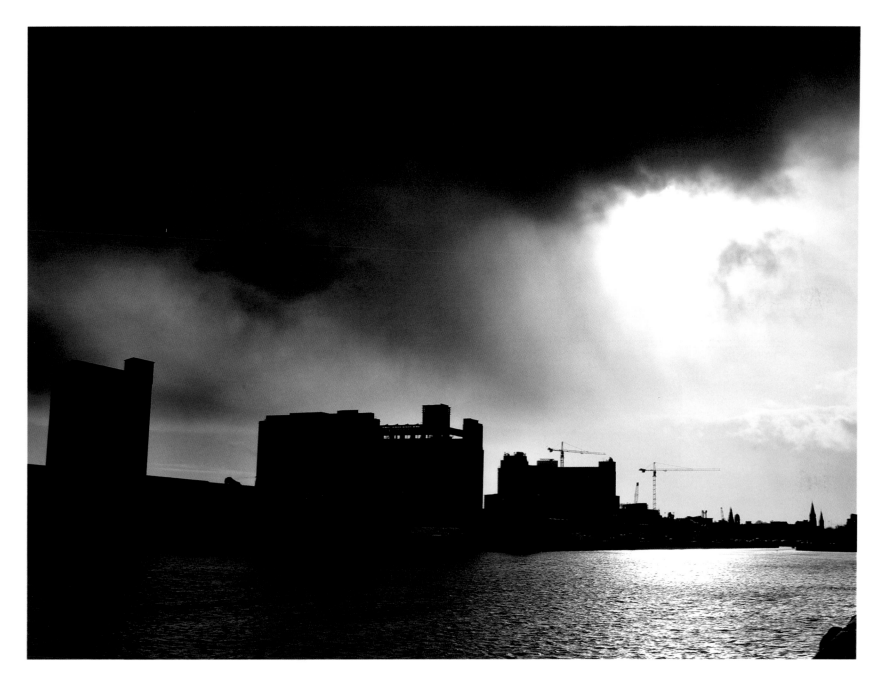

Opposite: Looking north to Horgan's Quay and Water Street, where a new bridge over the river will be built (taken with a pinhole camera).

Above: Spring rain sweeps in over the grain silos on the South Jetties.

Right: The *Baltic Sea* tied up to the North Jetties, with the houses of Summerhill and Saint Luke's Church in the background.

Opposite: Fishing trawlers raft side-by-side in the June 2008 blockade of the harbour.

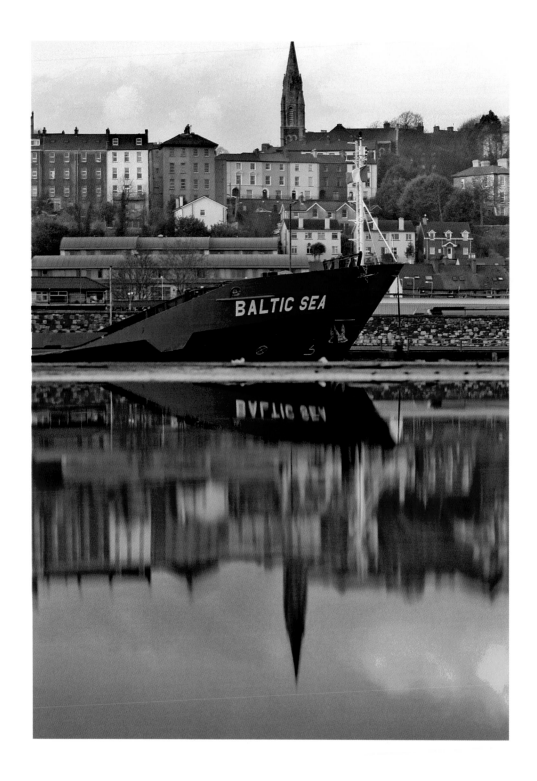

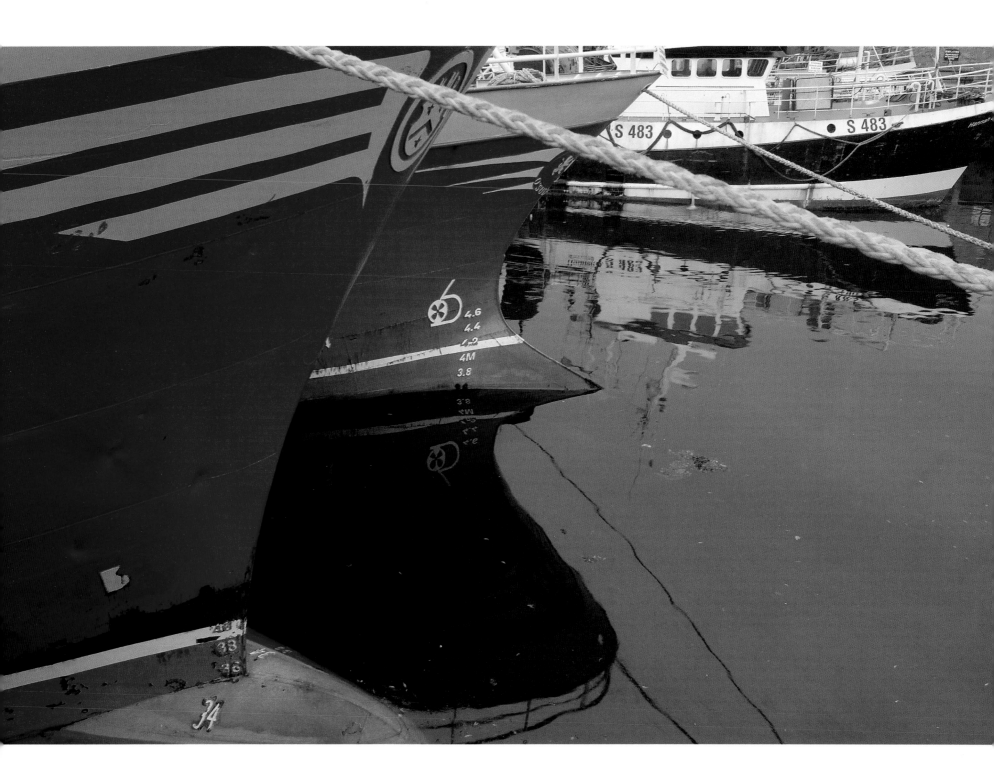

A colossal mooring buoy
used on the natural gas rigs
off Kinsale is stranded on the
dock at the North Jetties
(taken with a pinhole camera).

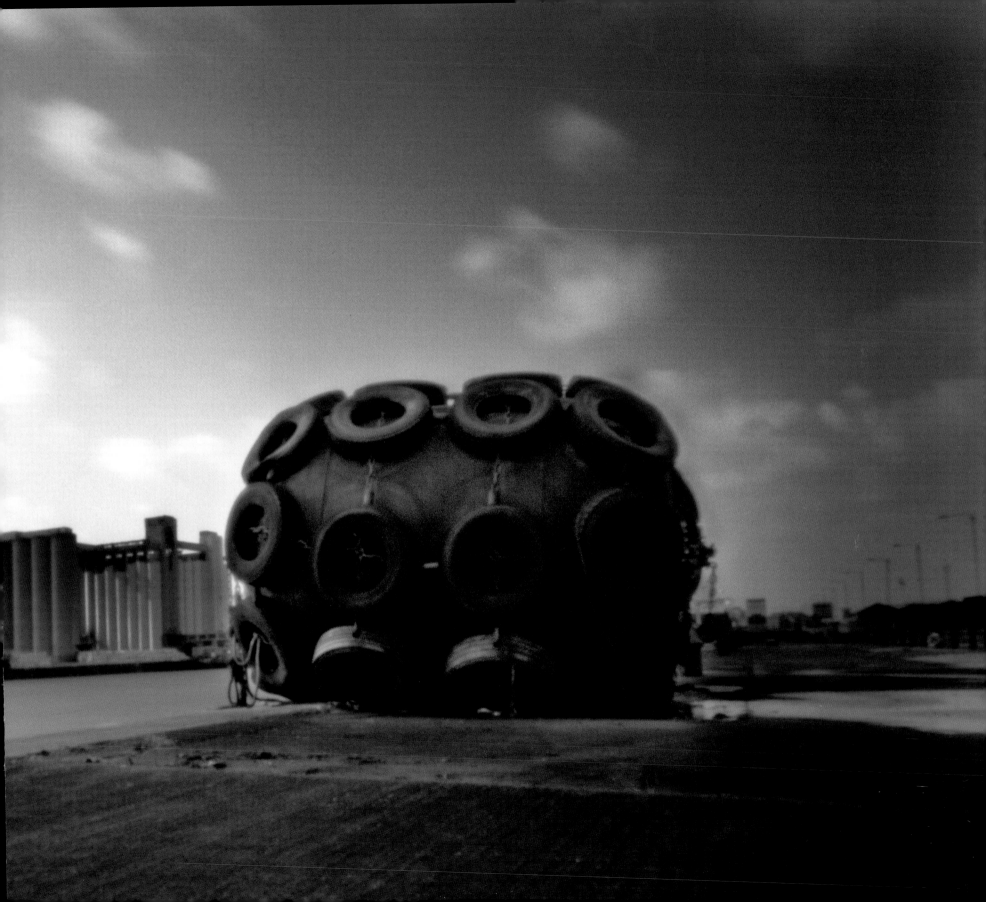

Right: The view from Lovers Walk looking back over the chimneys of Montenotte and on to the South Jetties.

Opposite: Cobwebs and the grime of time give the windows inside the Bonded Warehouse a haunted look.

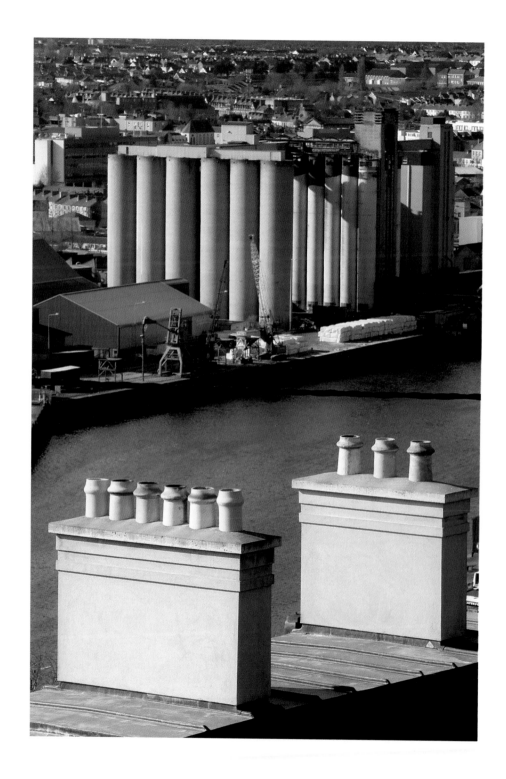

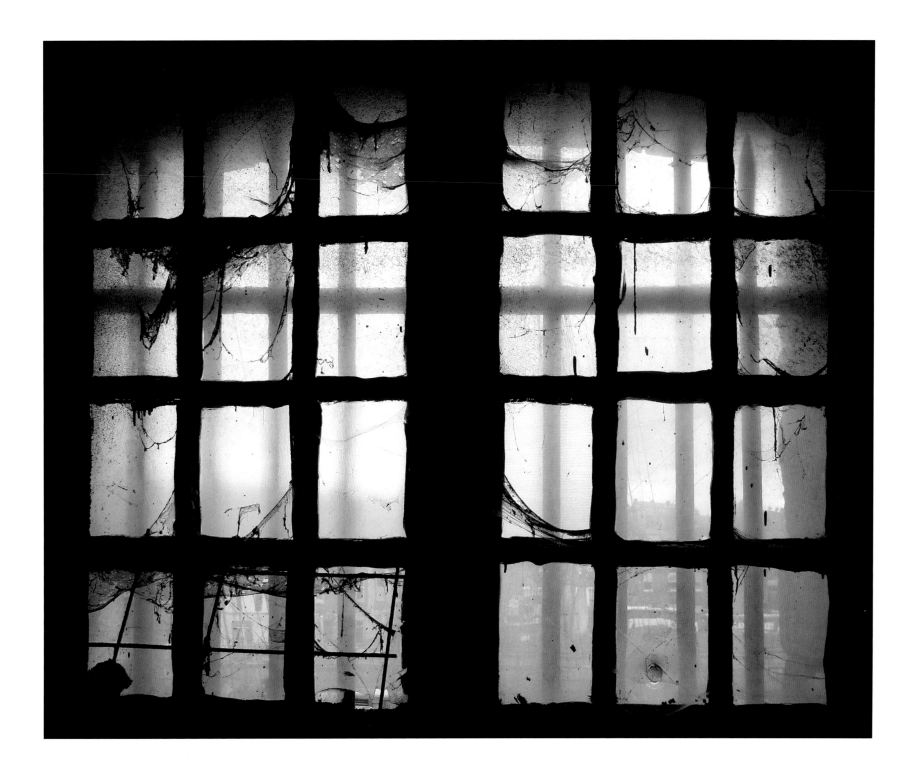

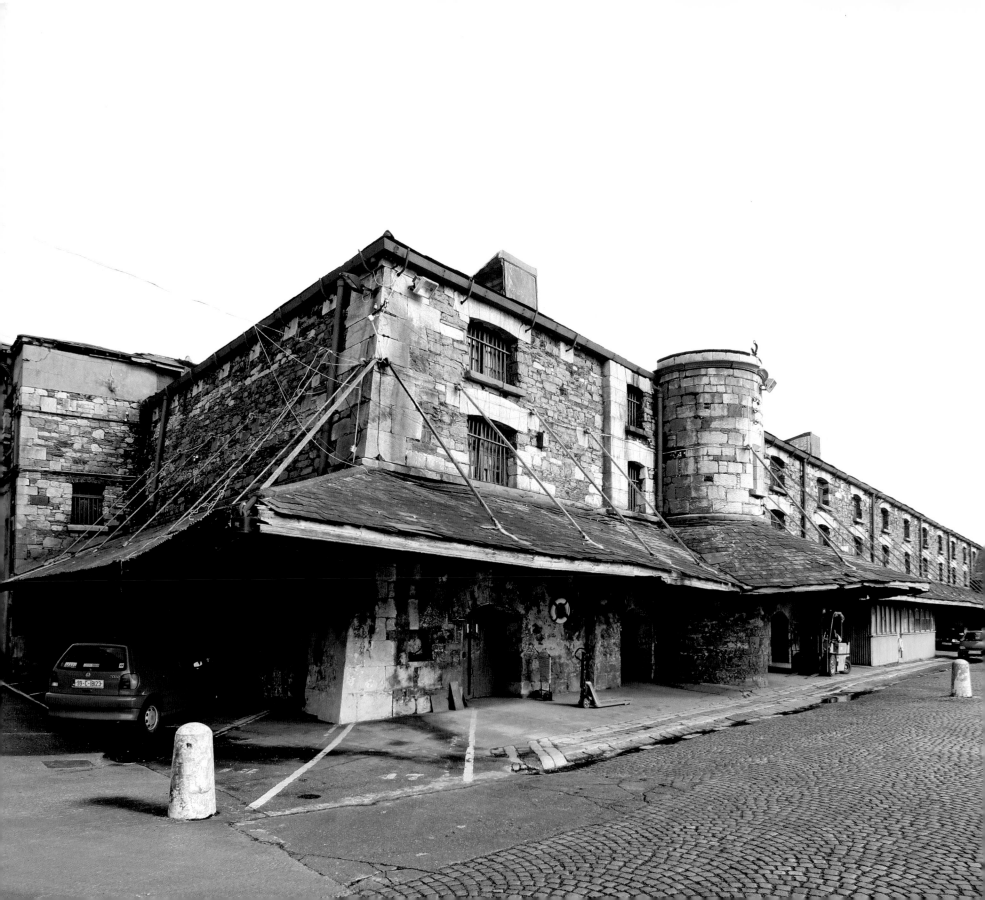

Previous: (left) The iconic Bonded Warehouse on Customs House Quay, soon to be converted to restaurants and cafés; (right) 'These days the warehouses are mainly used to store fine wines', Tom Coogan, storeman, Bonded Warehouse.

Right: In June 2008, dozens of protesting fishermen move their trawlers up the river to berth at Penrose Quay and force the government into negotiations over rising fuel costs and restrictive fish quotas.

Opposite: Calm waters make a safe port.

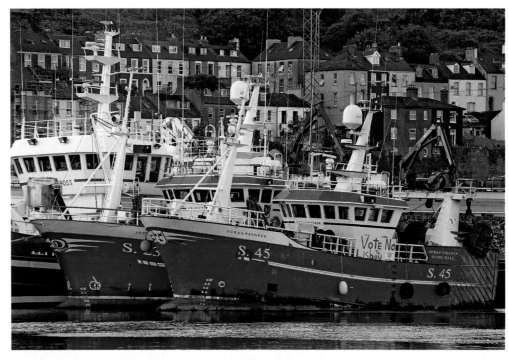

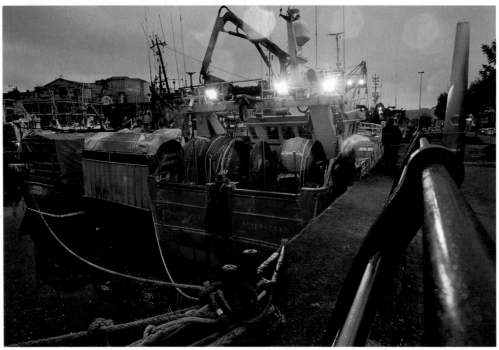

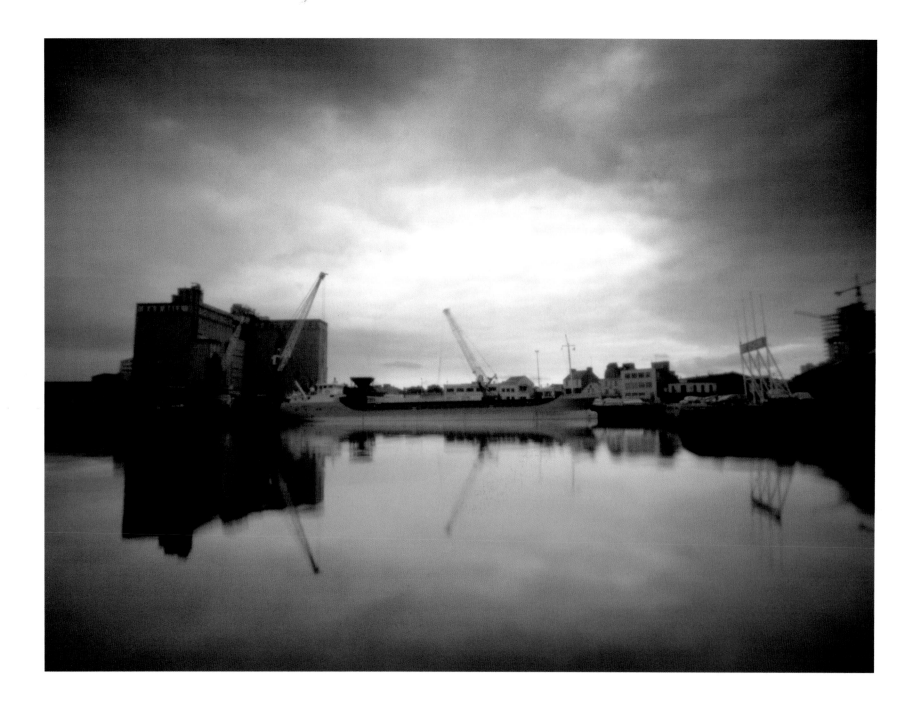

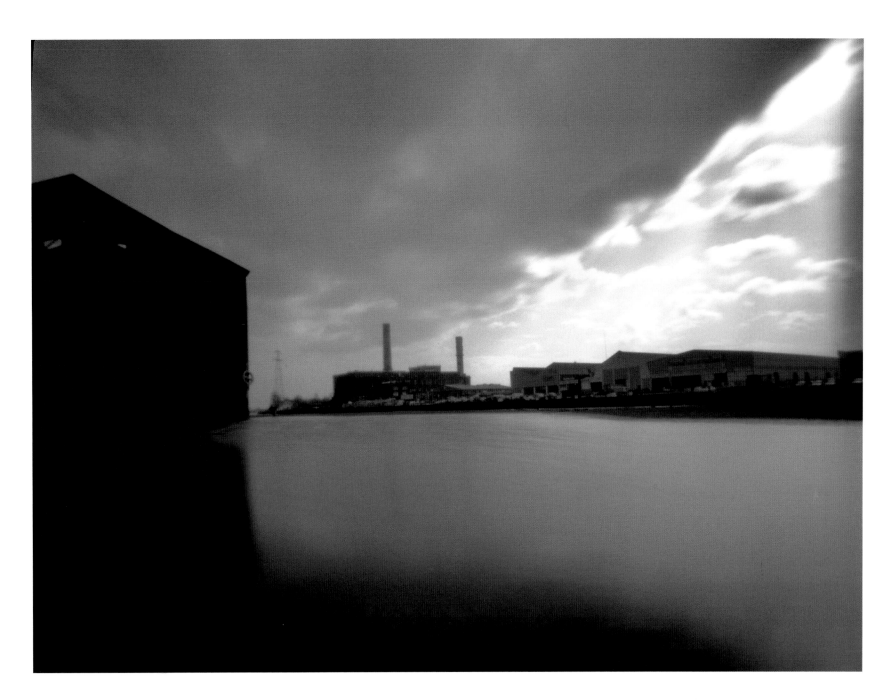

Opposite and above:
Looking south and southeast
from Horgan's Quay (taken
with a pinhole camera).

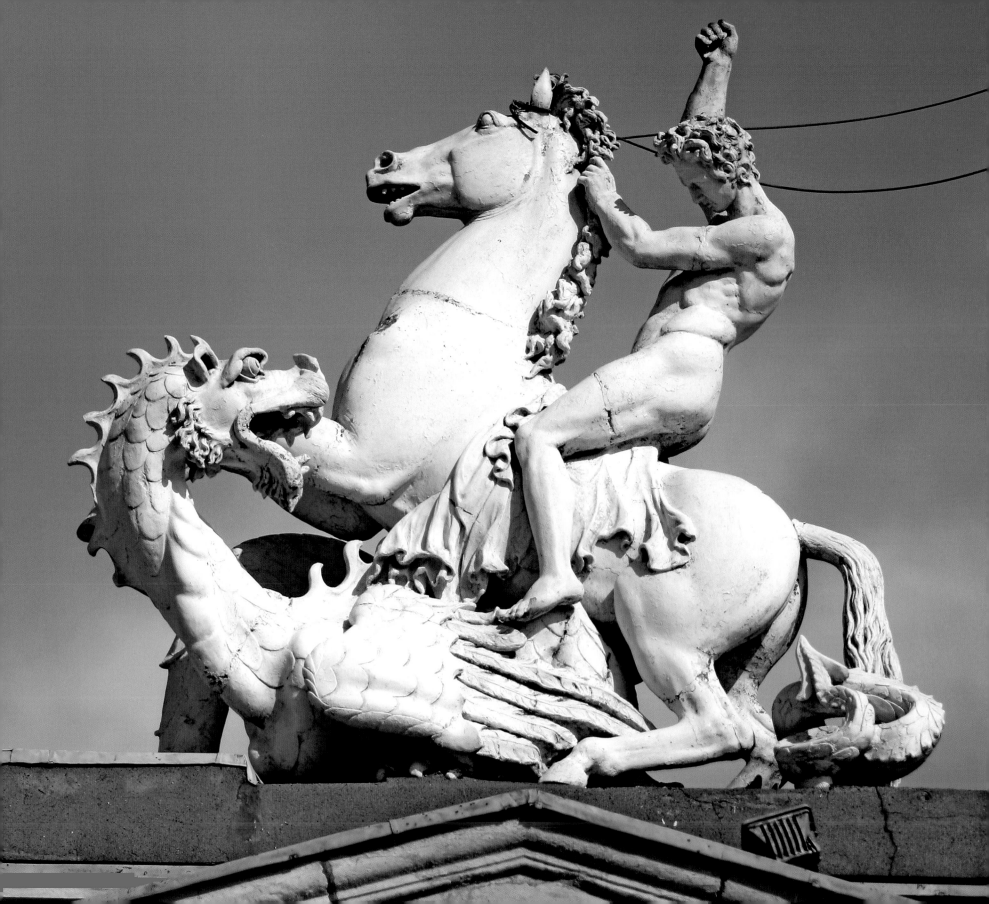

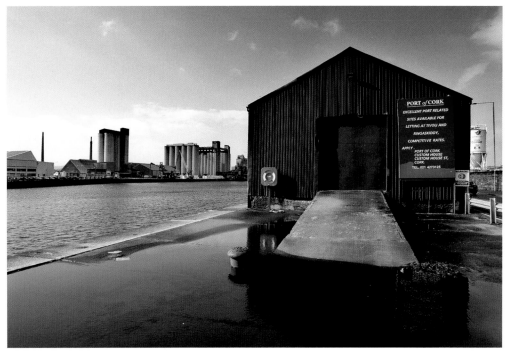

Opposite: St George fights the dragon on the roof of Penrose House at Penrose Quay.

Left: (top) Storage shed on the North Jetties; (bottom) The disused slipway and the old ferry boat crossing on Lower Glanmire Road.

The ESB Power Station,
framed by the bollards at
the ferry boat crossing on
Lower Glanmire Road.

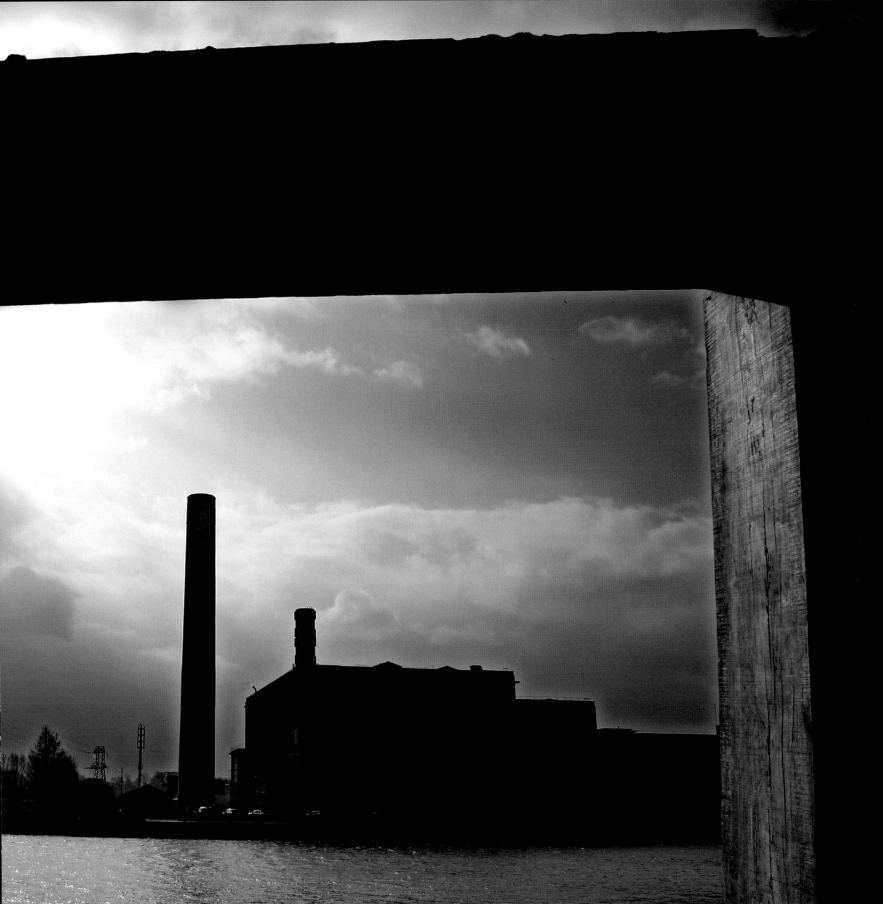

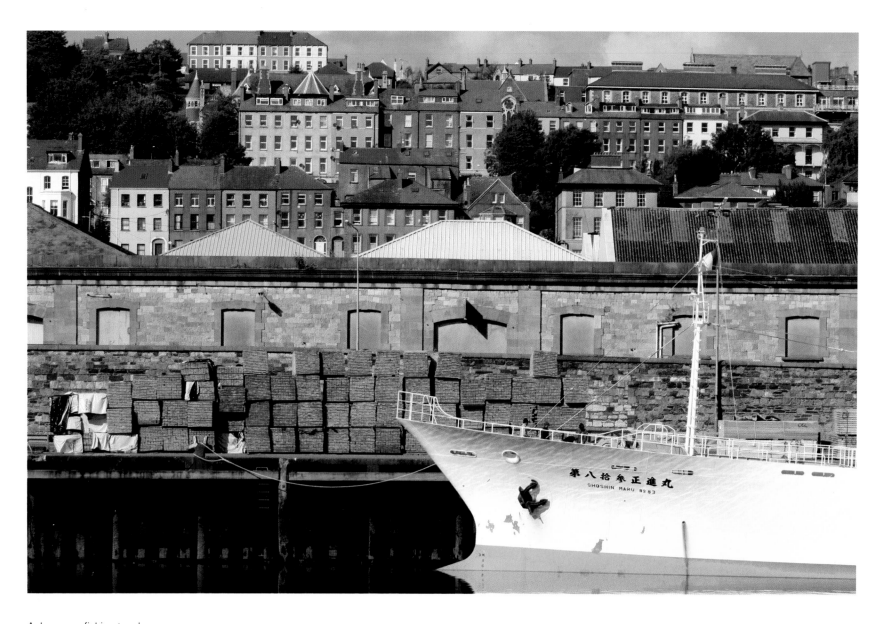

A Japanese fishing trawler
tied up on Horgan's Quay,
with the rail sheds and
Summerhill behind.

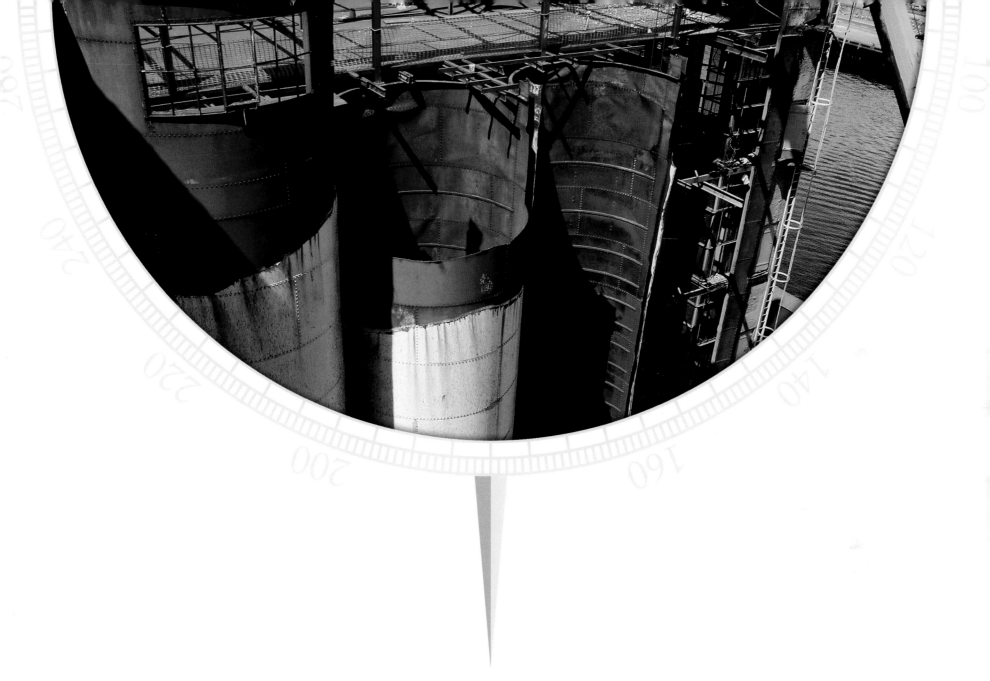

SOUTH

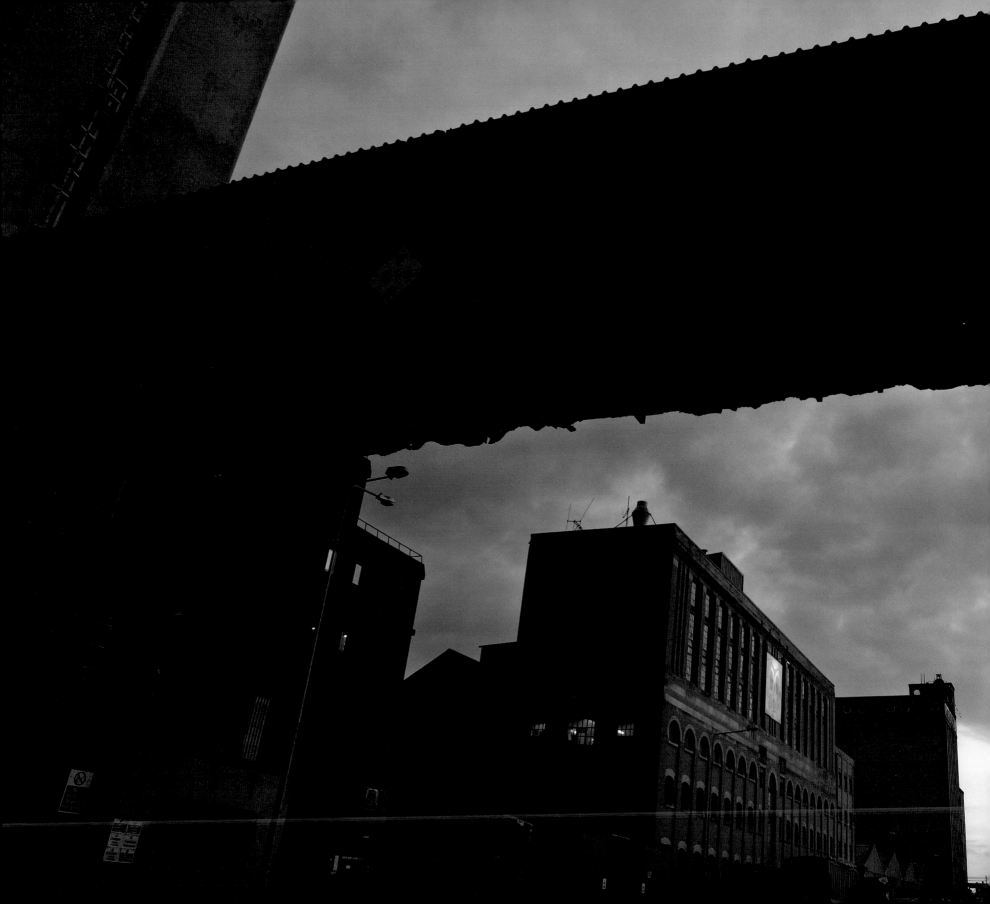

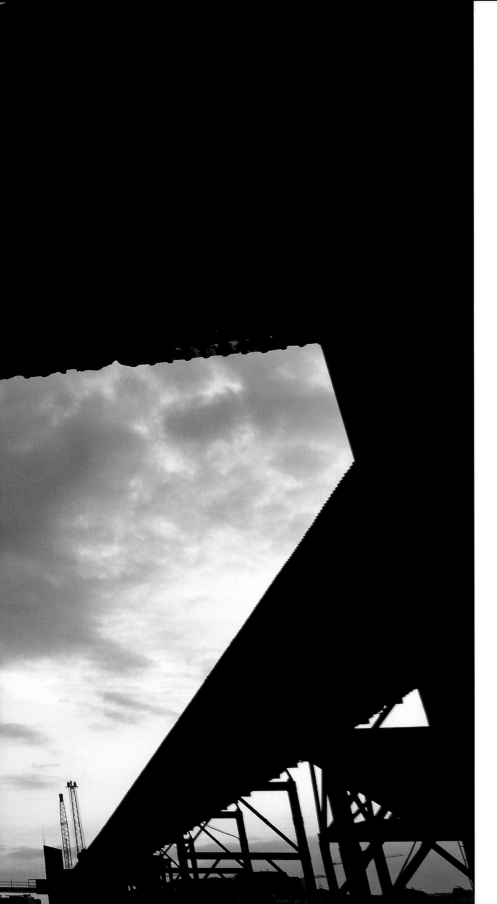

The elevated conveyors frame the art deco façade of Odlums' mills.

29

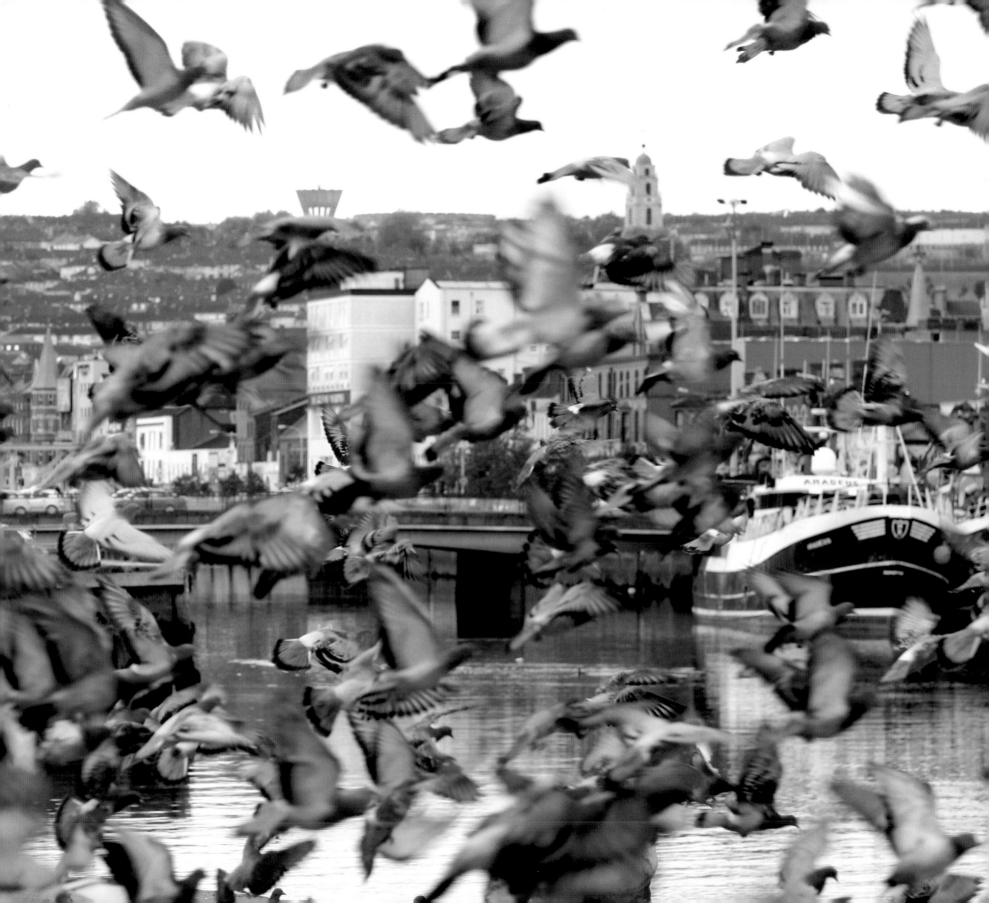

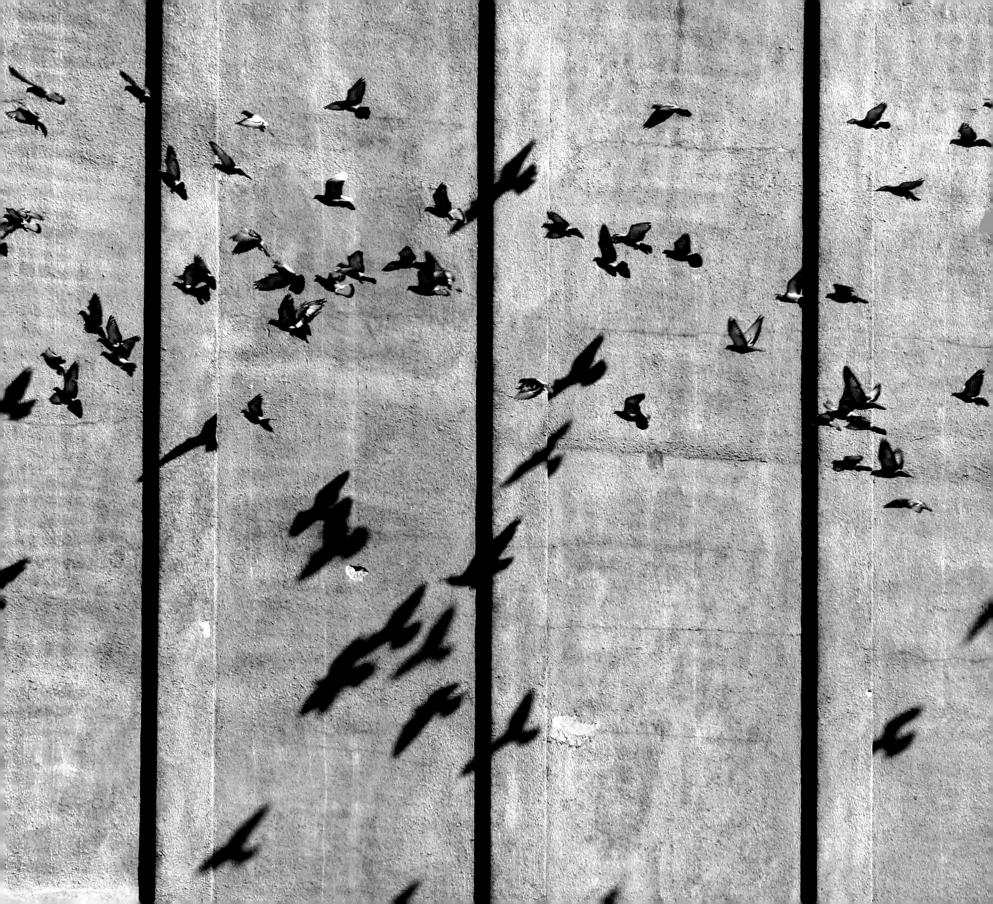

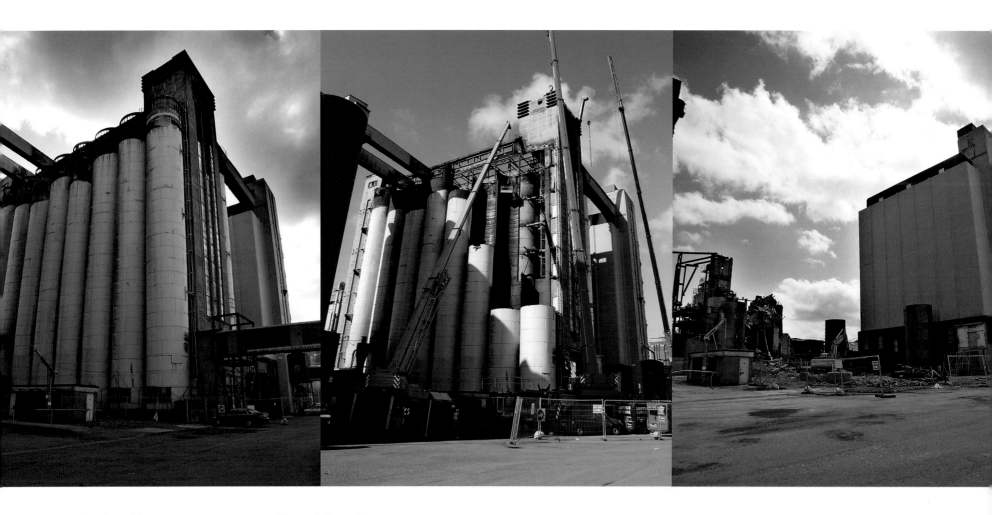

Previous: Pigeons are
a part of dock life, feeding
freely on spilled grain from the
storage silos.

Above: Going, going, gone.
Demolition company, Loftus,
dismantle the silos on
Kennedy Quay in June 2008.

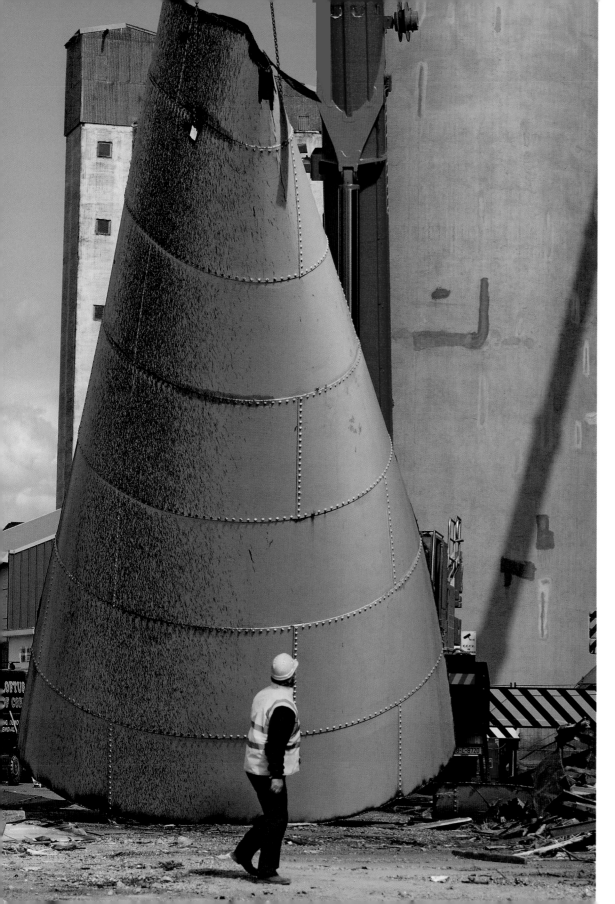

Hilary Loftus of the Loftus demolition company surveys the mid-section of a silo as it is lowered to the ground.

33

The MIAG silos stand
like organ pipes on
Kennedy Quay.

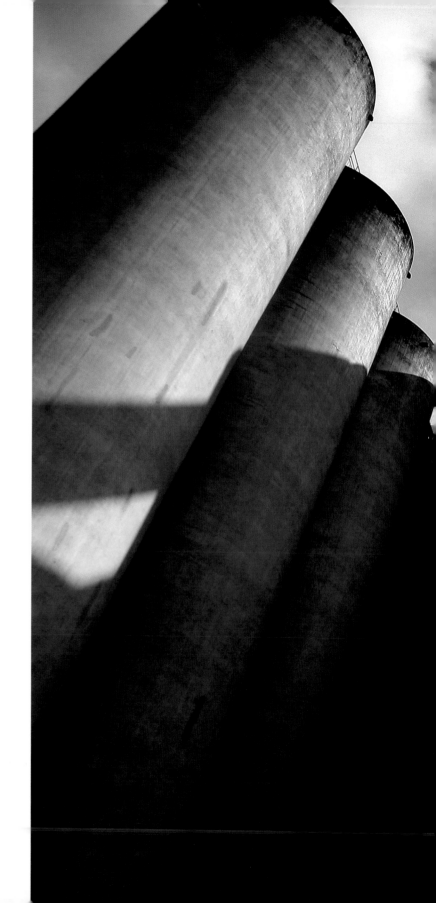

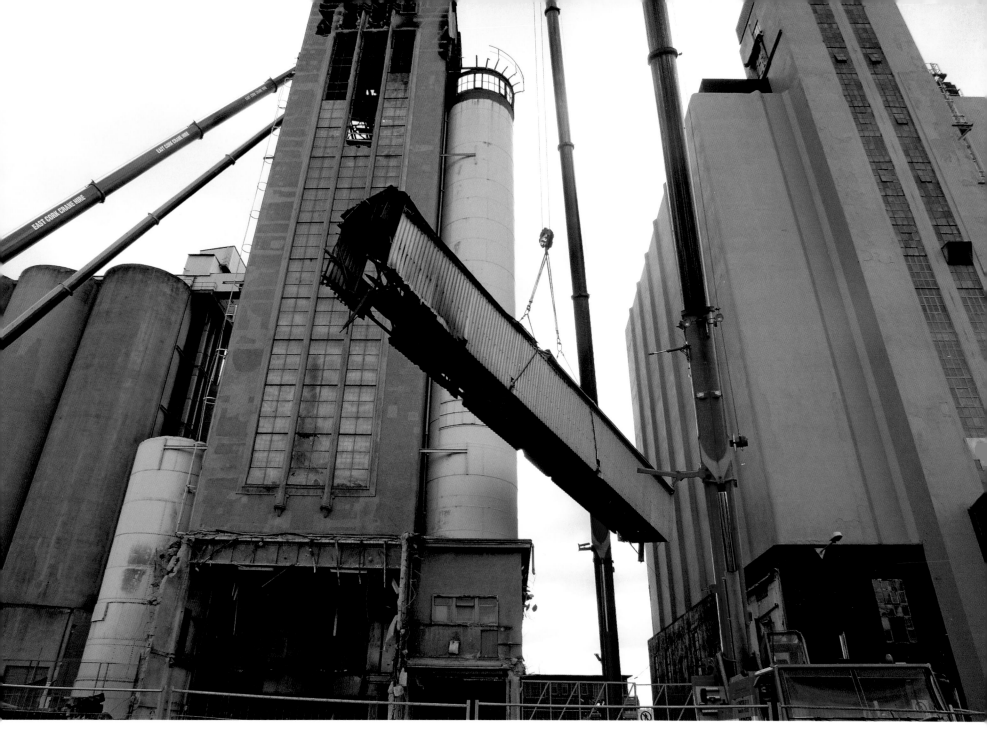

Opposite: A gantry connects the blocks of silos.

Above: The gantry is cut clear and taken away for scrap.

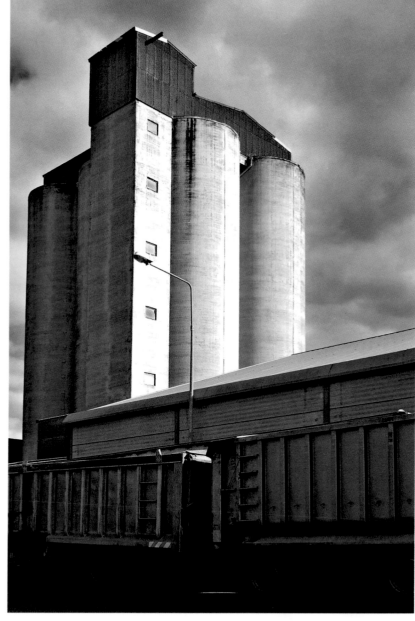

Above: (left) Chimney stack and tanks at Goulding Fertilisers; (right) Arkady Feed silos on Kennedy Quay.

Opposite: A ship's stern reflected in the still waters of the River Lee.

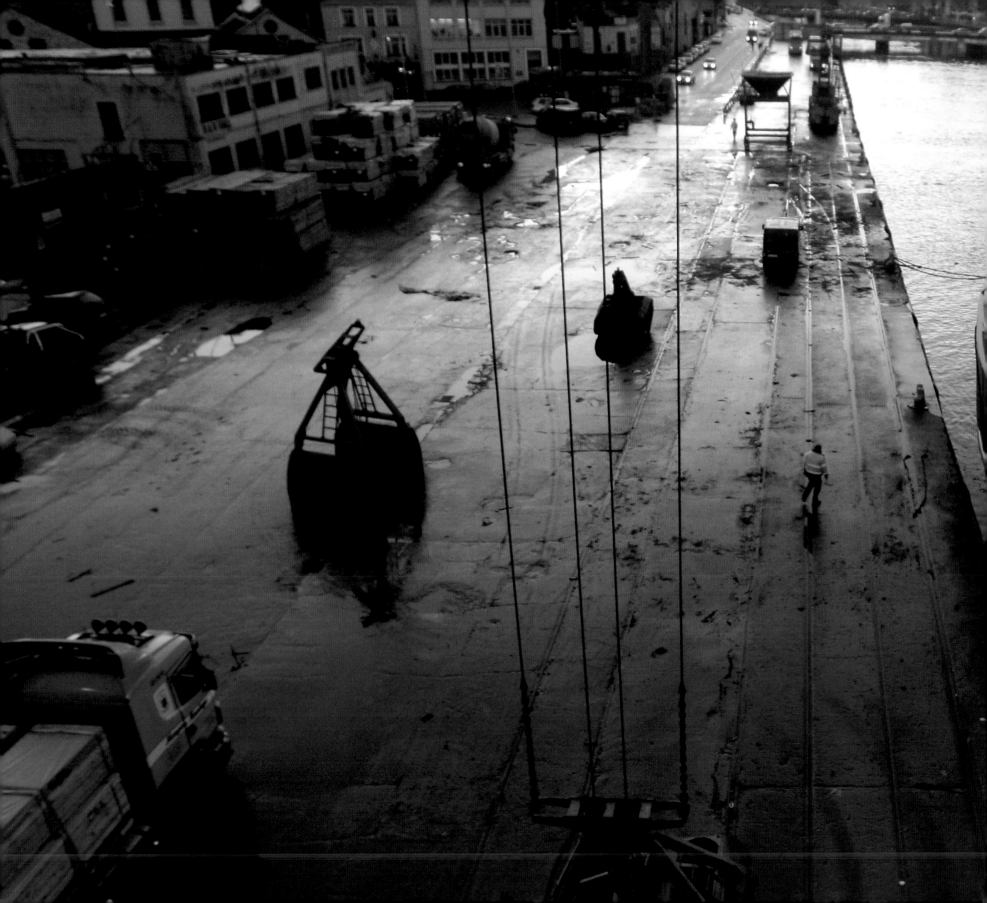

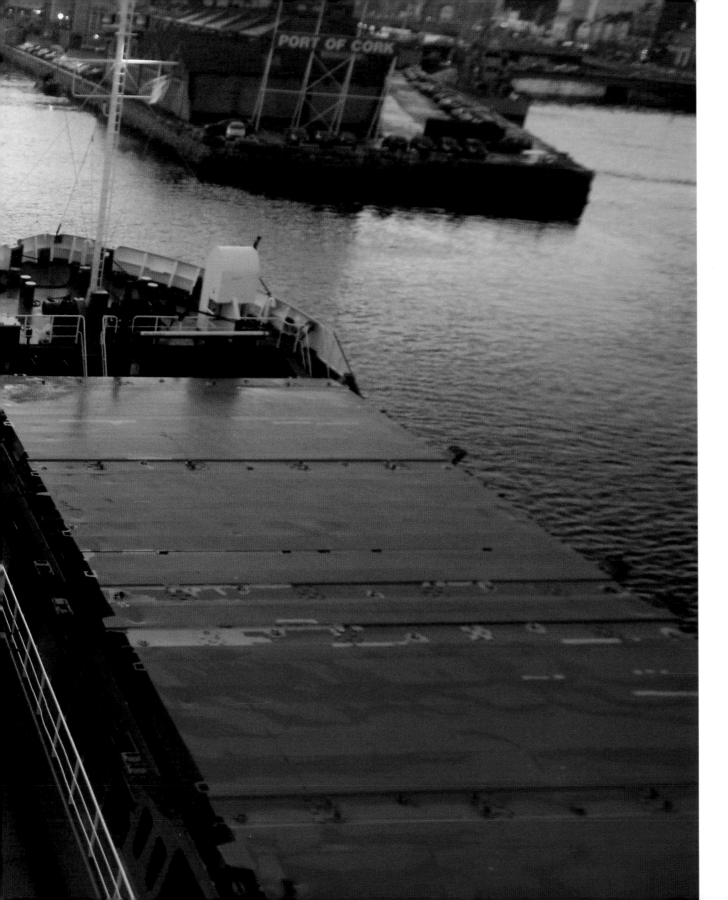

Brian Doyle, crane driver, finishes a day's work unloading cattle feed. The ship's cargo bays are closed in preparation for its departure.

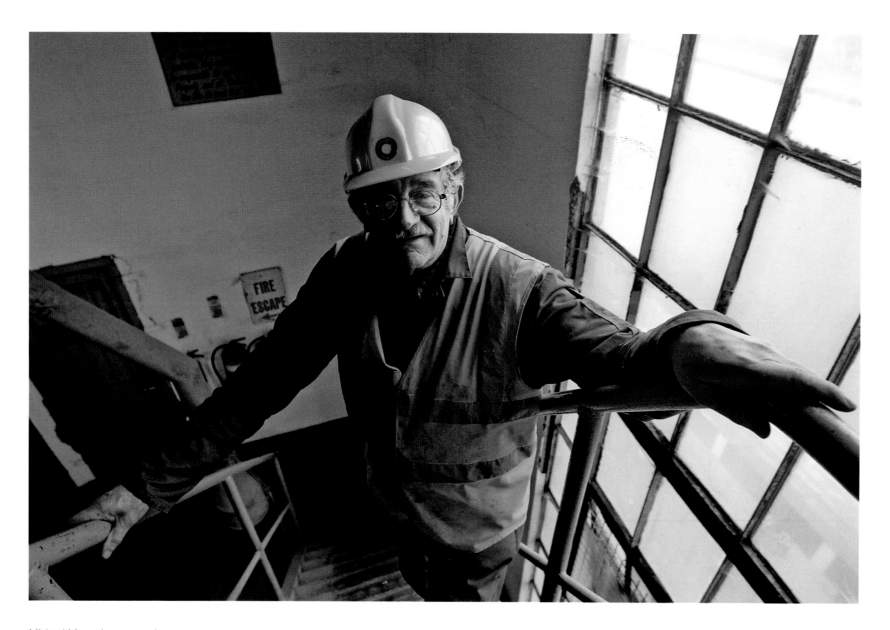

Michael Moore is set to retire
after fifty years as a silo operator
with R & H Hall.

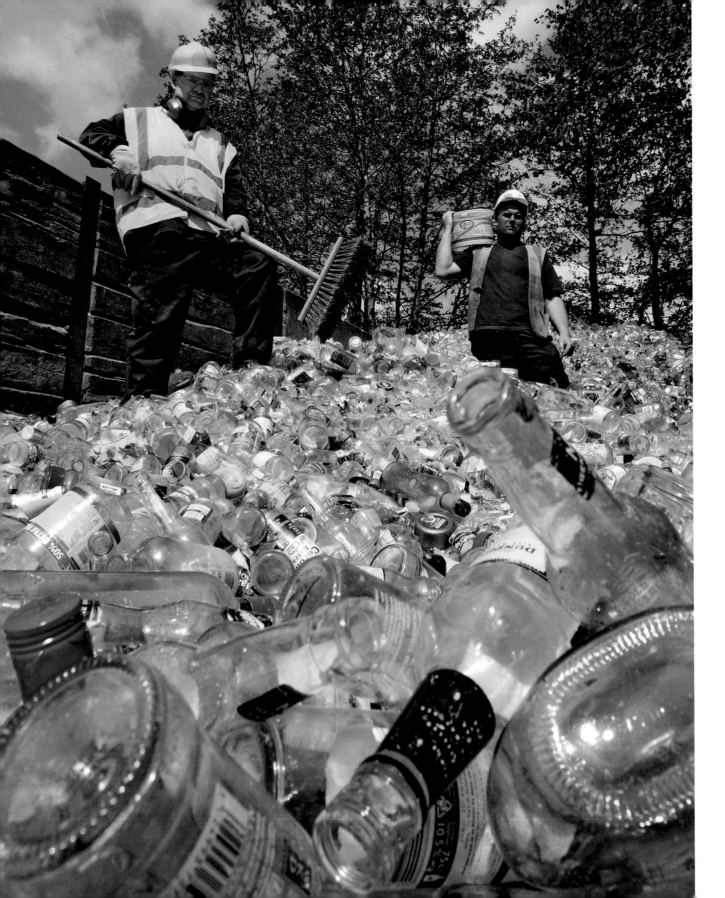

Ger O'Callaghan and Frank
Guinane sort glass bottles at
the Rehab Recycling Centre
on Monahan's Road.

45

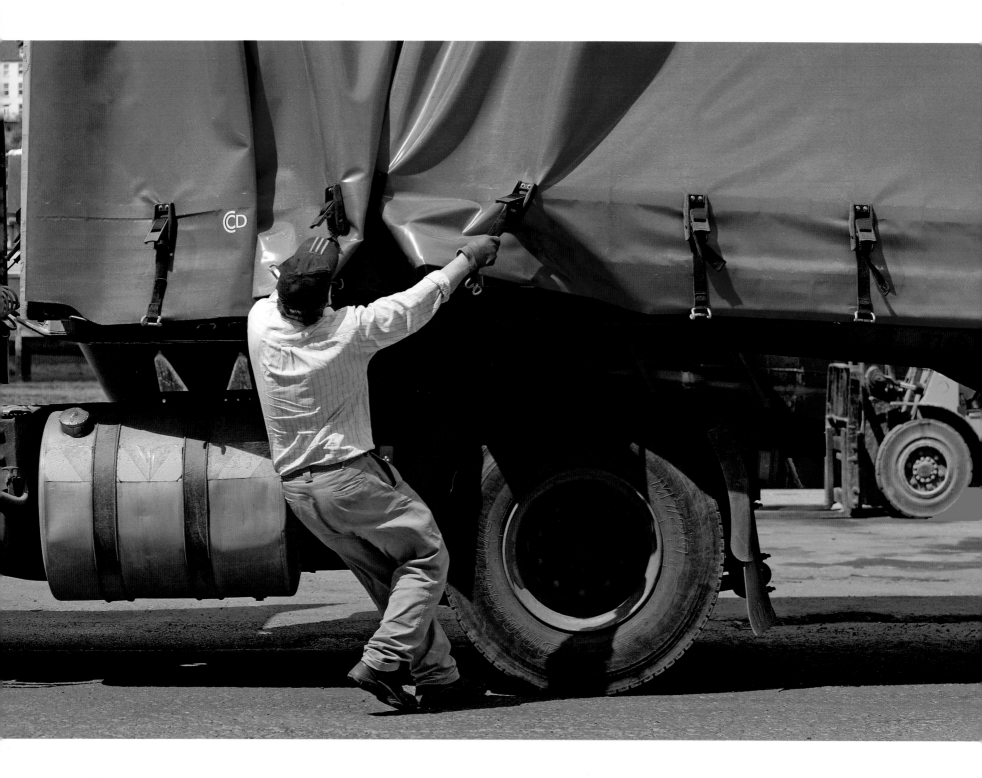

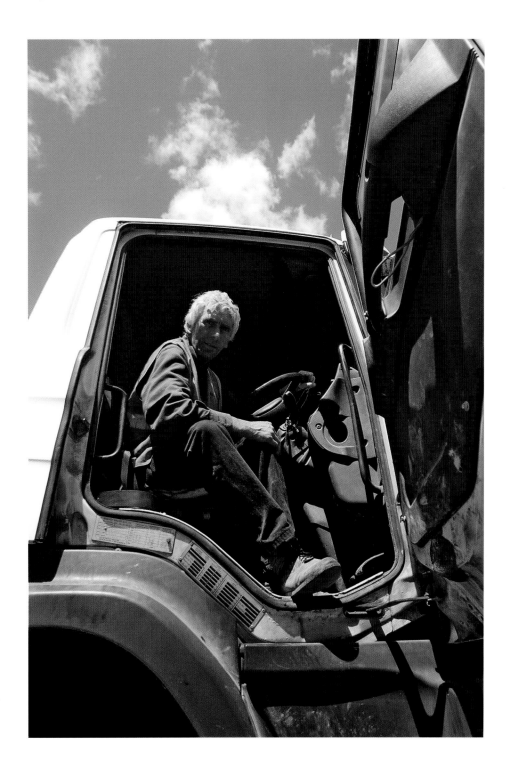

Opposite: Opening the sidewalls of a truck to take a load of timber.

Left: Terry O'Keeffe, trucker, could make up to twenty trips a day to the docks.

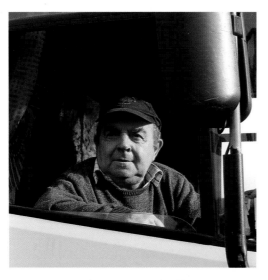
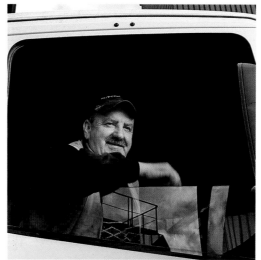
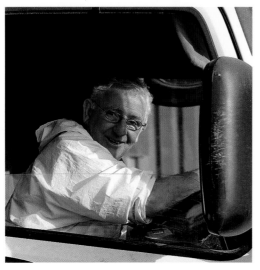
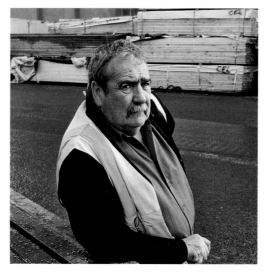

Above: (clockwise from top left)
Truck drivers: Ritchie McCarthy,
Jimmy O'Sullivan, Tony O'Callaghan
and Seanie O'Sullivan.

Opposite: Truckers Paddy 'Bandon'
Murphy and Patrick McCarthy chat
while waiting to load coal.

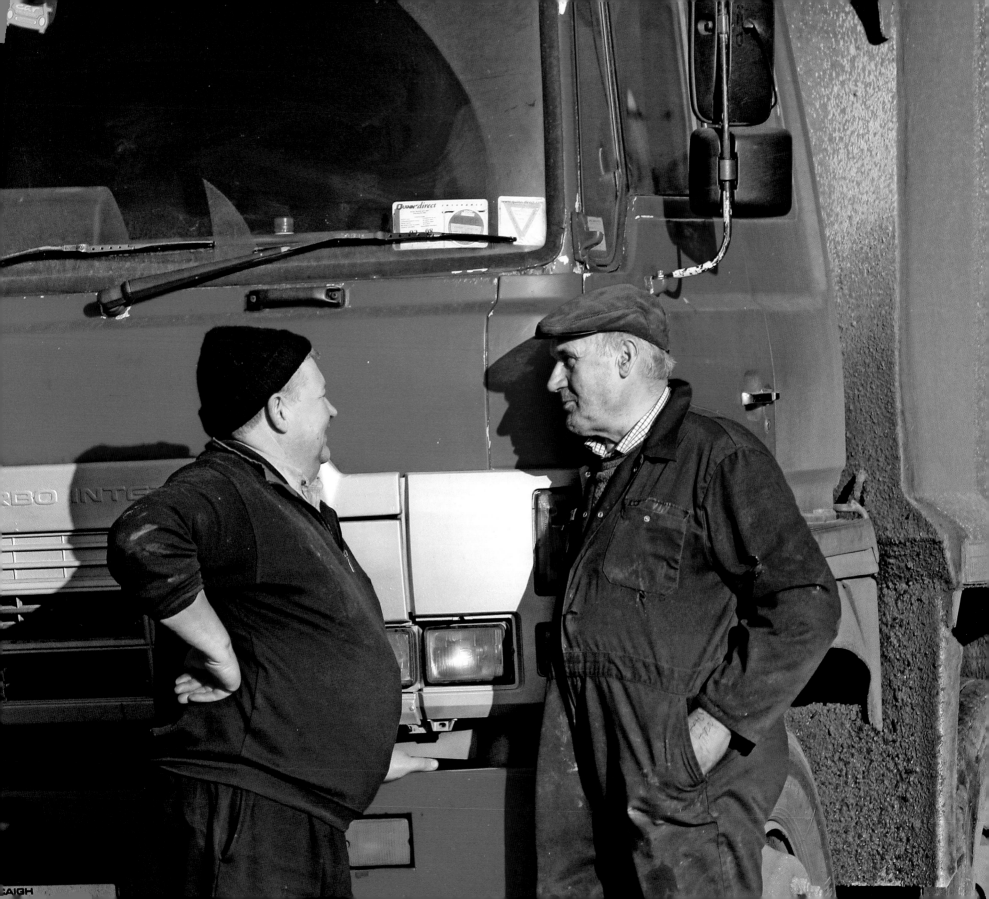

Dockers will work in the rain, depending on the cargo to be unloaded.

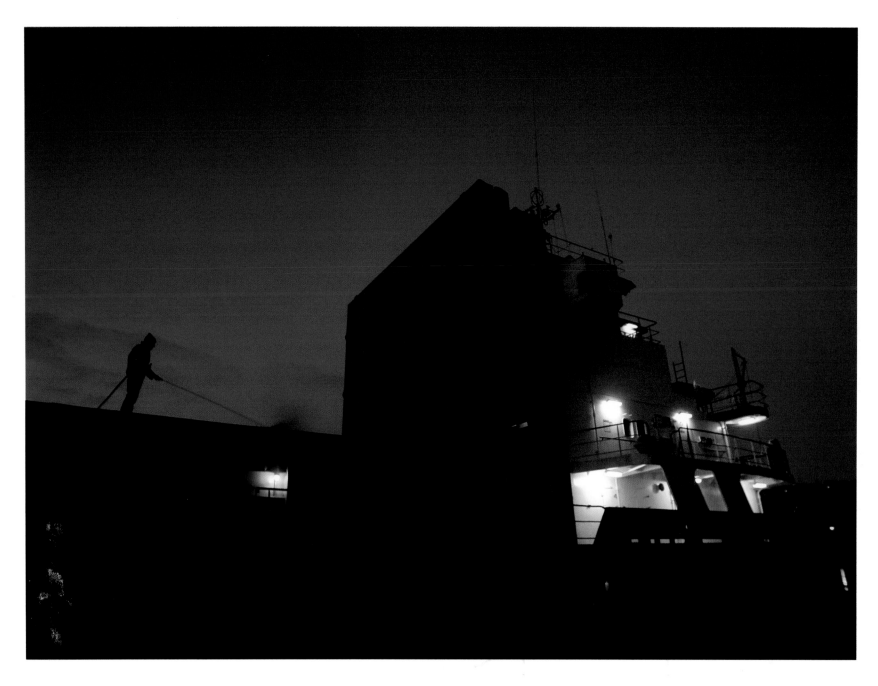

Above: A crewman washes
the hatches of a ship prior
to departure.

Opposite: Hooks and ropes
still play a part on the docks.

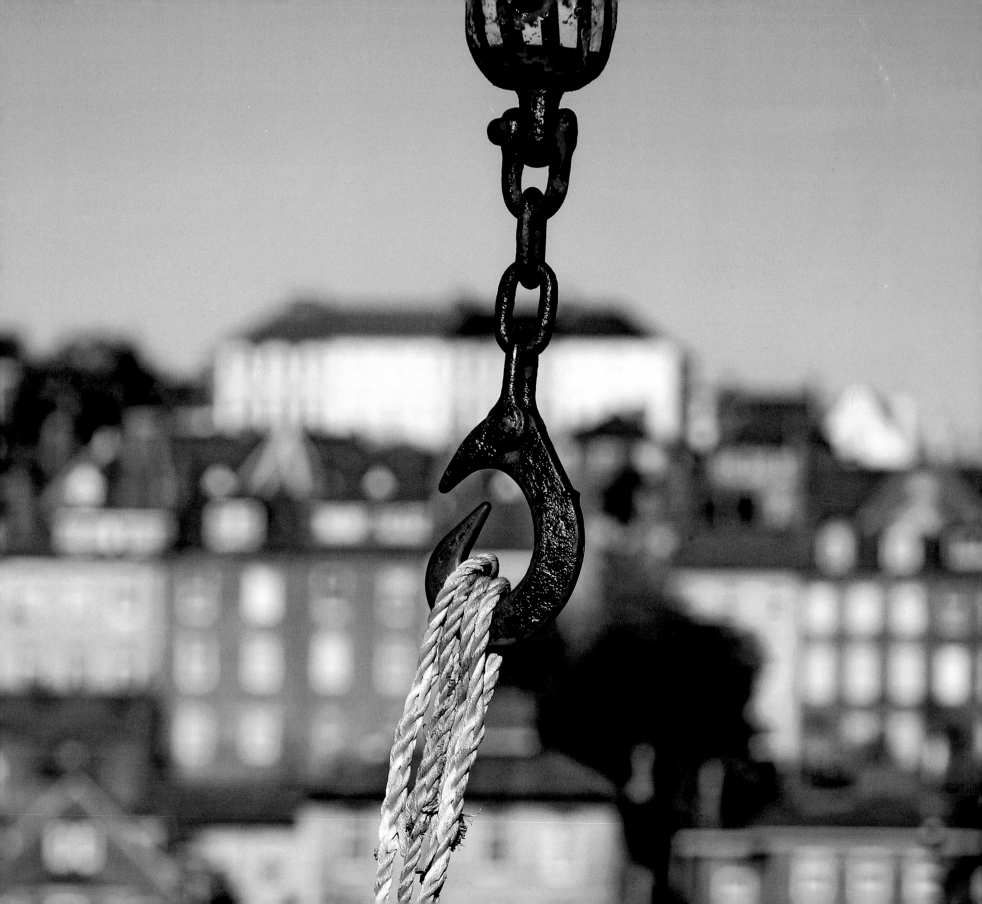

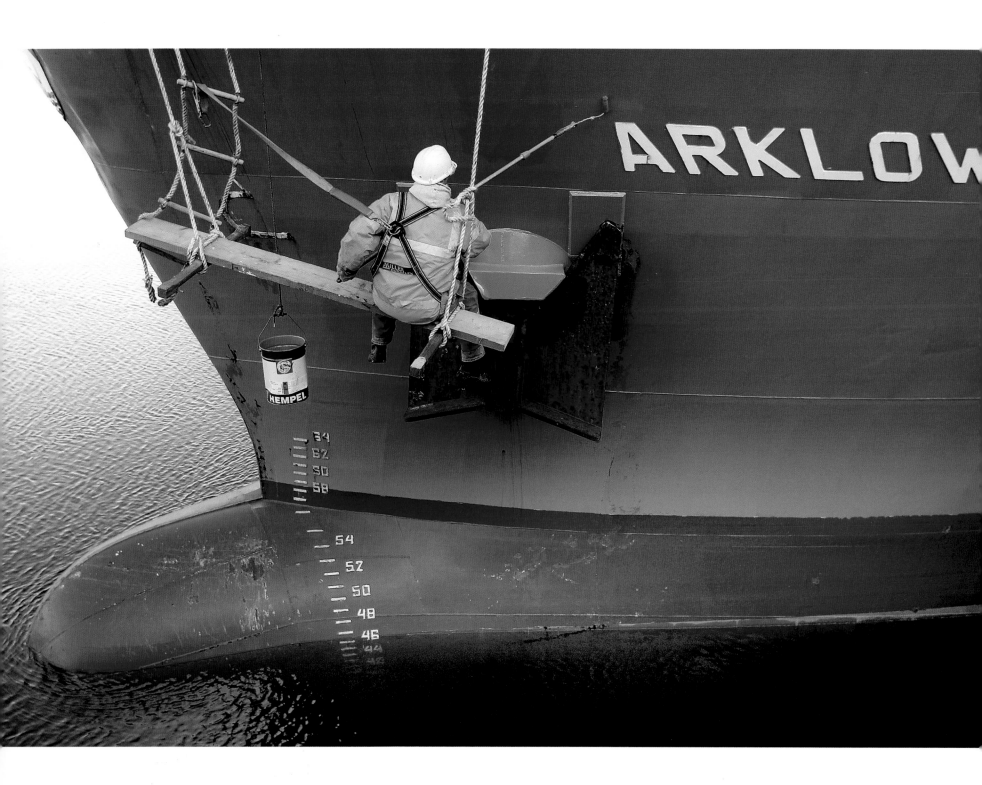

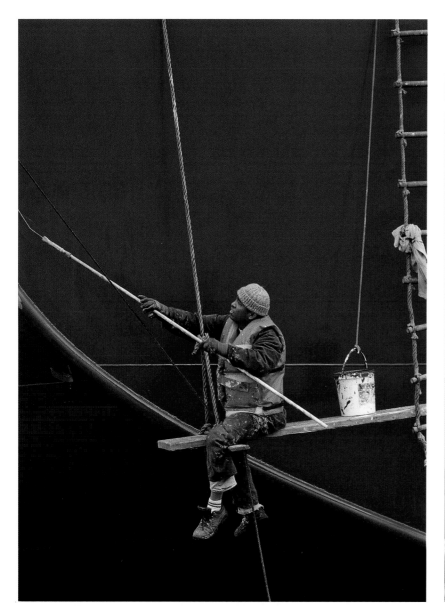

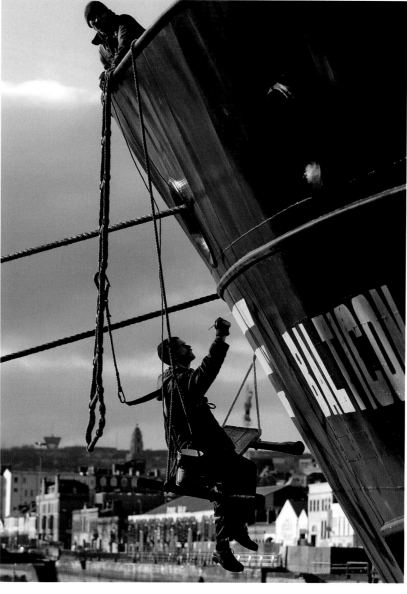

Opposite and above:
Crewmen take advantage
of the calm waters to touch
up the paintwork.

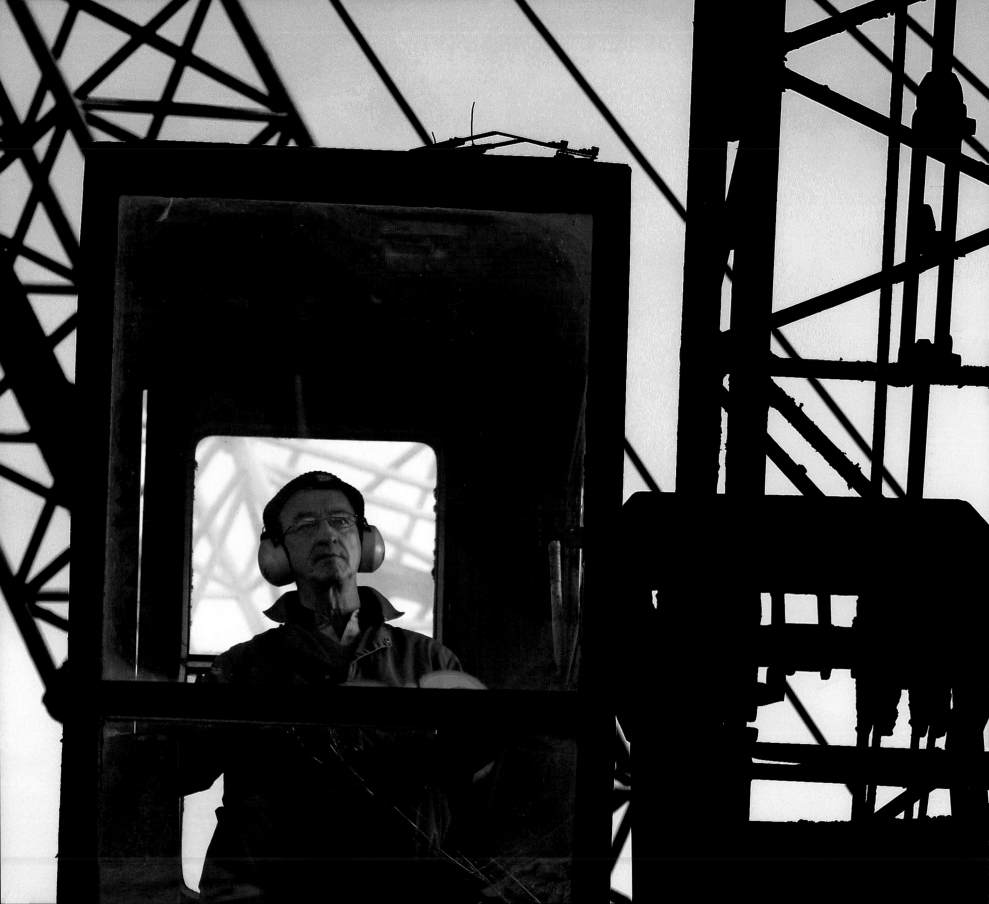

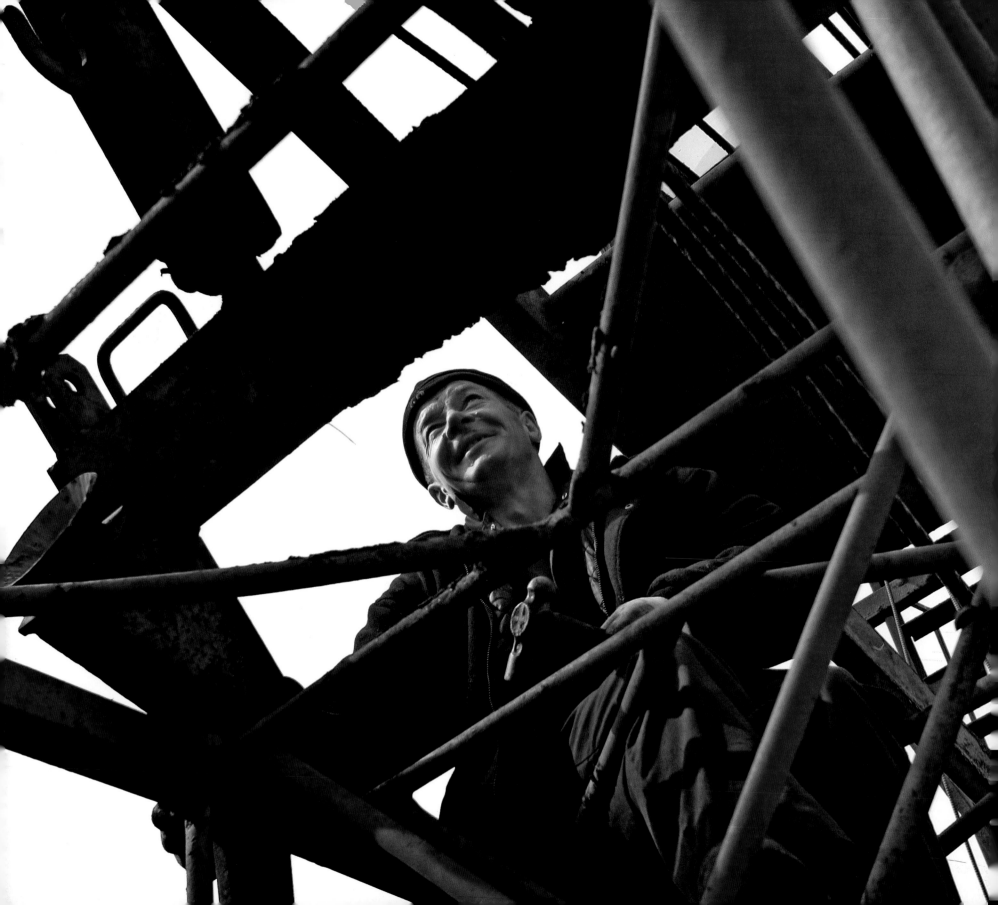

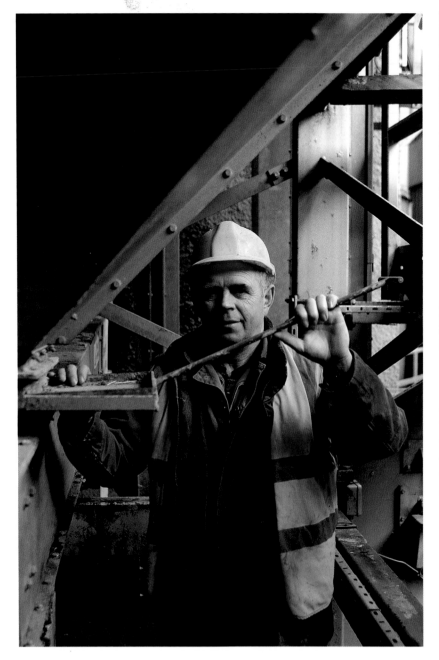

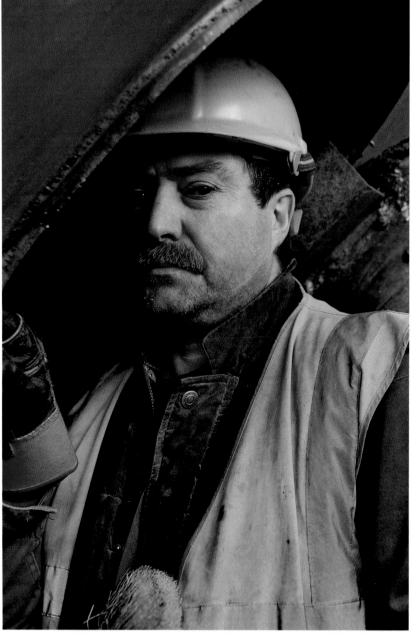

Previous: (left) Conor O'Callaghan, crane driver, unloads coal; (right) Kevin Coomey, fitter, maintains the cranes.

Above: (left) Pat Hennessy, fitter, R & H Hall; (right) Barry Kelleher, silo operator, R & H Hall.

Opposite: 'Watching the comings and goings is an education,' Andy Breen, security guard.

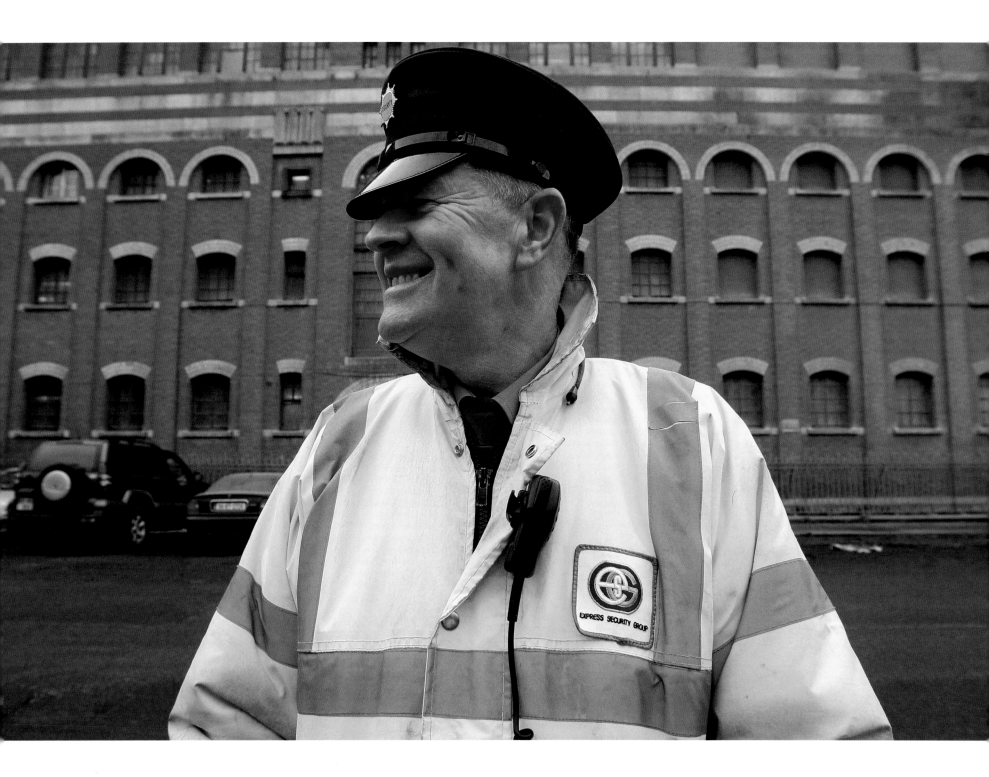

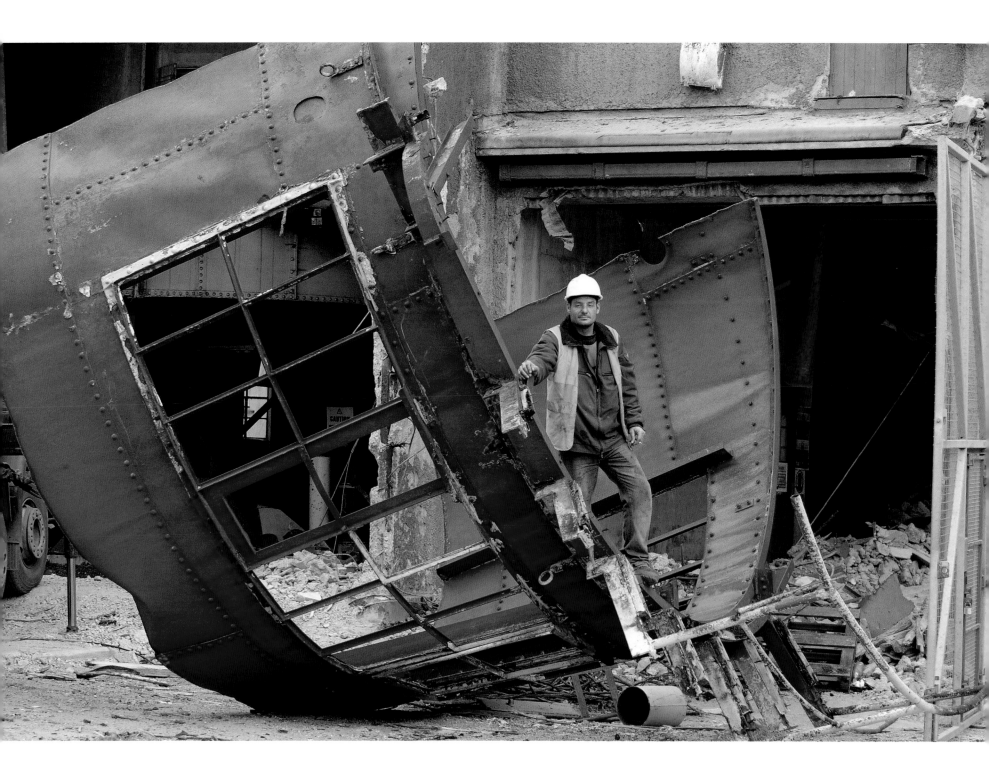

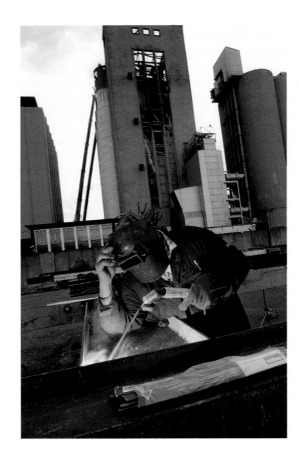

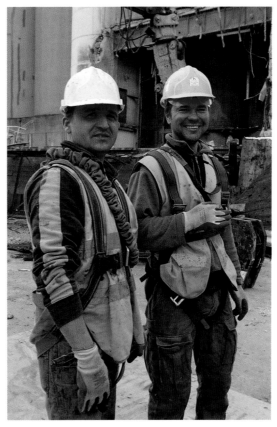

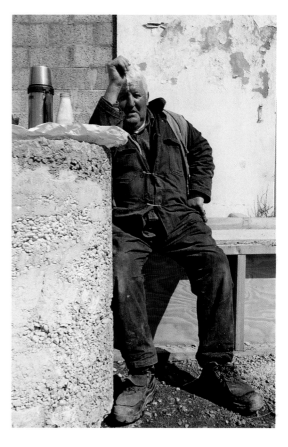

Opposite: Peter Buck, demolition expert, Loftus.

Above: (left to right) Welding as part of the demolition process; Polish workers Tomasz Lepa and Tareh Michalah; Tim Kenny takes a tea break.

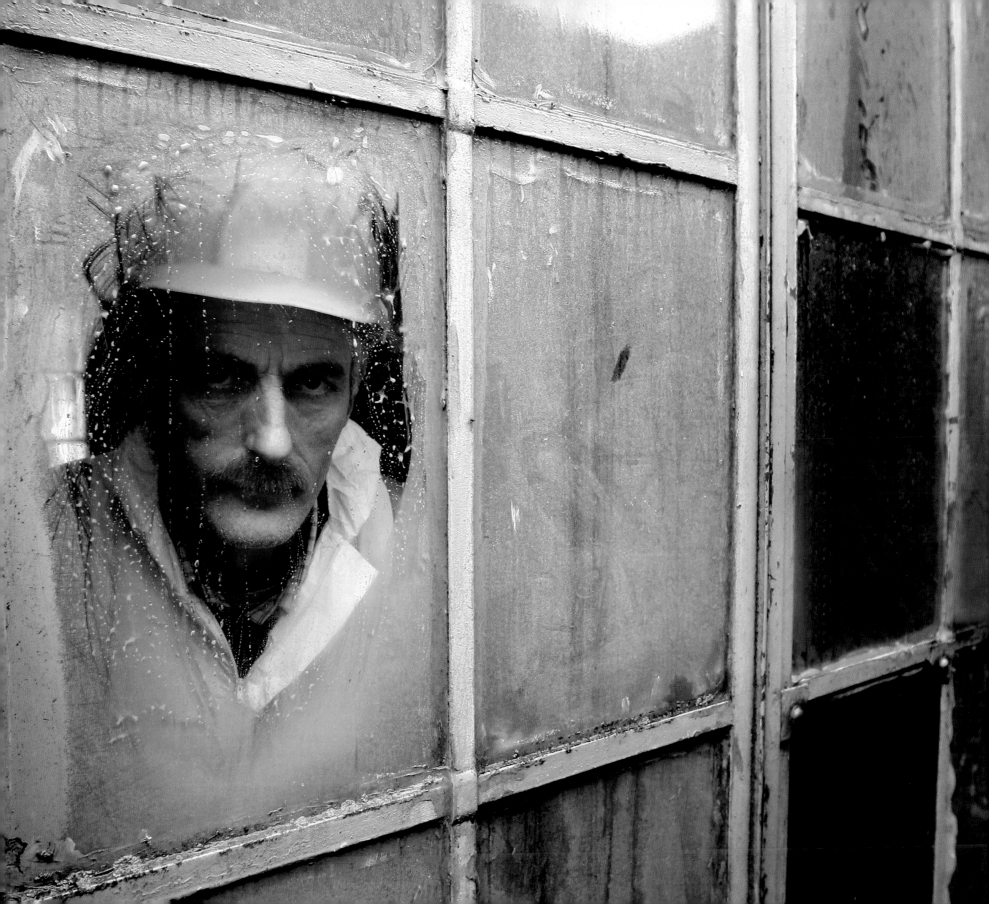

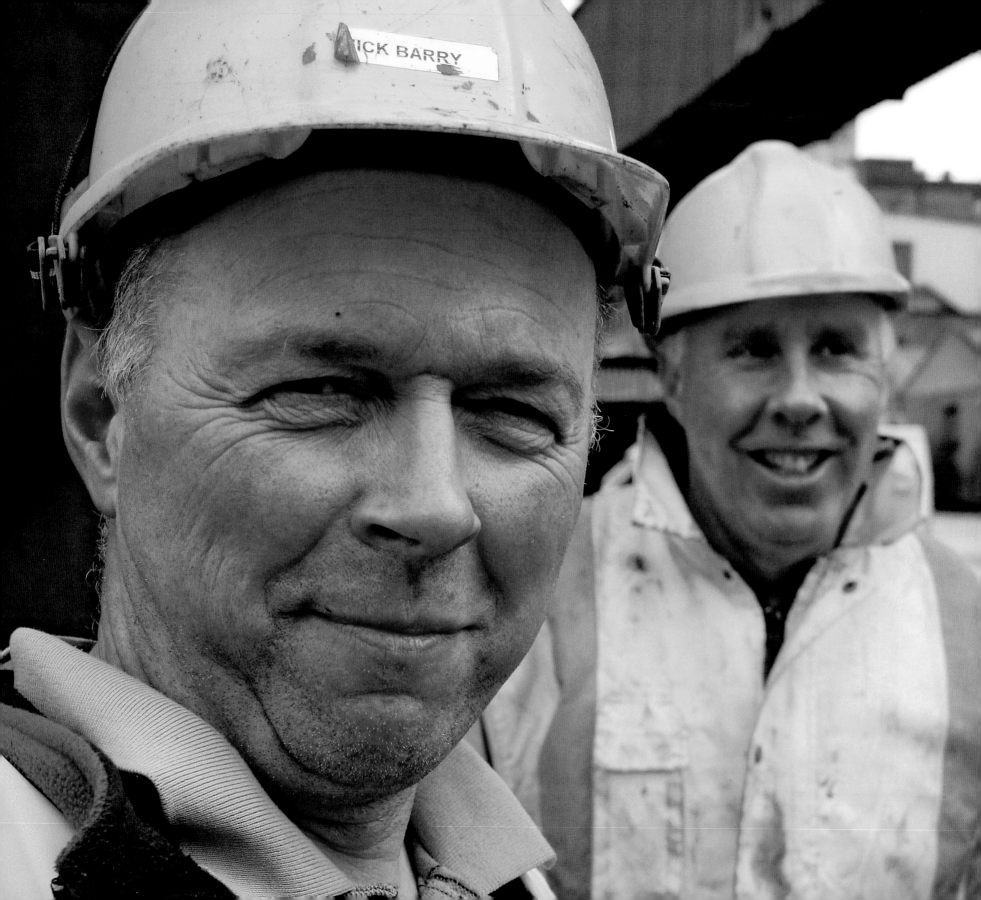

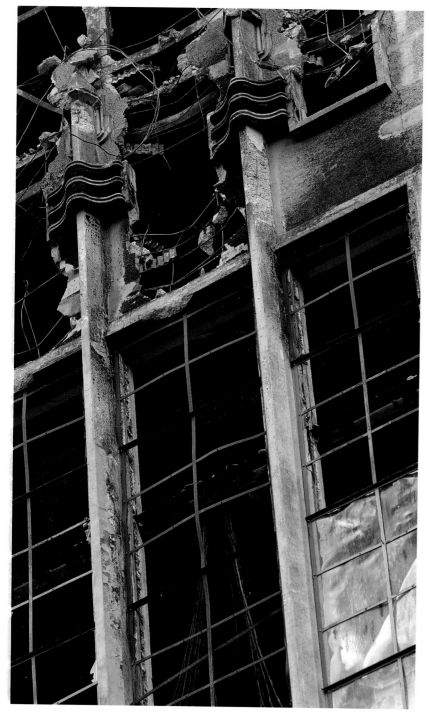
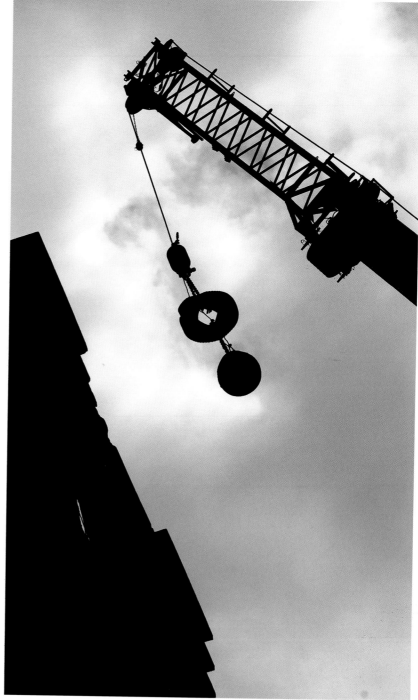

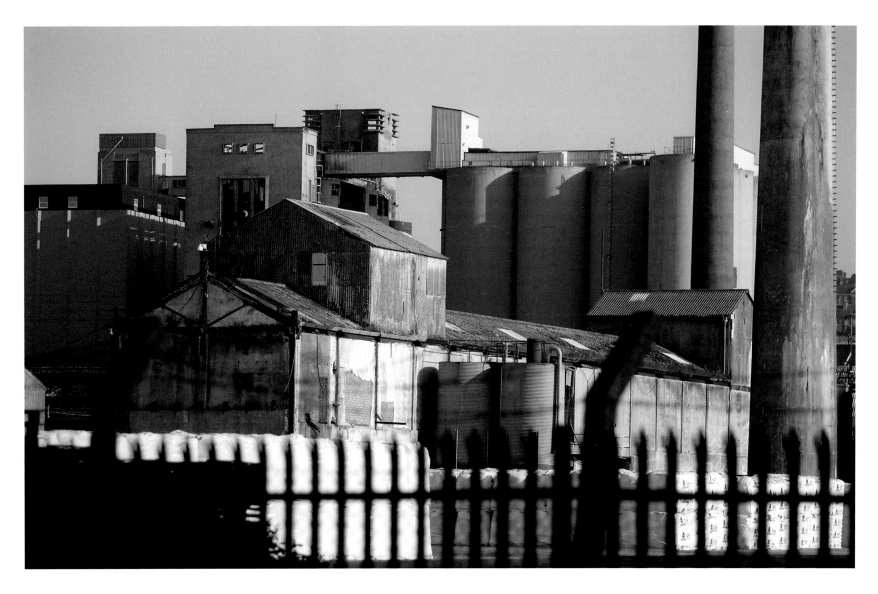

Previous: (left) Peter Cotter, silo operator, R & H Hall; (right) Mick Barry and Noel Collins, fitters, R & H Hall.

Opposite: The wrecker's ball has an immediate impact.

Above: A view across the storage yards of Goulding Chemicals.

Pigeons roost in the tall
buildings as a transatlantic
jet crosses the sky.

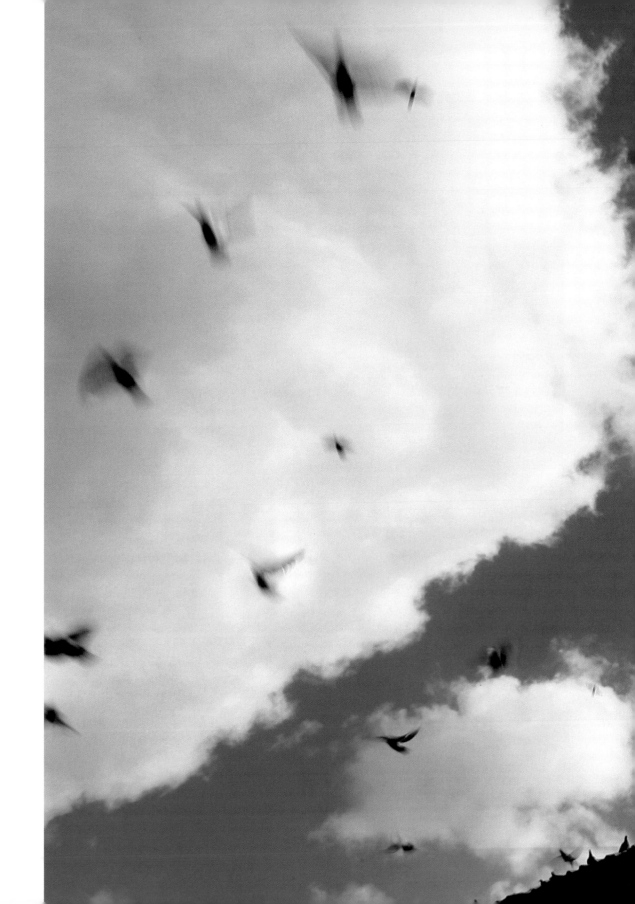

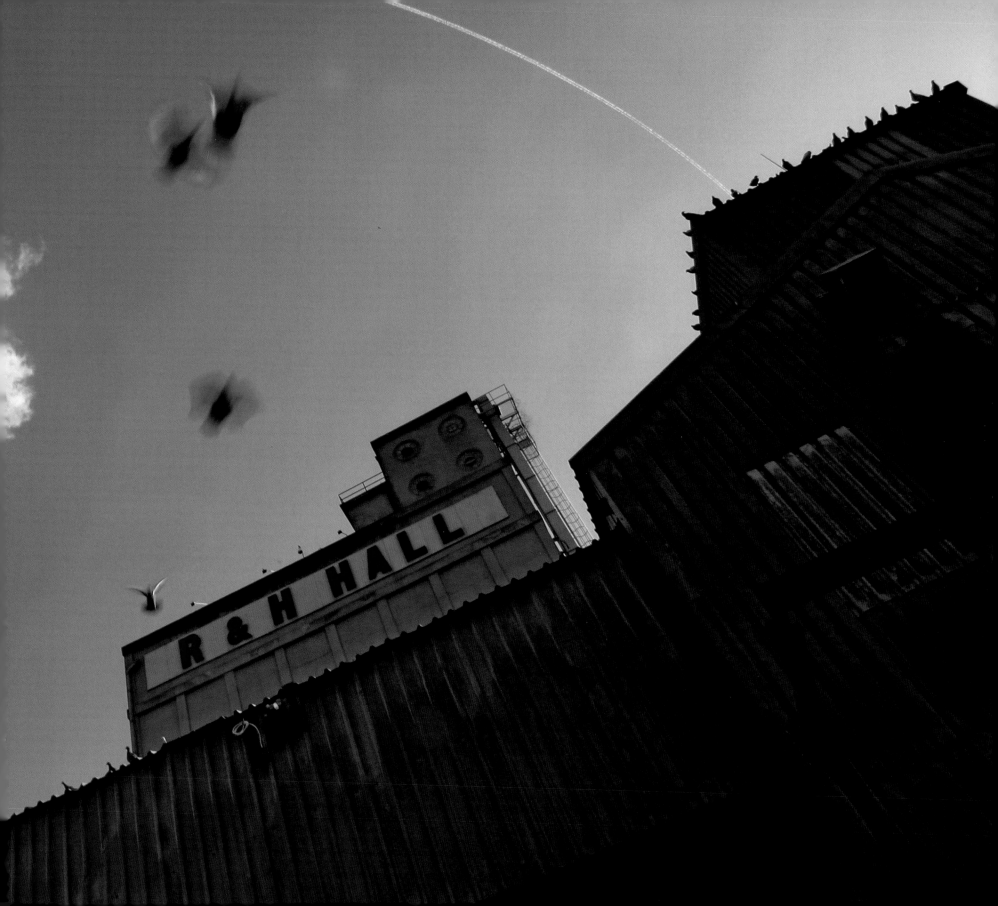

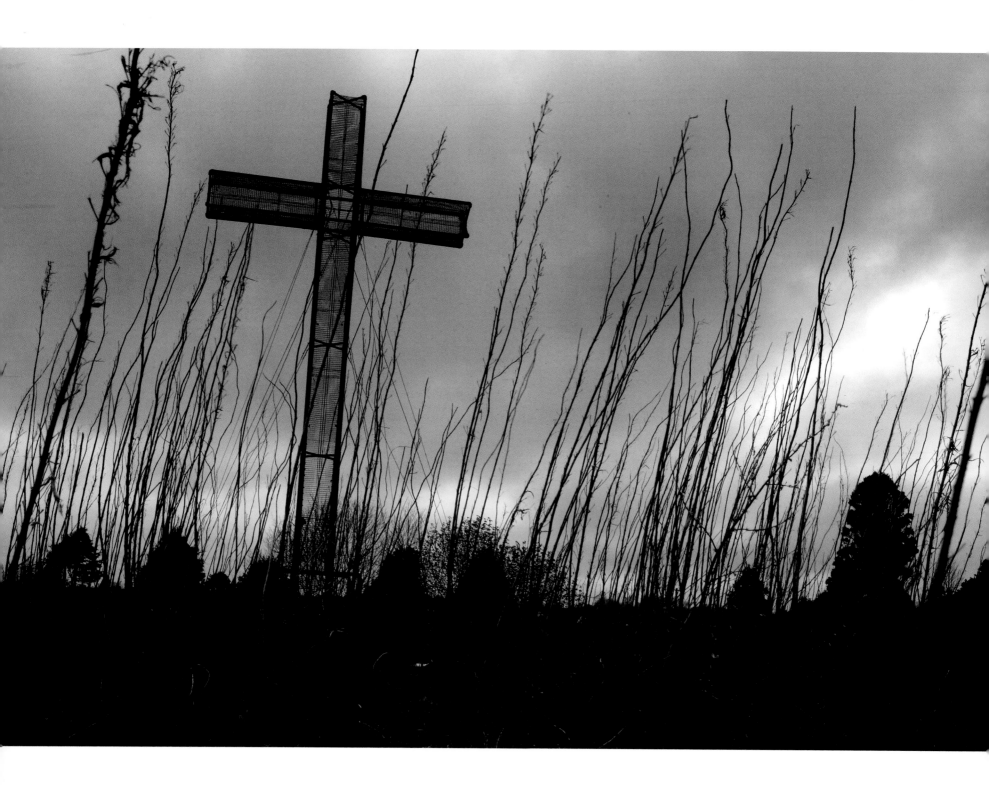

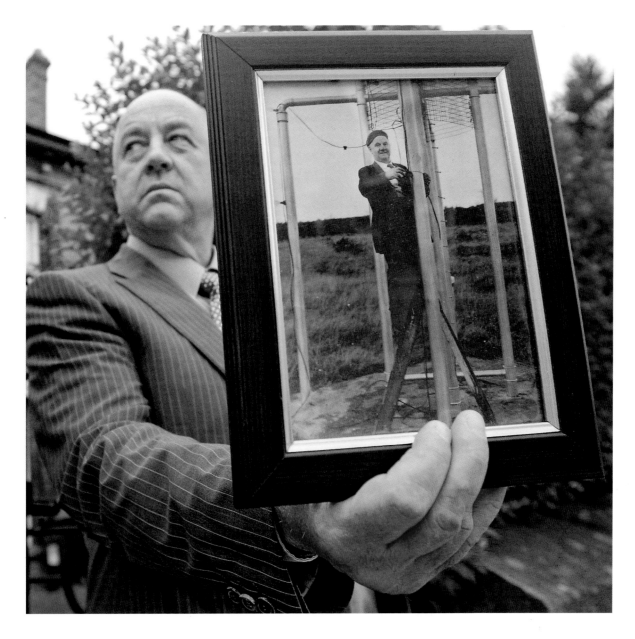

Opposite: In the 1950s, taxi driver Olaf Sorensen built a cross in tribute to the famine paupers buried at Carr's hole on the road to Carrigaline. The cross was constructed in his garden at Park View.

Above: His grandson, also Olaf Sorensen, holds a photo of his grandfather installing the cross.

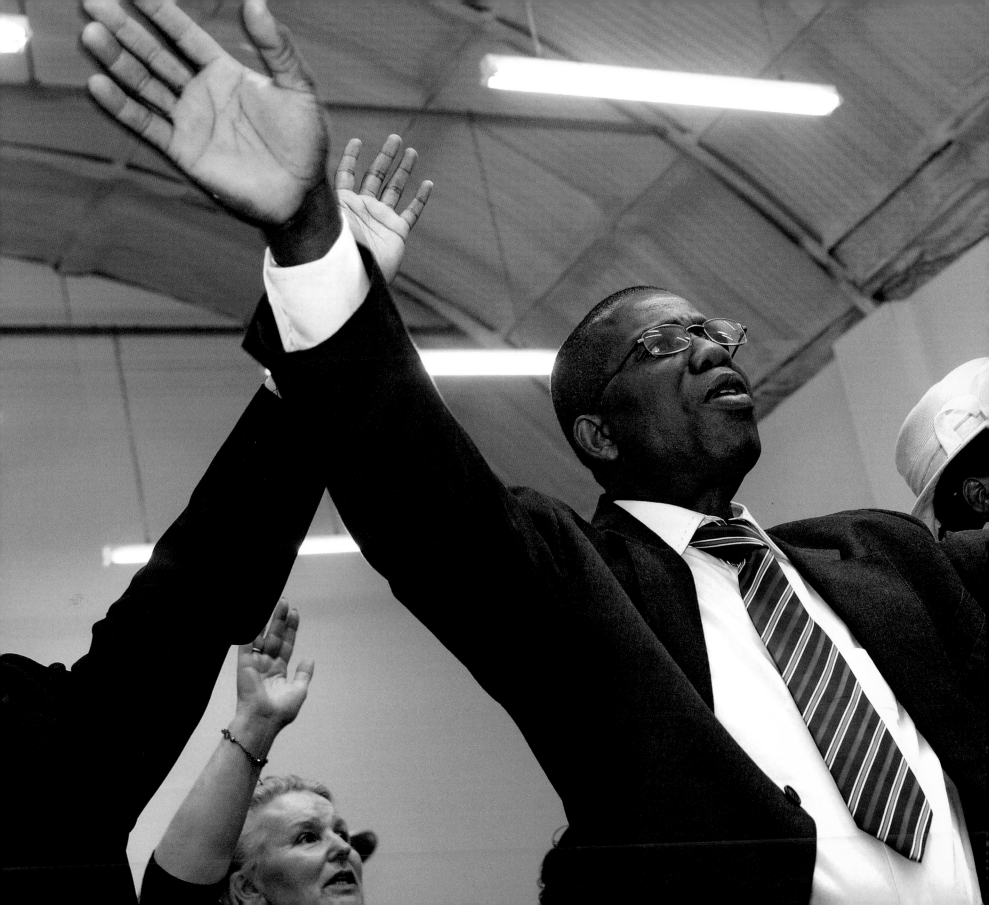

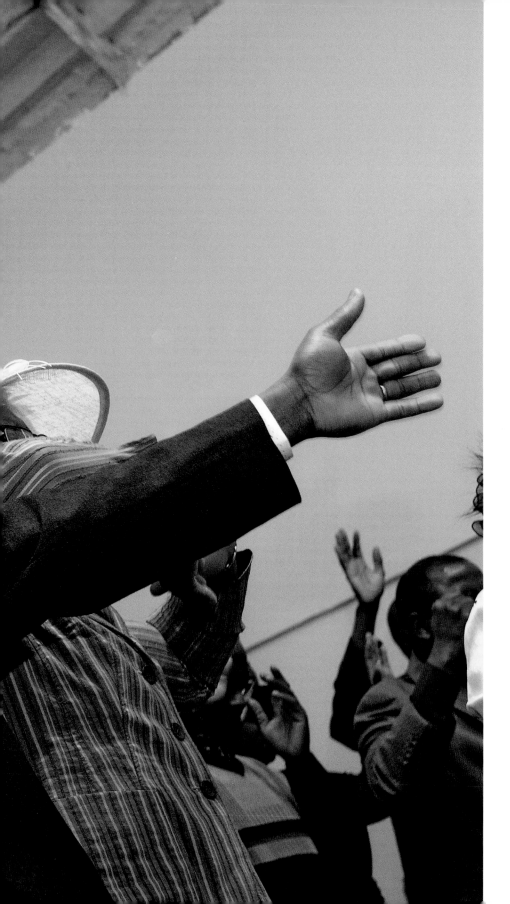

Members of the Pentecostal
Christ Jesus Centre worship
at a new church opened in
a former panel beaters'
workshop on Monahan's Road.

Above: (left to right) Friends for forty-five years: Billy Kemp, Gerry O'Reilly and Noel Browne.

Opposite: The men are the last of a large group of friends that met regularly at the Silo Bar (now Idle Hour) on Albert Quay.

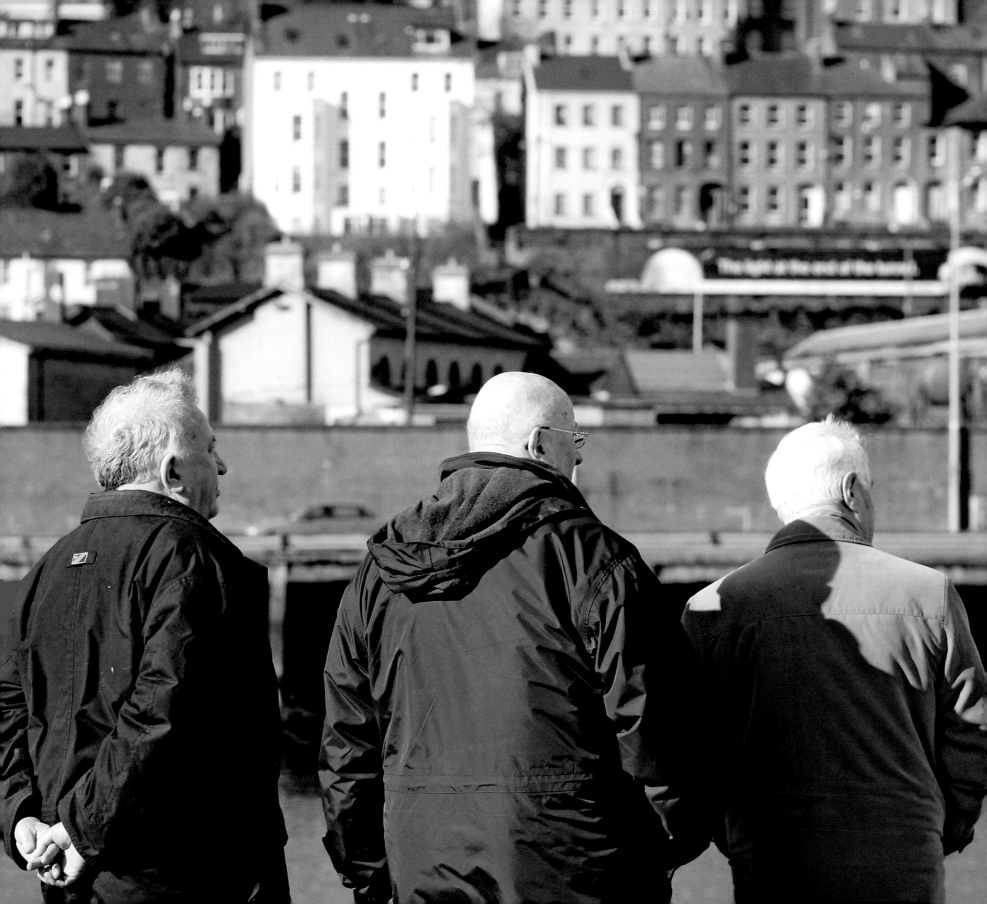

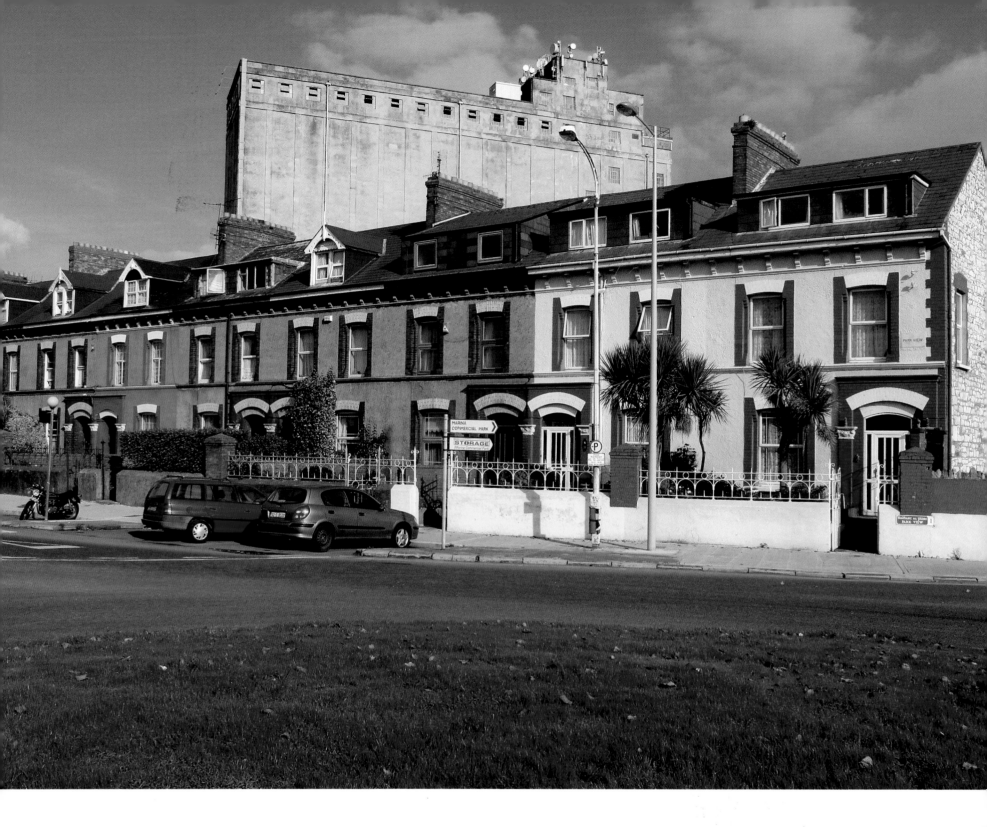

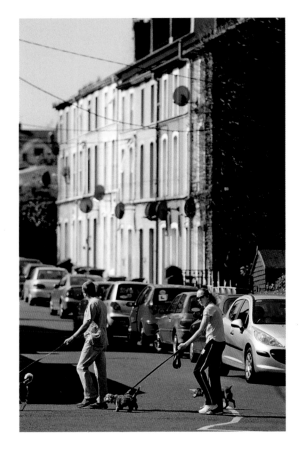 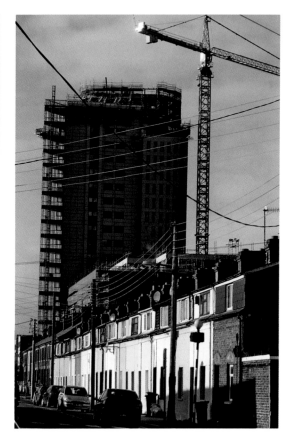

Opposite: Houses at Park
View are overshadowed by
the granaries.

Above: Long-term residents
renovate their old homes,
while the new Elysian tower
brings change to the area.

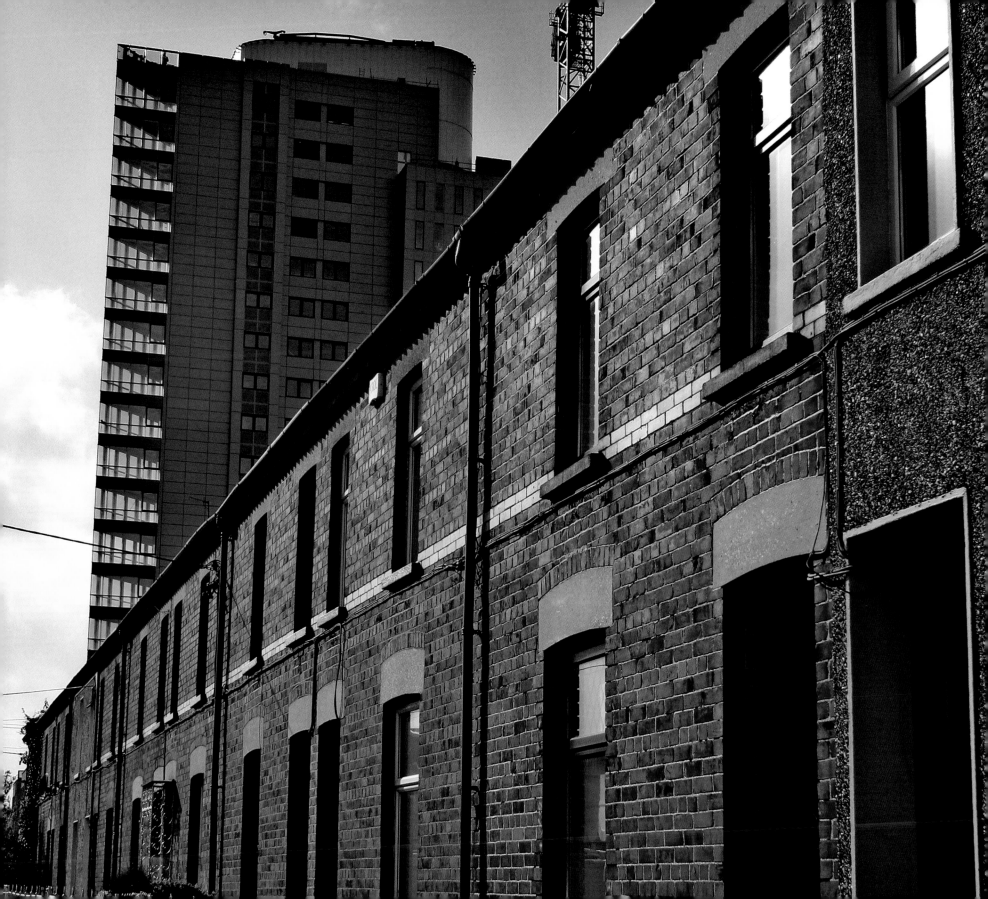

The Elysian tower looms over Monerea Terrace on Old Station Road.

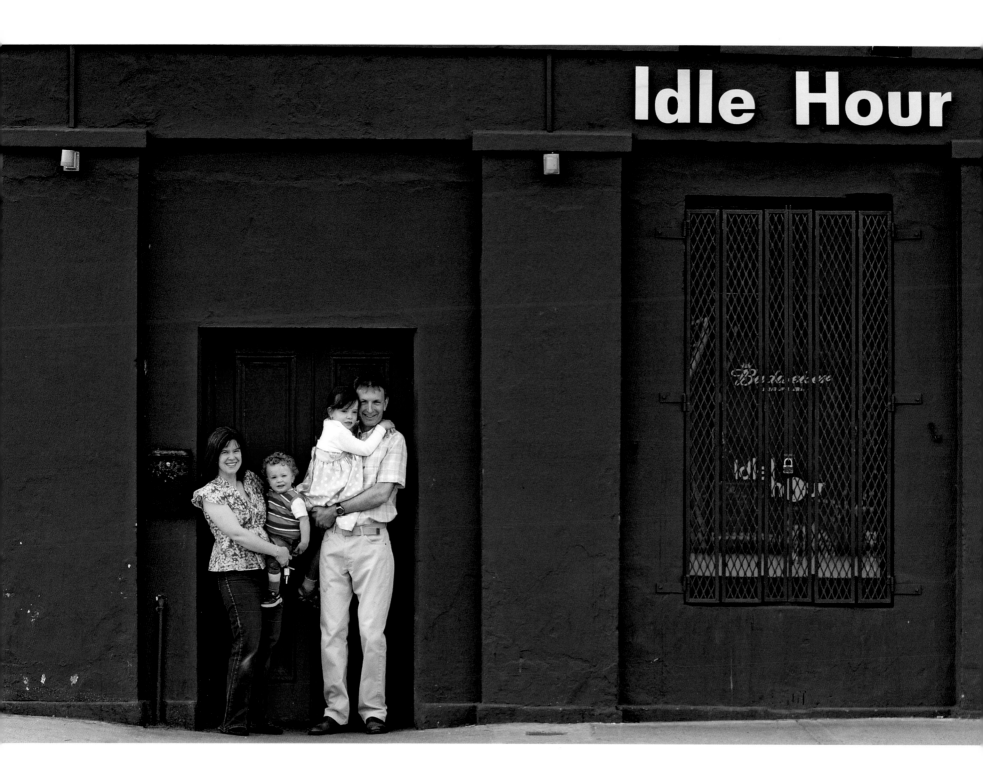

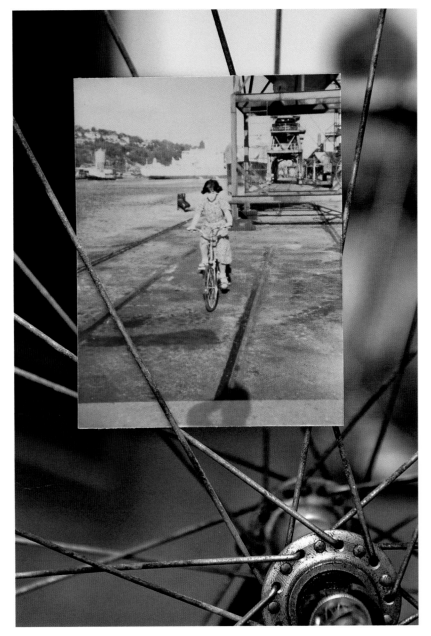

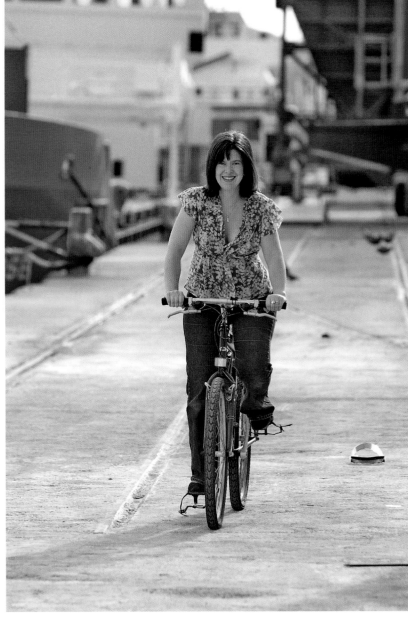

Opposite: Hugh and Mary Morley and their children. Mary's family, the O'Flynns, owned the bar, then called the Silo Bar, for many years.

Above: (left) Mary learning to cycle on the docks as a teenager; (right) And today.

Right: Kennedy Park got its name after a visit from the former US president. UCC students Julius Schabel from Germany and Benjamin Mercer from Canada learn the art of hurling.

Opposite page: 'The dockers were always gentlemen,' Mrs Eileen Campbell, aged eighty-six, has lived in Marina View for sixty years.

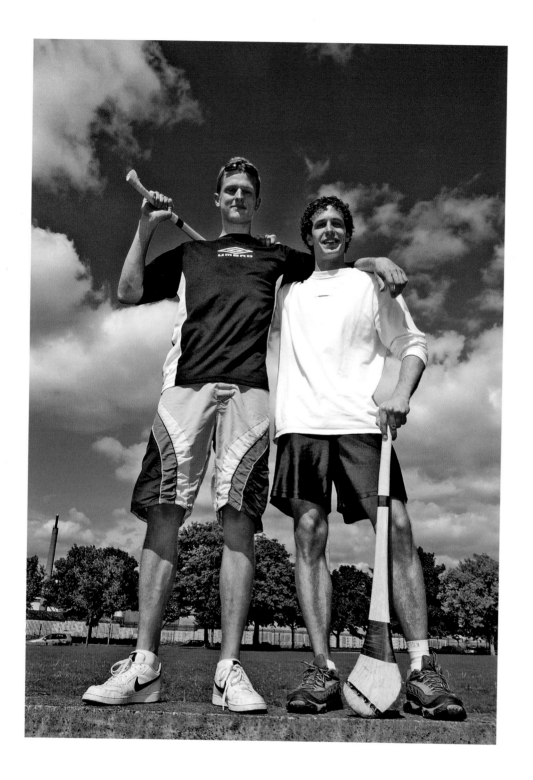

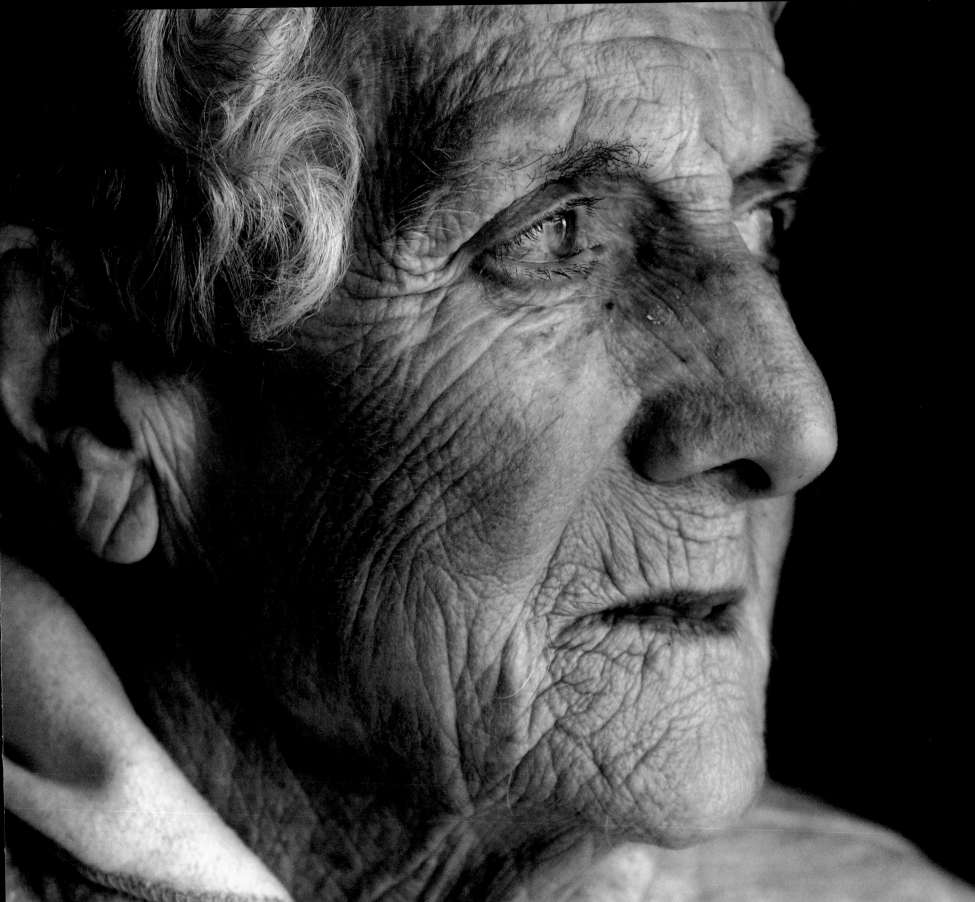

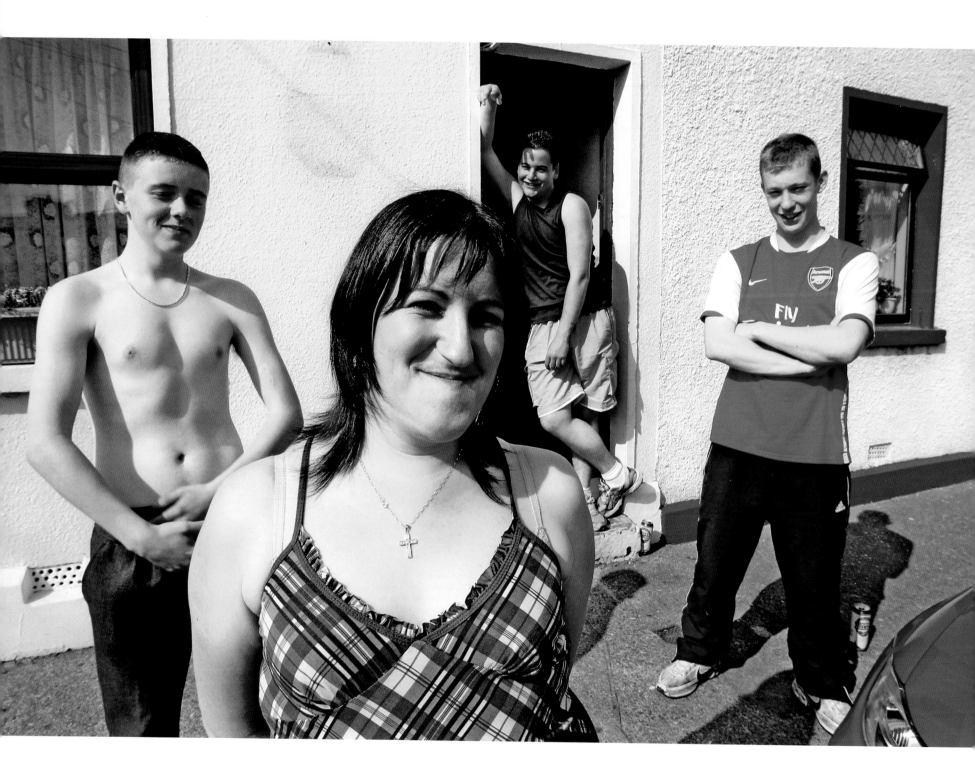

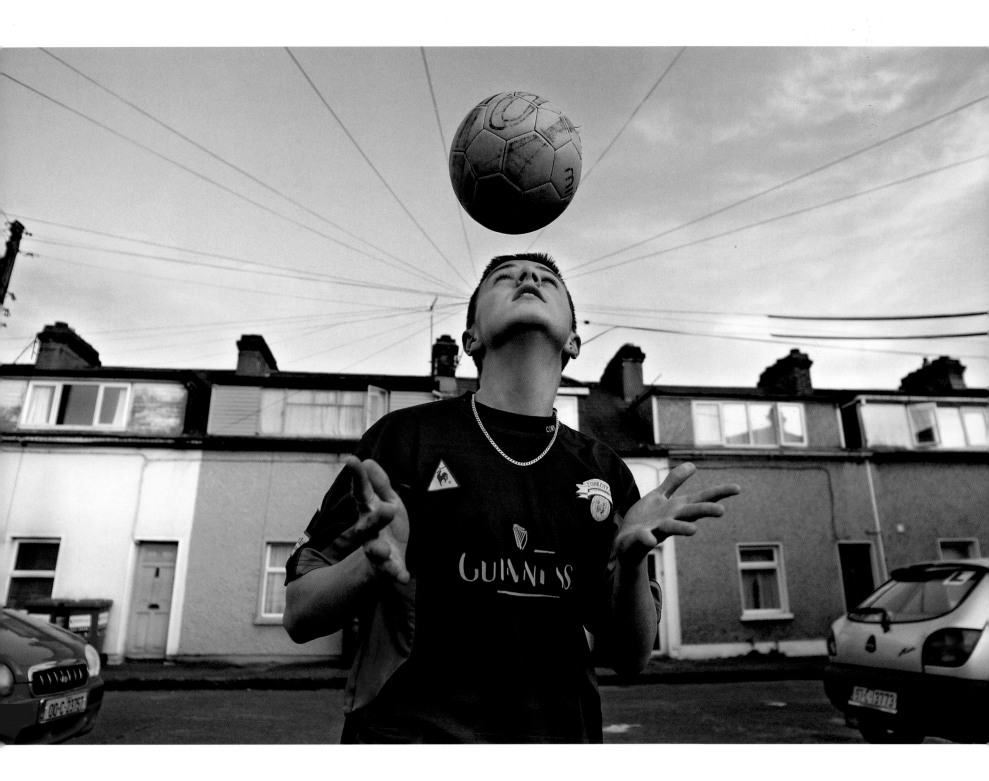

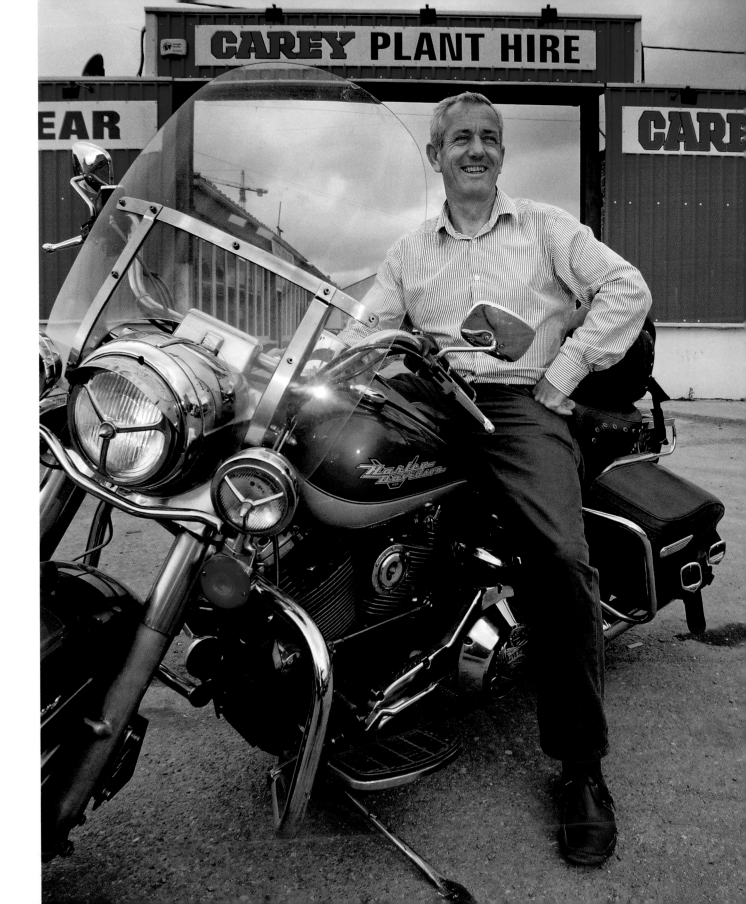

Previous: (left) Local residents (left to right) Jonathon McGlynn, Mary Davis, William O'Donohue and Elliott Watkins in the back streets of Albert Road; (right) McGlynn practises soccer between the parked cars.

Right: Ken Carey, son of Joe Carey, runs the family's plant hire business in what was once the old Blackrock-Passage rail station.

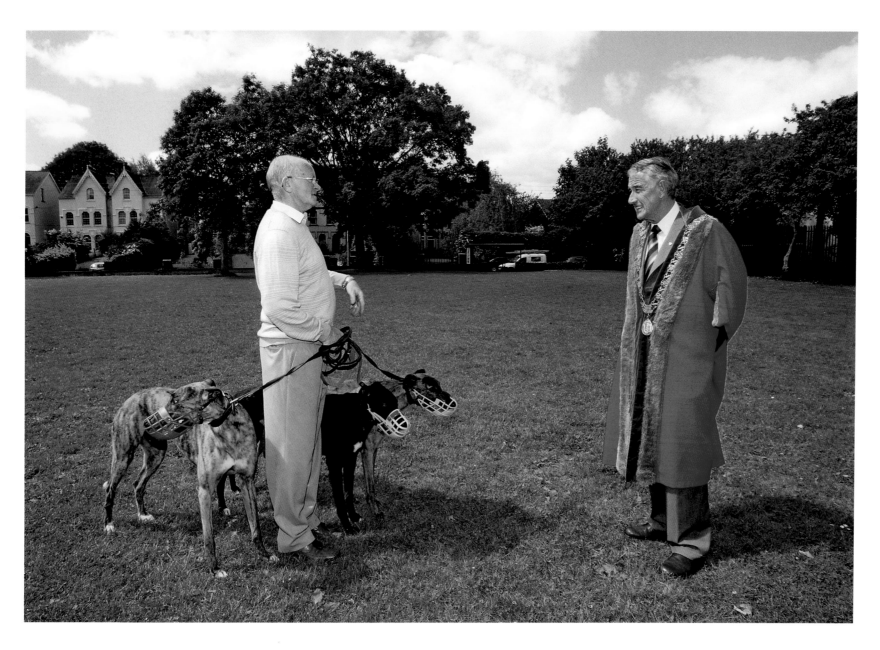

Lord Mayor and local
representative Donal Counihan
meets one of his constituents,
Derry Terry, in Kennedy Park.

'It's still a close community, where neighbours look out for each other,' John Slattery.

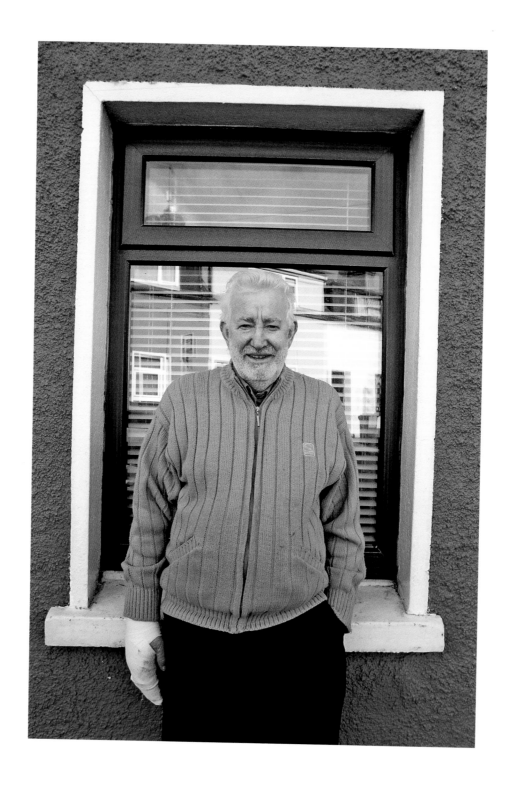

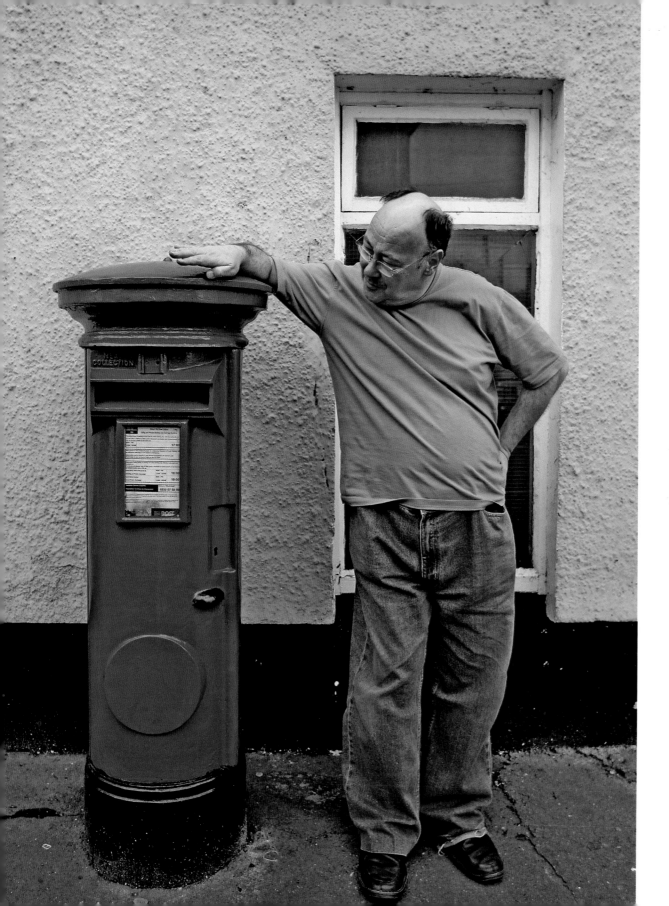

'I love living so close to the city because I can walk everywhere,' Kevin McIlroy.

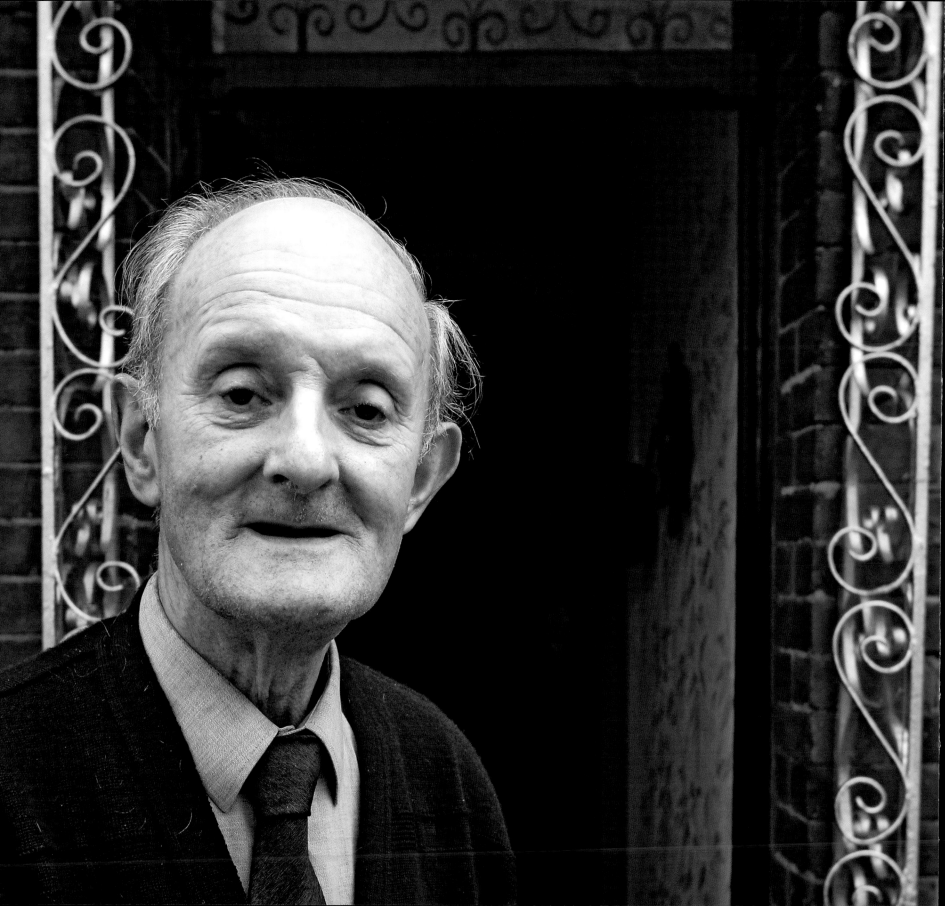

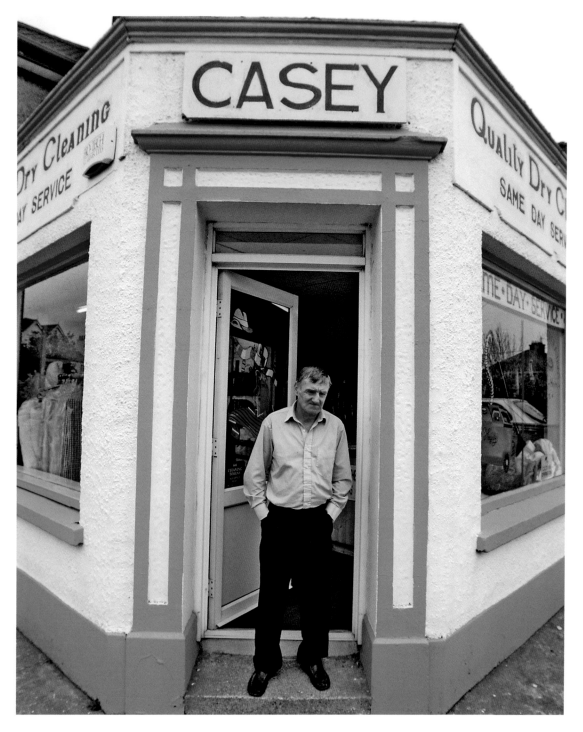

Opposite: Tom Moore, cabinet maker, Monerea Terrace.

Left: John Griffin, Casey Dry Cleaners, corner Victoria Road and Marina Park.

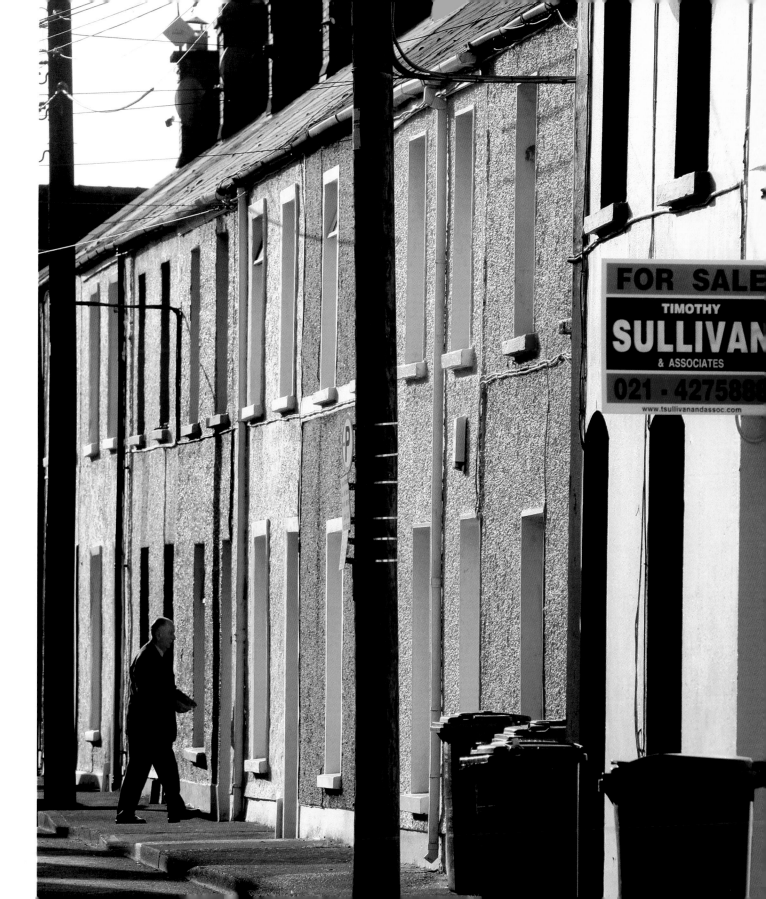

Right: Neighbours live side-by-side in the tightly packed terraces.

Opposite: Current and former Albert Road residents (clockwise from top left) Ger and Hazel Murphy, Mary O'Mahoney, John Riordan, Mary Cummins, Hannah Sexton, James Riordan Jnr.

90

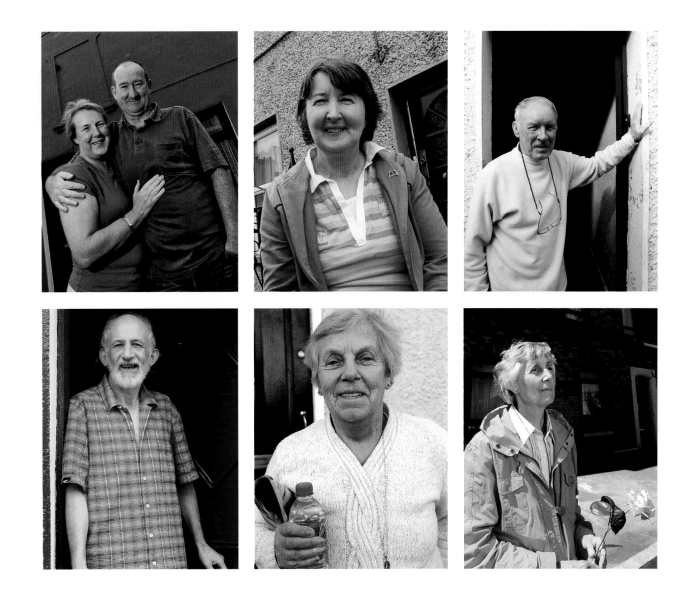

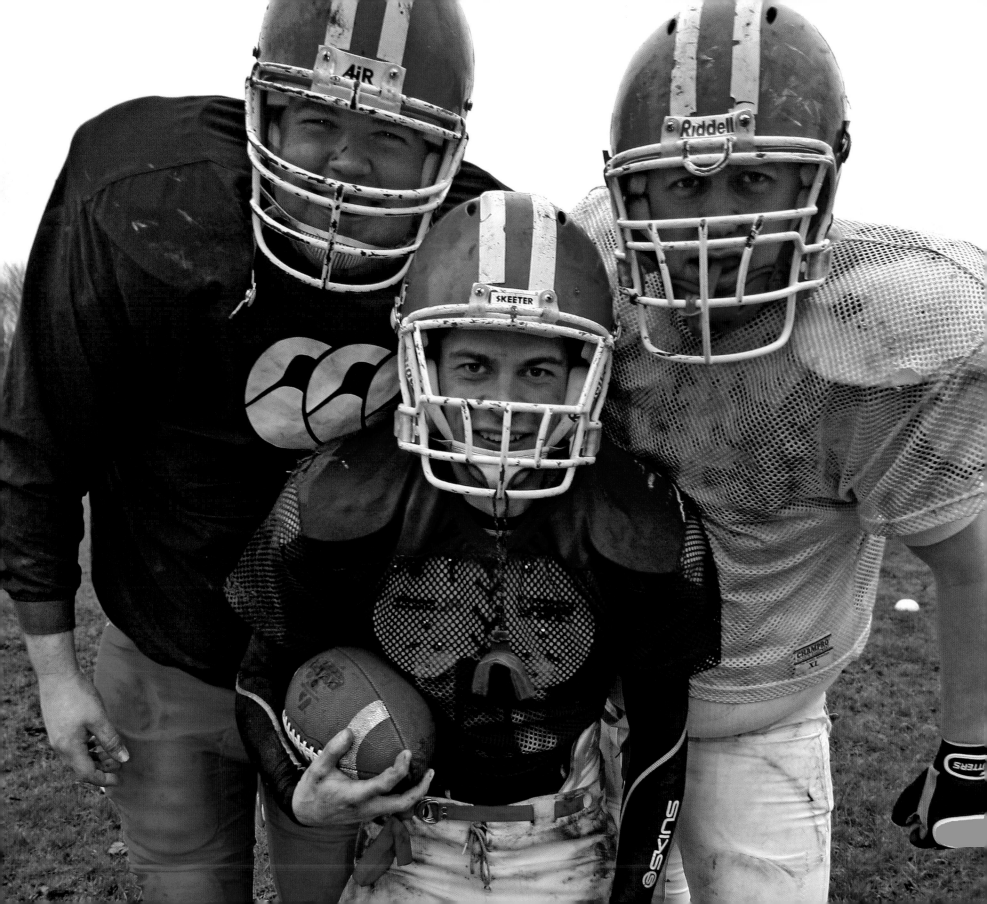

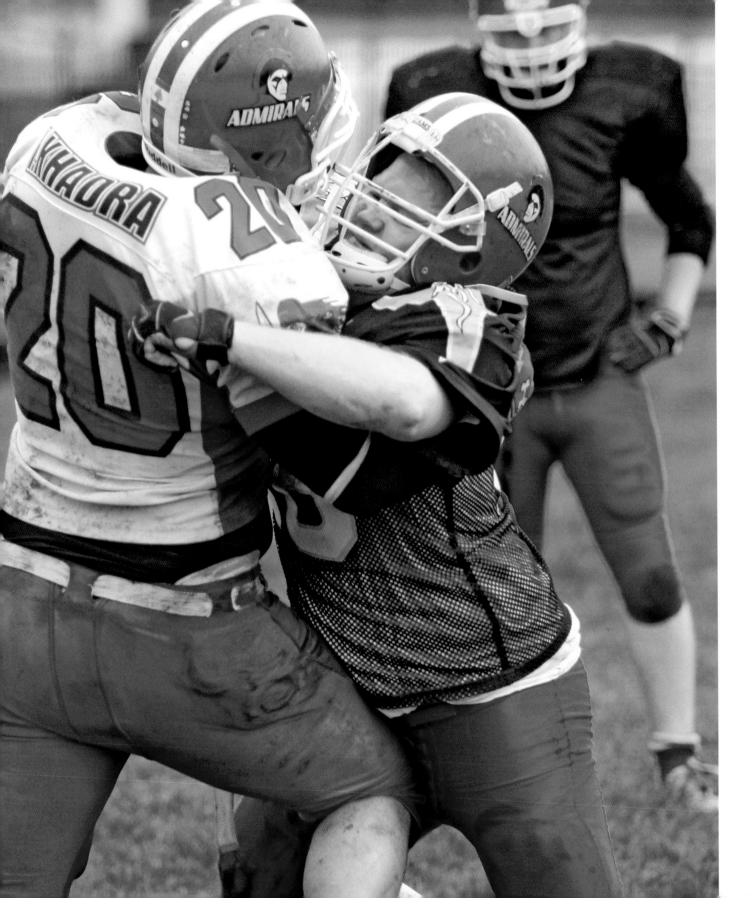

Cork Admirals American football team trains in Kennedy Park. **Opposite:** Barry Rea, Keith O'Callaghan and Robert Hennessy. **Left:** Ibrahim Khadra and Shane Galway.

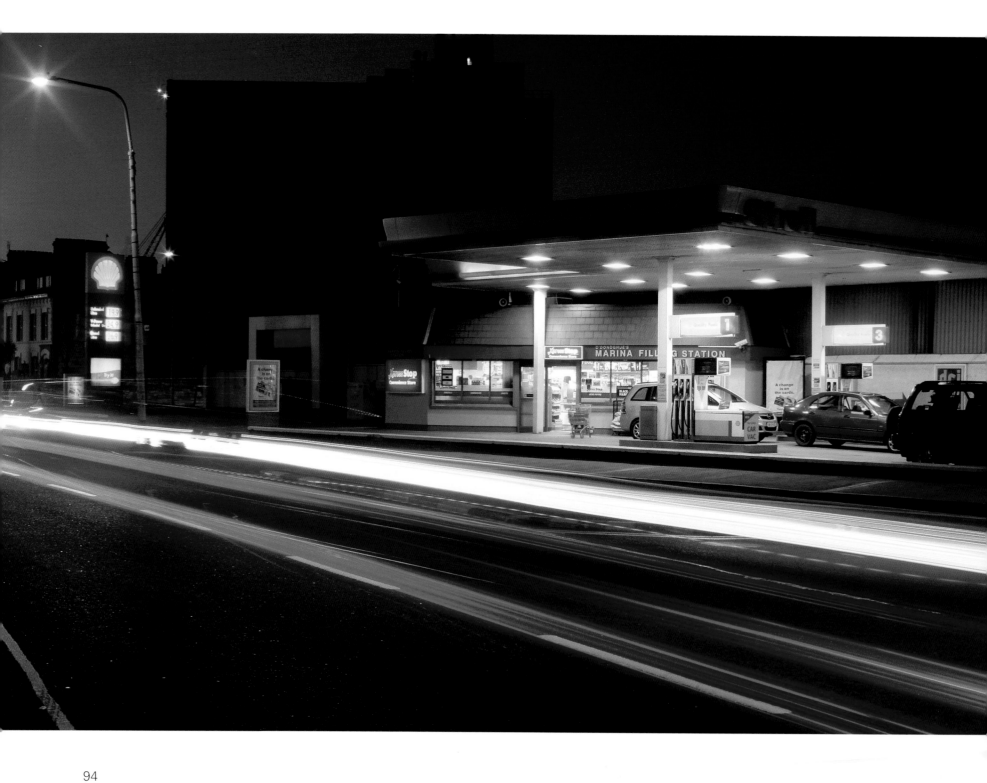

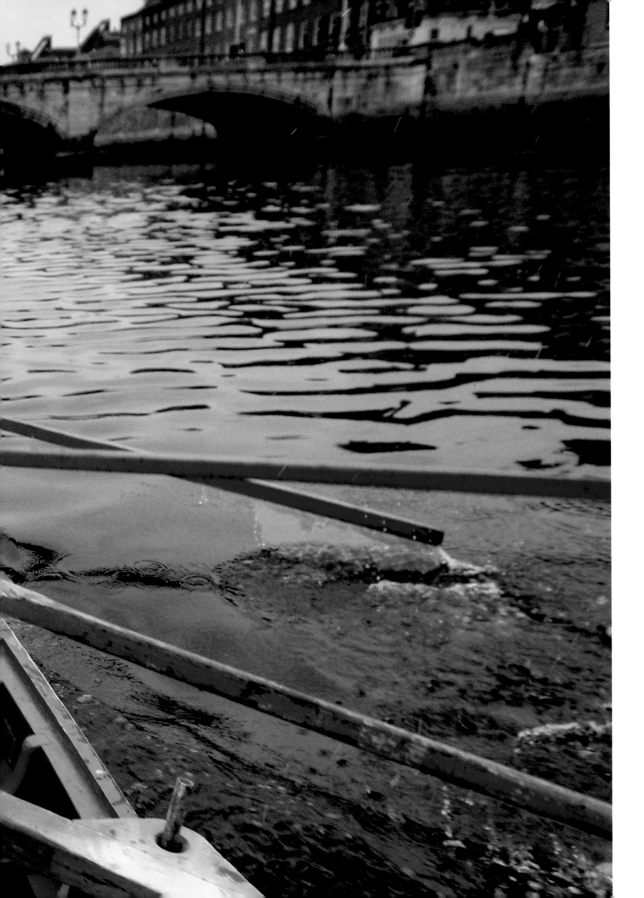

The Naomhóga Chorcaí
traditional boat rowers prepare
for the Ocean to City race
in May.

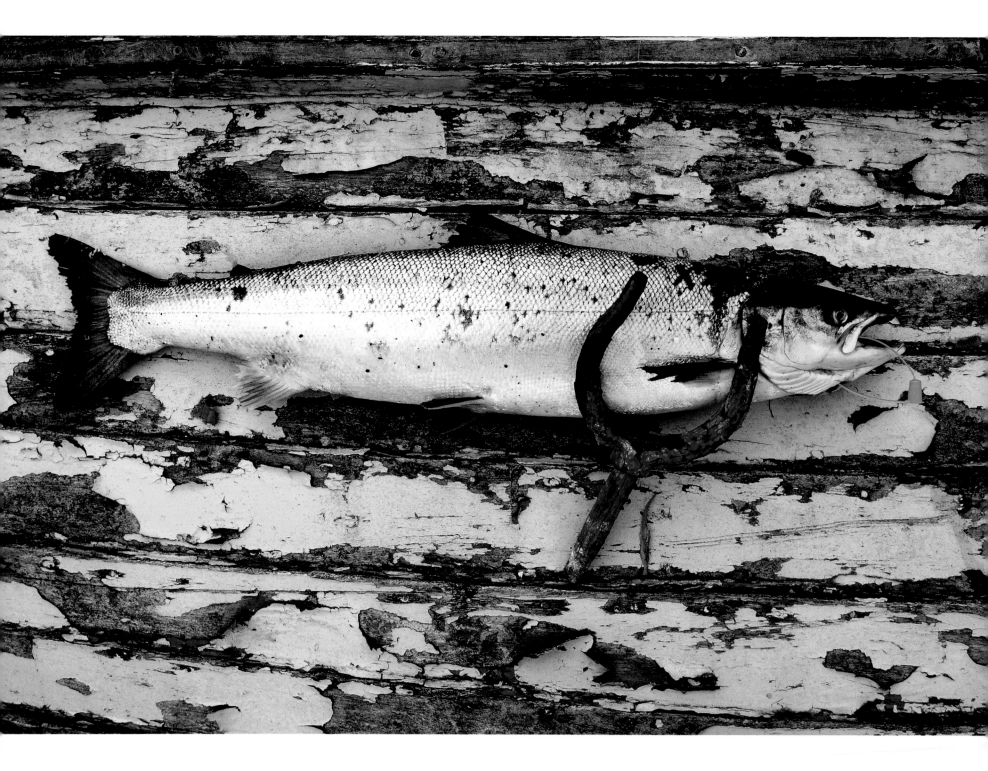

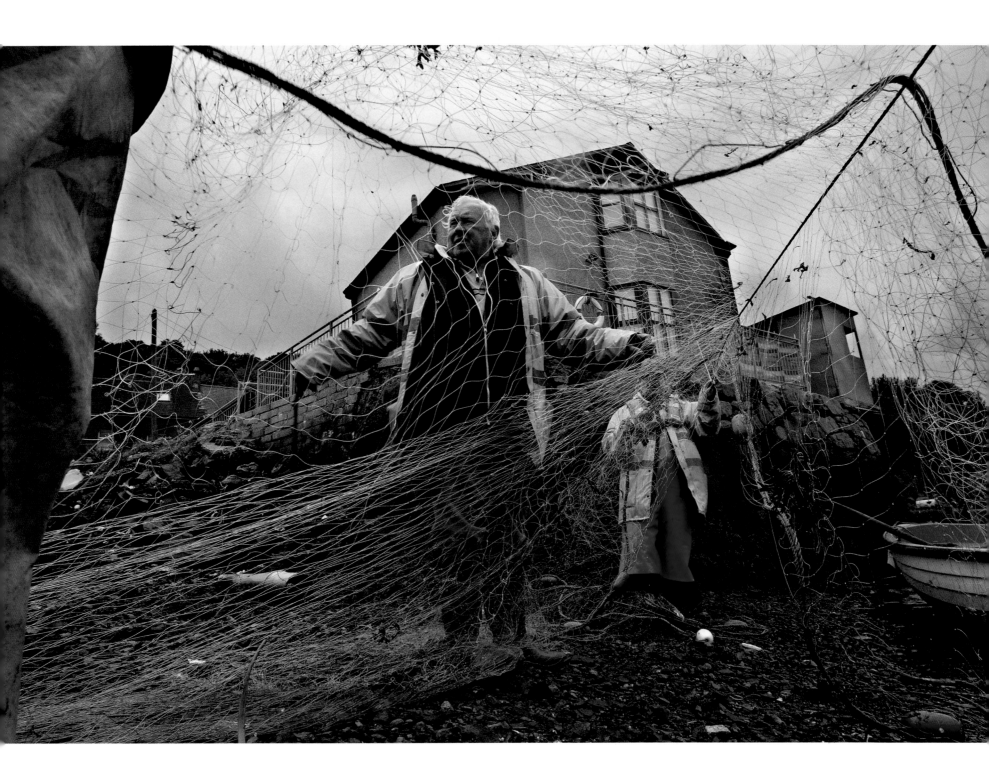

Previous: (left) Tagged salmon; (right) Docker Simon Quilligan has been fishing on the river since he was a boy.

Right: (top) Simon Quilligan sits atop his fishing hut spotting for salmon, while son Anthony manoeuvres the boat; (bottom) Landed fish.

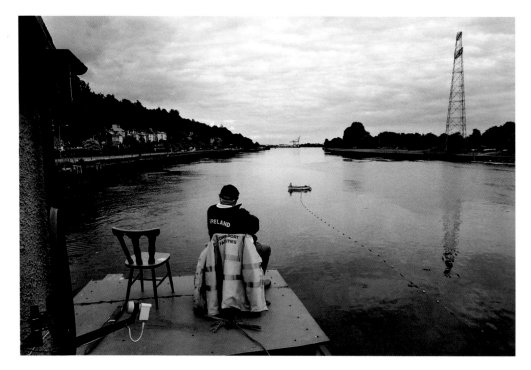

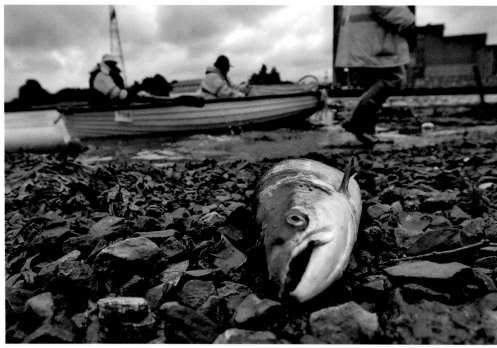

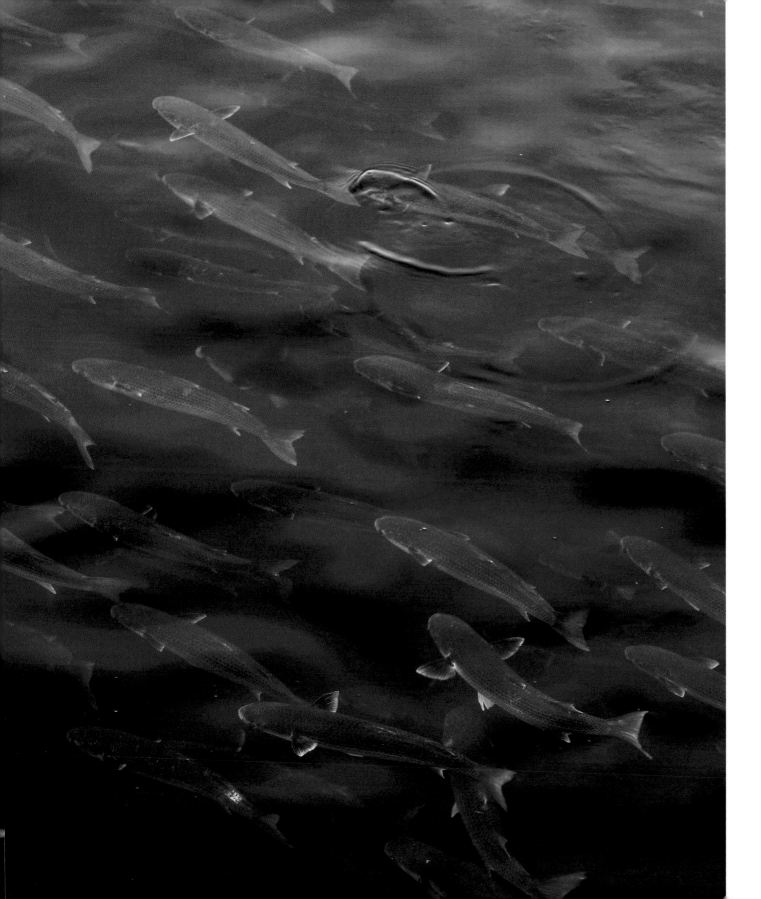

The river is never lacking in mullet.

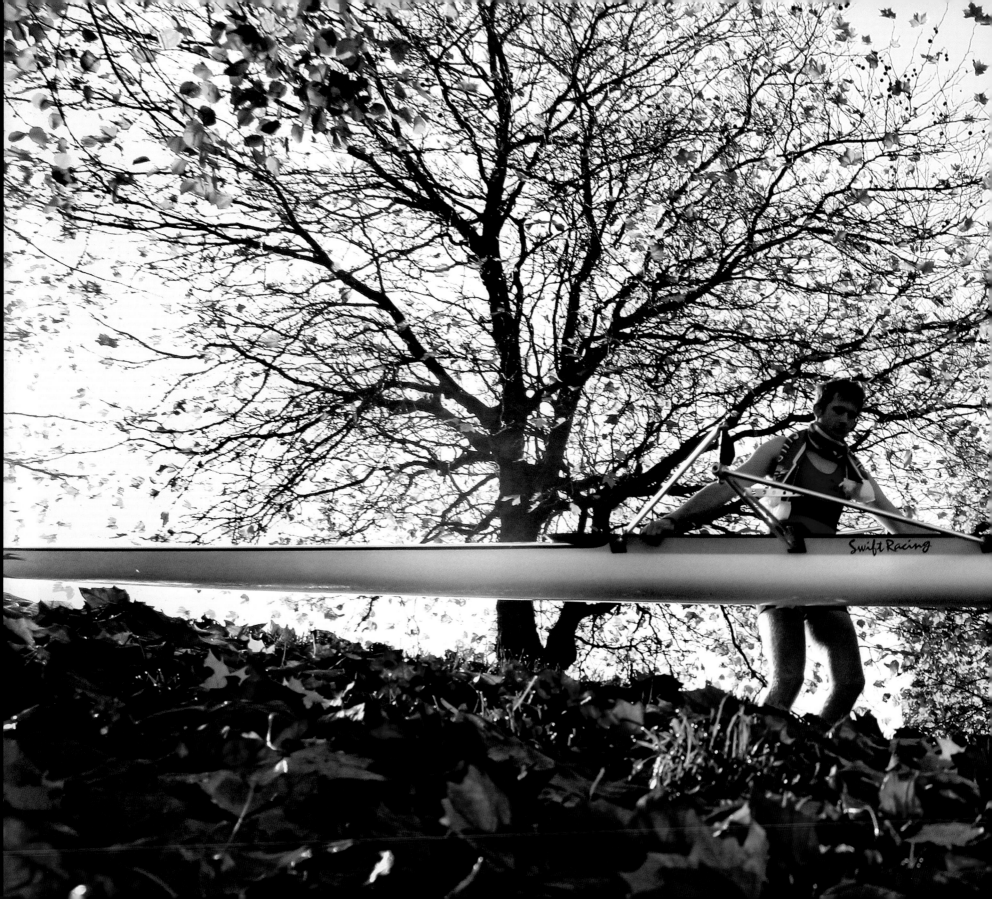

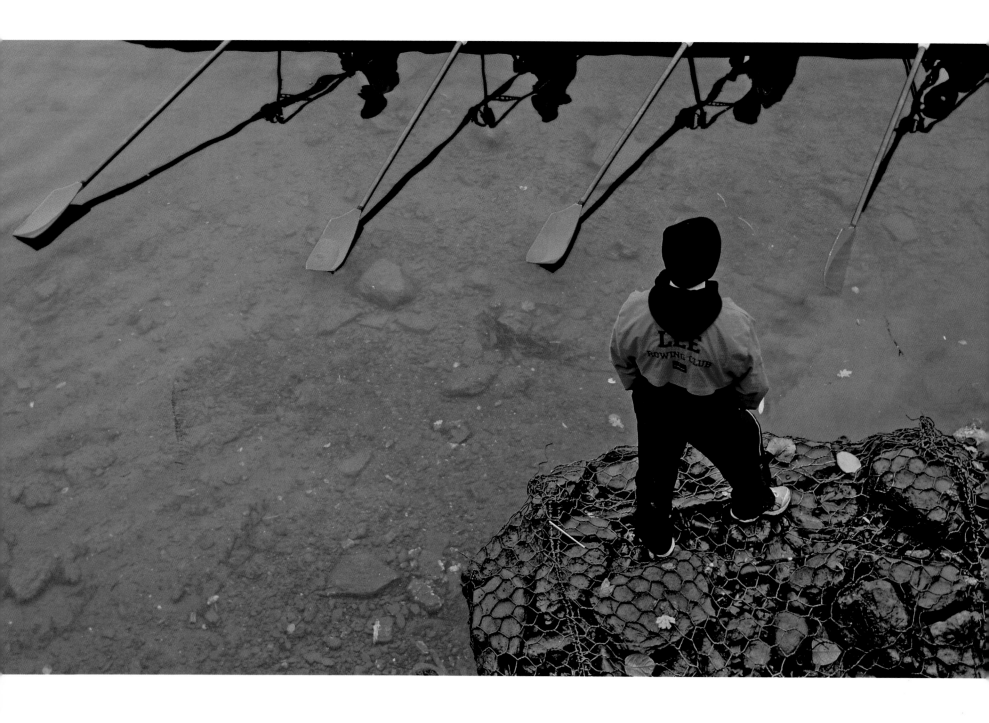

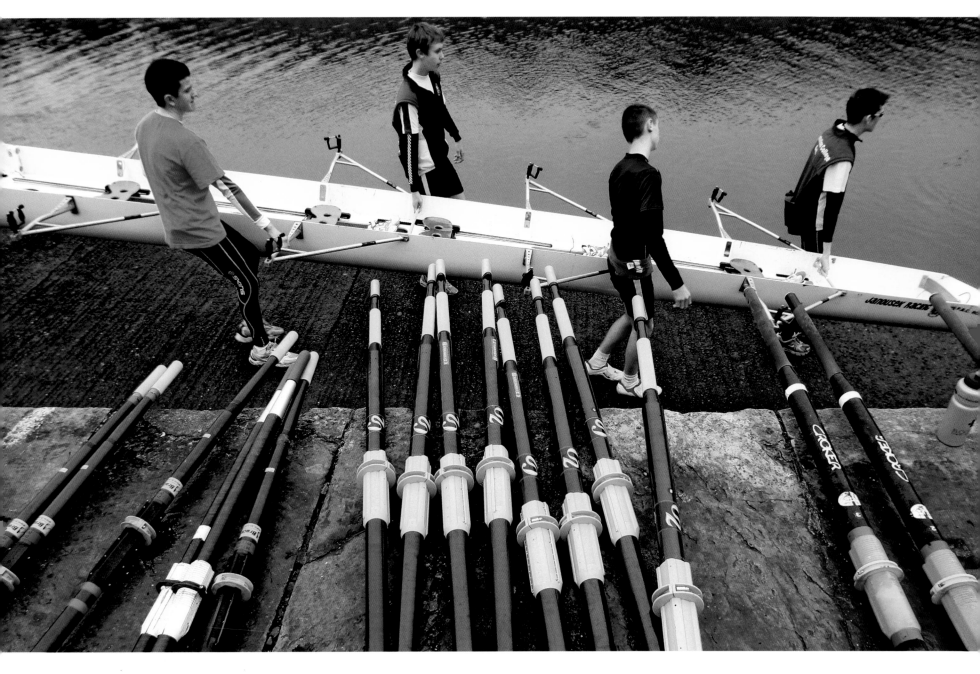

Previous: A crisp autumn morning greets a rower from the Lee Rowing Club.

Left: Words of advice from the coach before setting off.

Above: Tides and unsafe slipways make launching the boats a tricky task.

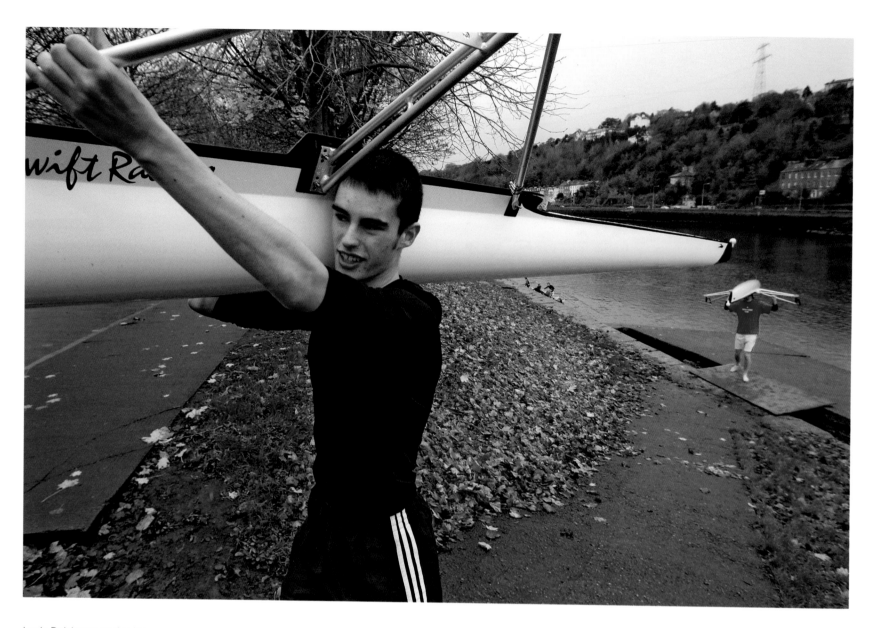

Louis Delahunty carries his
boat from the river after a
training run.

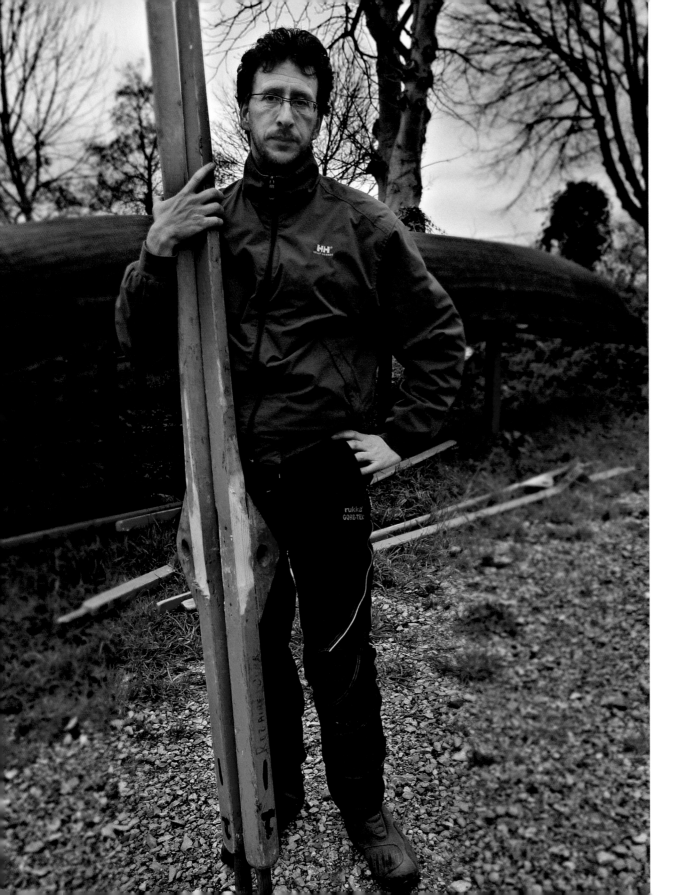

German-born Stefan Wulff is a key figure in the local currach rowing club.

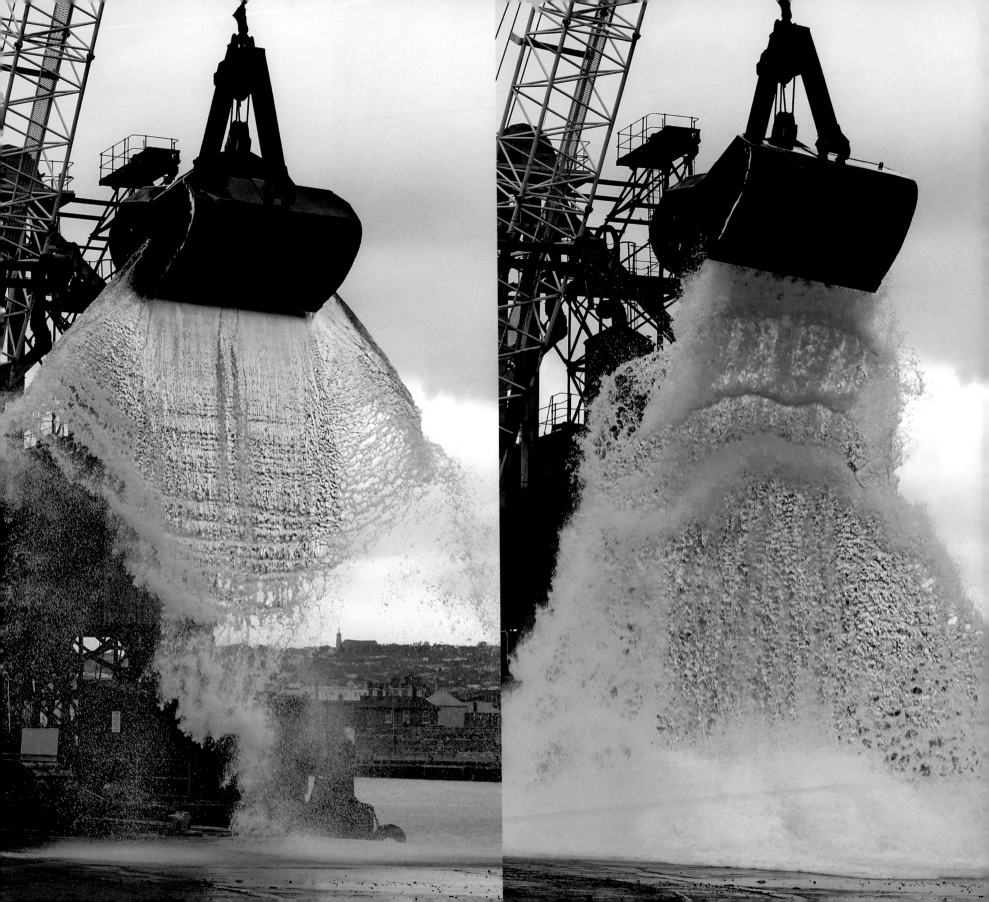

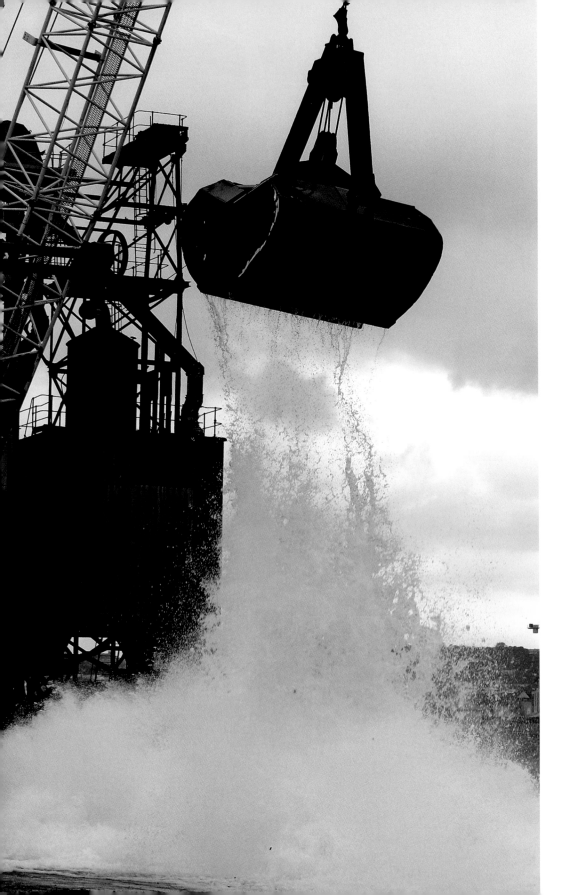

Crane drivers use river water to wash the dust and dirt from the docks after a day's work.

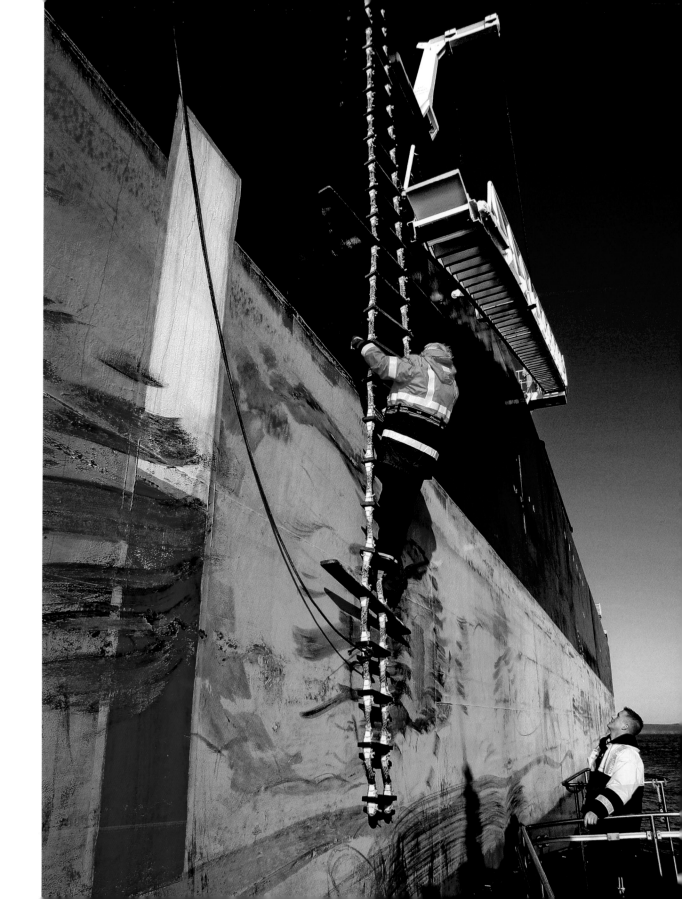

Pilot Brian Daly tackles the vertical climb up the side of a tanker, watched by Mark Moran on the launch.

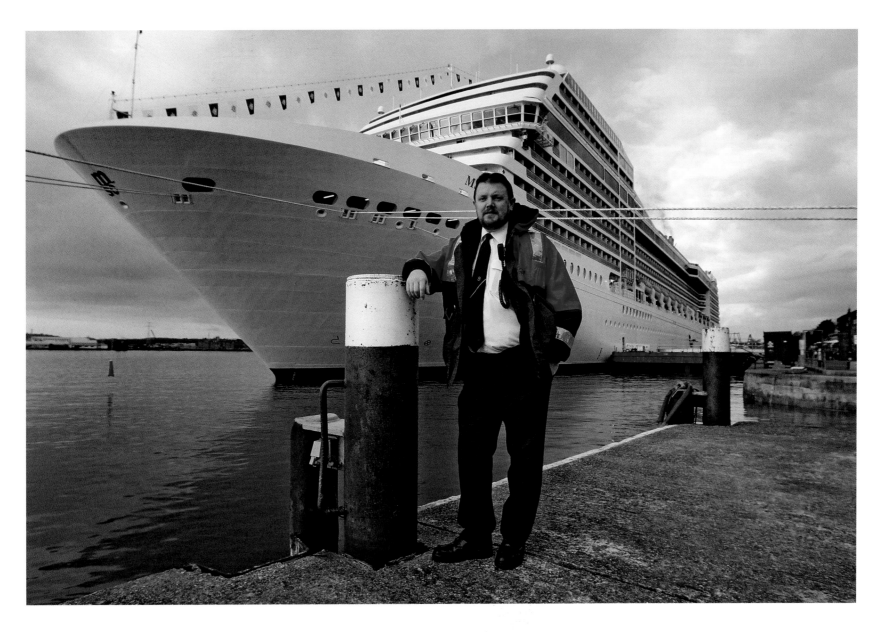

'Docking the large cruise liners
is spectacular, but it is the oil
tankers that bring a sweat to
your brow,' Aidan Fleming, pilot.

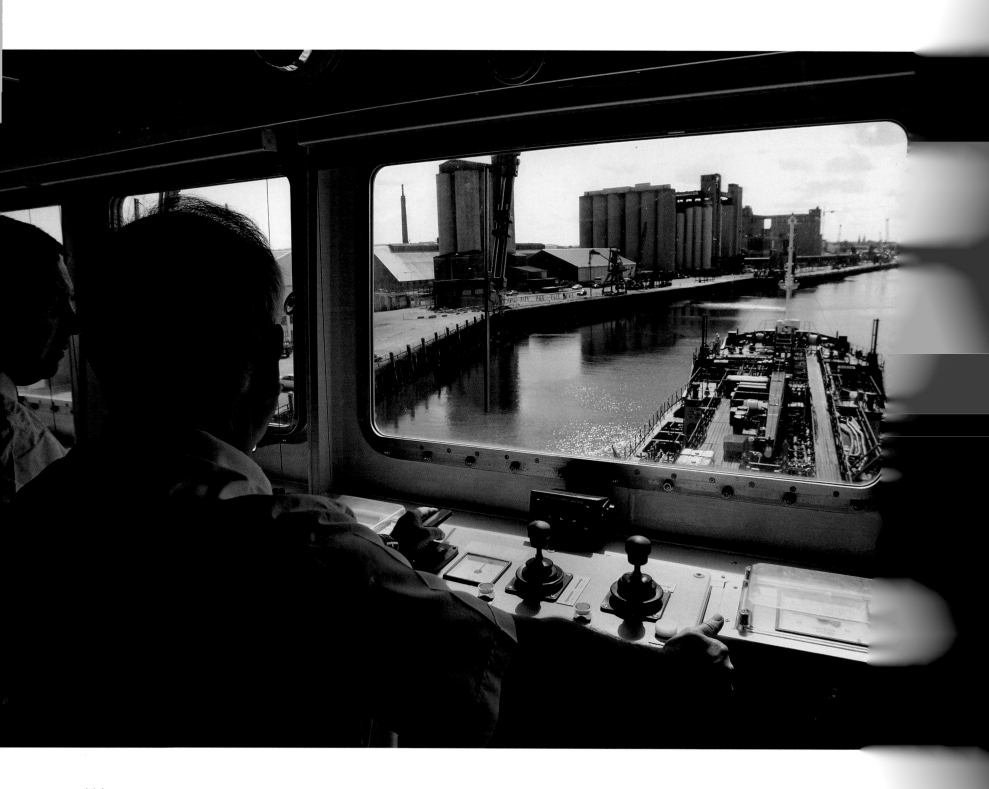

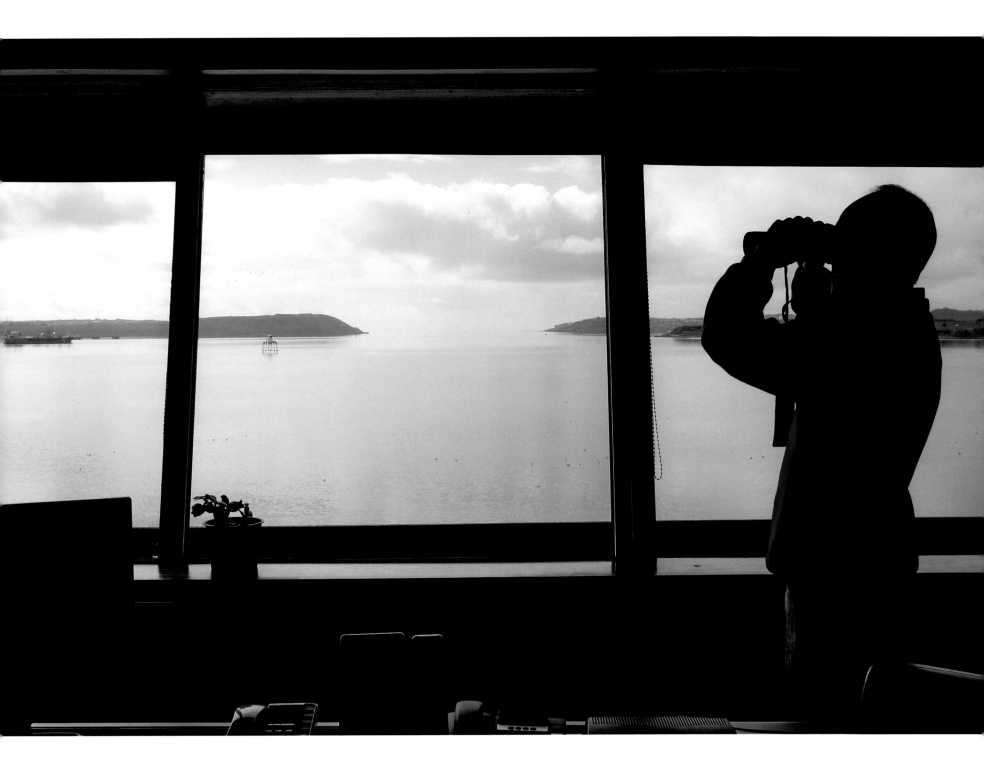

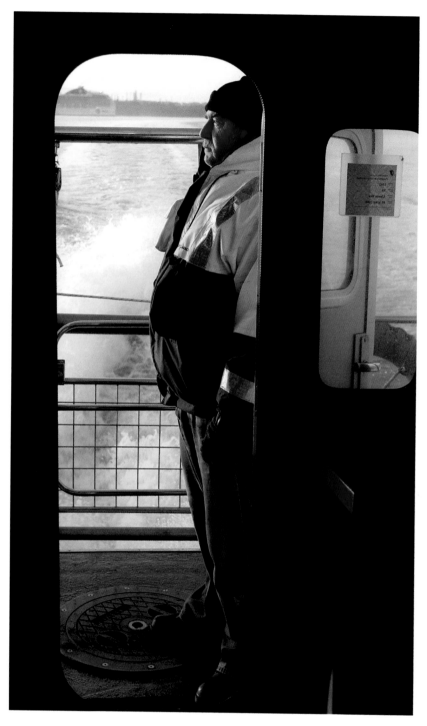
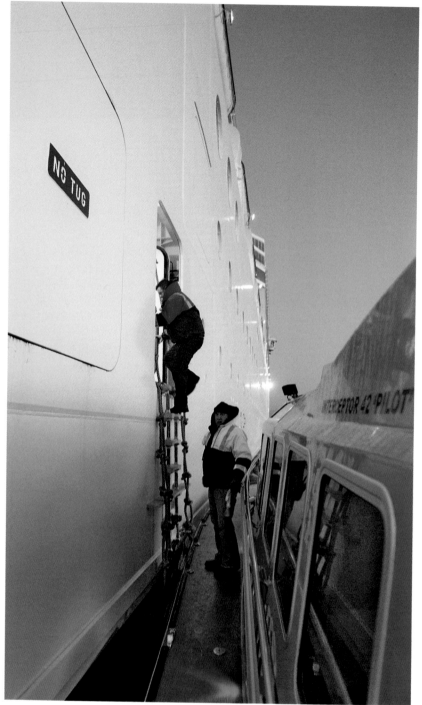

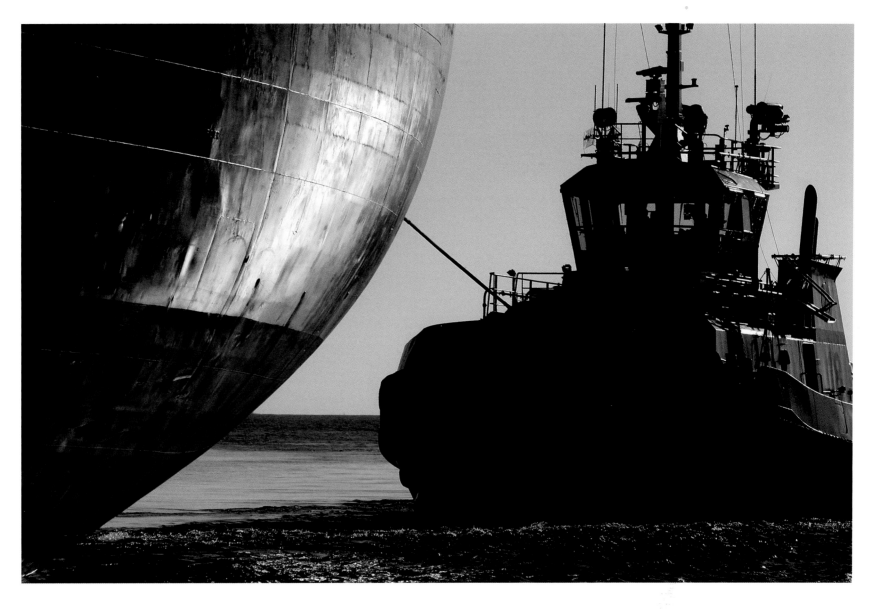

Previous: (left) Pat Chandler, third-generation pilot, gently nudges the 3,853-tonne chemical tanker *Stolt Avocet* upriver; (right) Sean Donovan watches over the mouth of the river from the Port Operations control room in Cobh.

Opposite: (left) Peter 'the Greek' Kelly delivers pilots to the ships; (right) Aidan Fleming, pilot, says the work is easier on calm days.

Above: One of two large tug boats that operate on Cork Harbour.

Docking scars disfigure the
side of a ship.

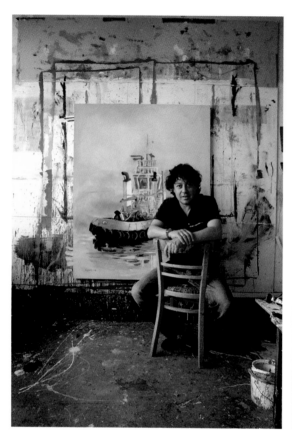 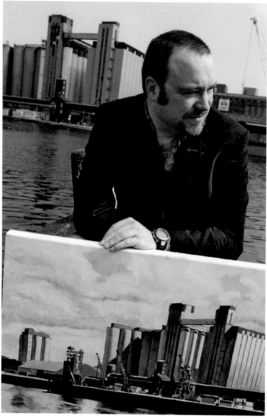 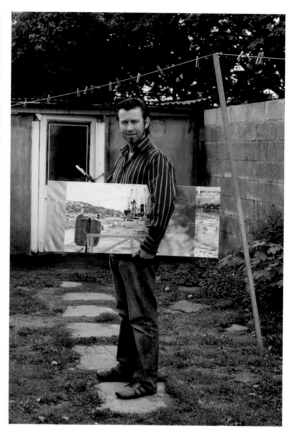

(left to right) Artists John Adams,
Cian O'Sullivan and Willie
Redmond draw inspiration
from the docks.

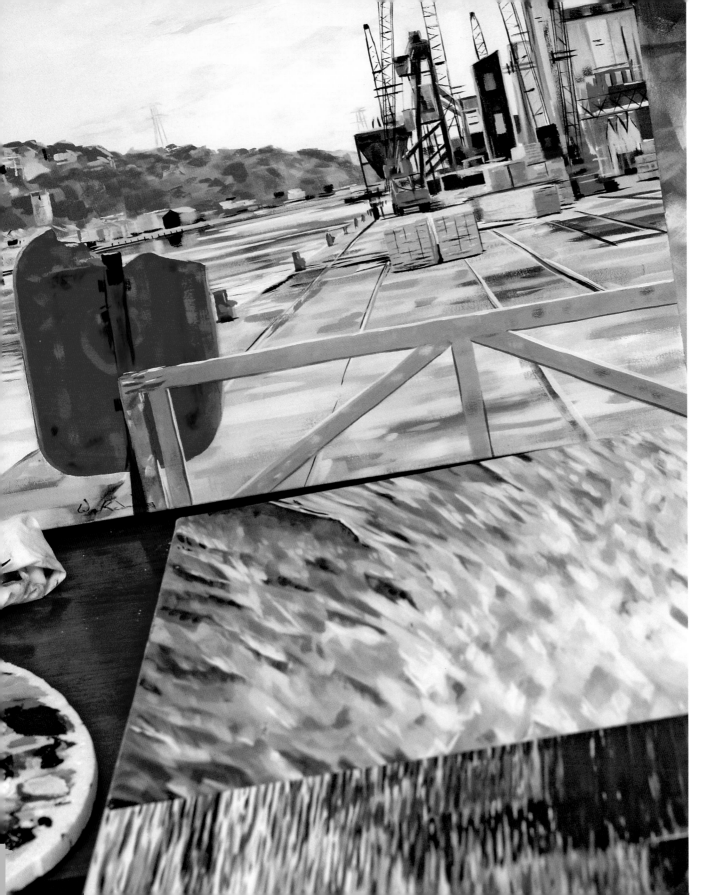

Detail from dock painting by Willie Redmond.

For decades the annual
funfair at the Showgrounds
has thrilled the people of Cork.

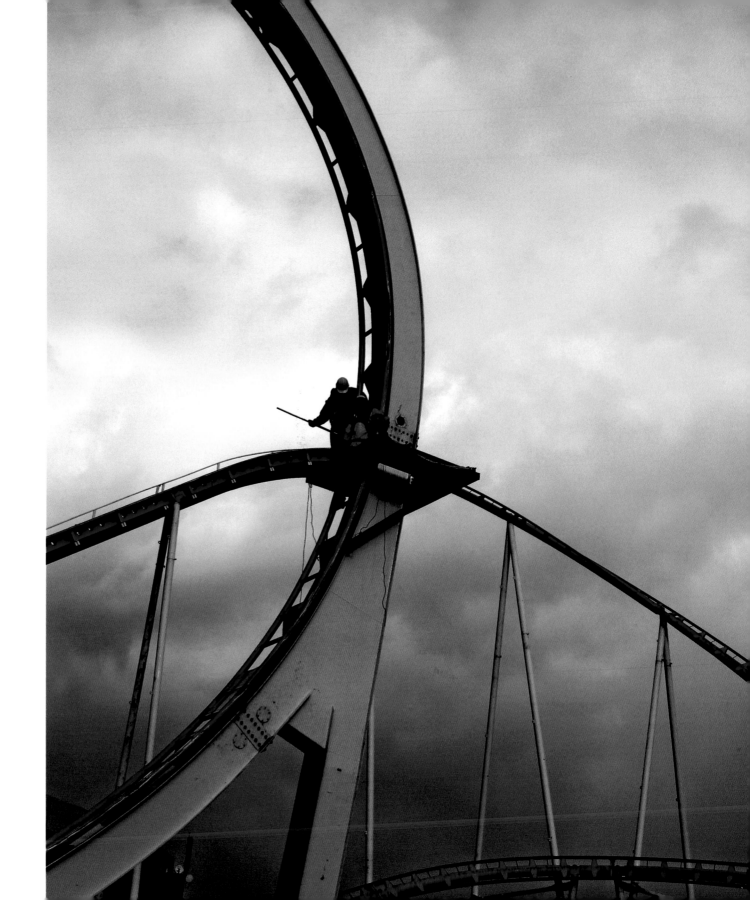

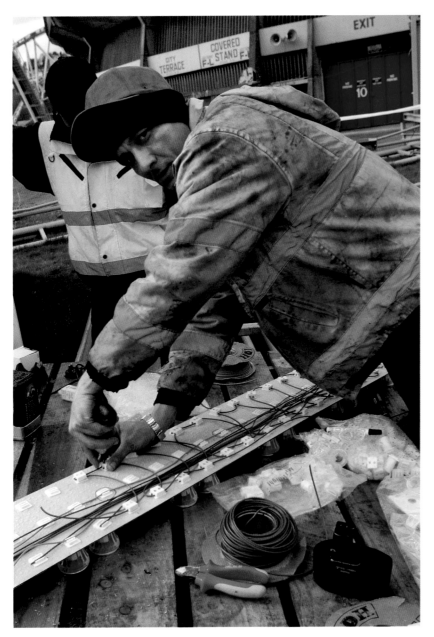
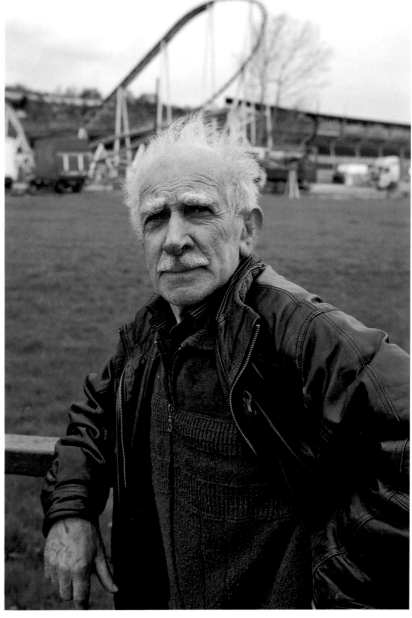

Above: (left) Replacing bulbs is
a constant job; (right) Gerry Farrell,
circus ringmaster, has worked
with Funderland for most of his
seventy-four years.

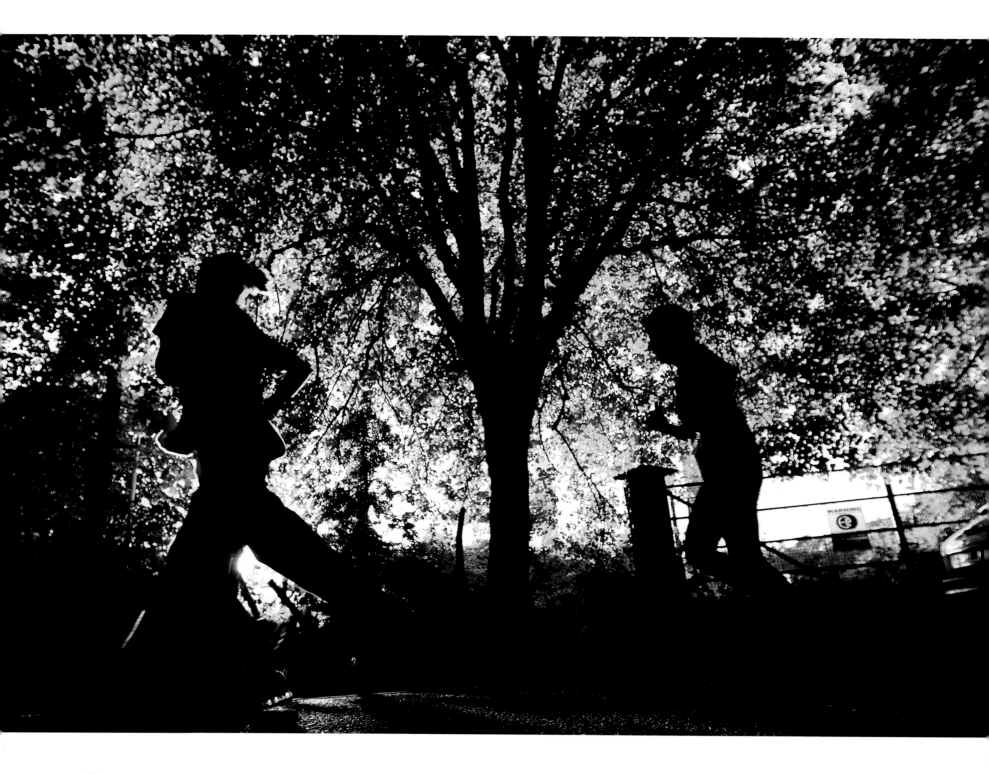

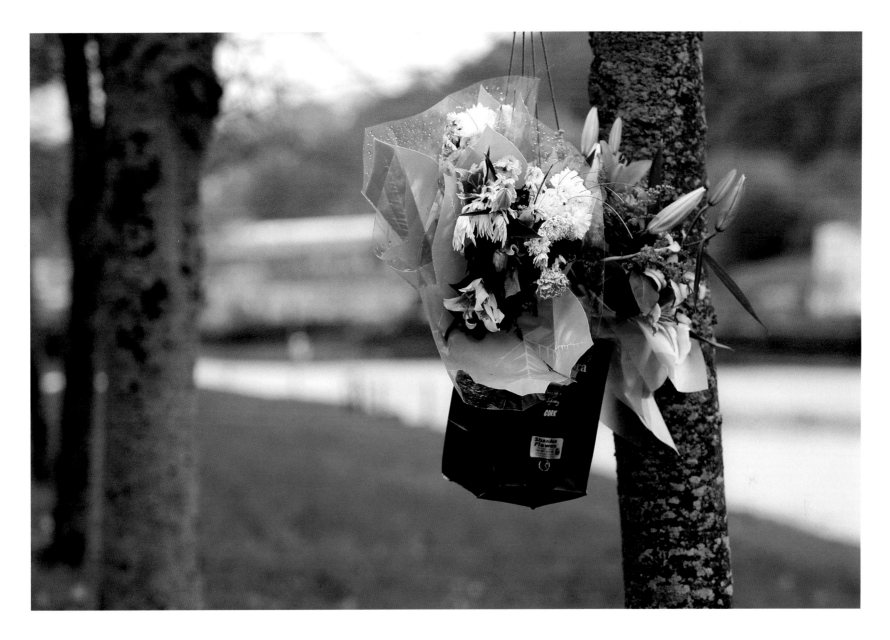

Opposite: The Marina is a popular running beat all year round and the City Marathon also passes through it.

Above: Floral memorials to the victims of accidents in the streets surrounding the docks. There are no memorials to the many dock workers who have died on the job.

Greg Coughlan, CEO,
Howard Holdings.

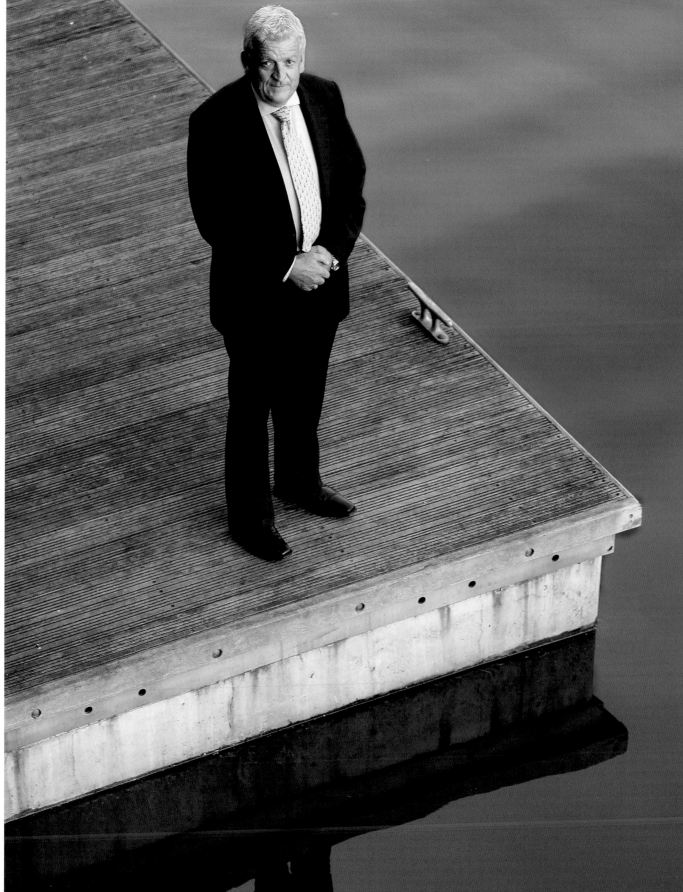

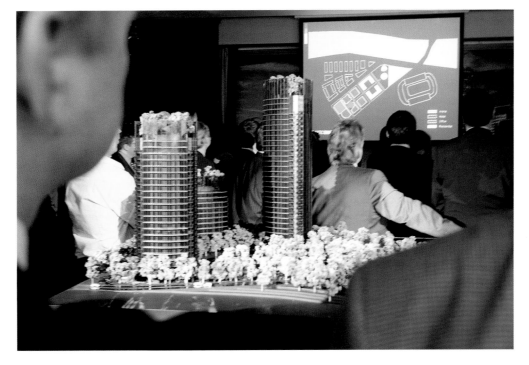

Howard Holdings is the first to propose a multi-faceted development project at the eastern end of the Marina.

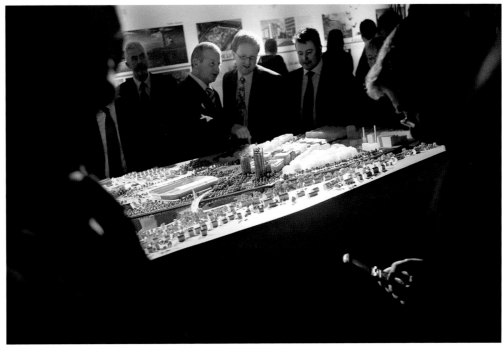

Cork business people view the plans for the proposed Howard Holdings development at a launch party in the Clarion Hotel.

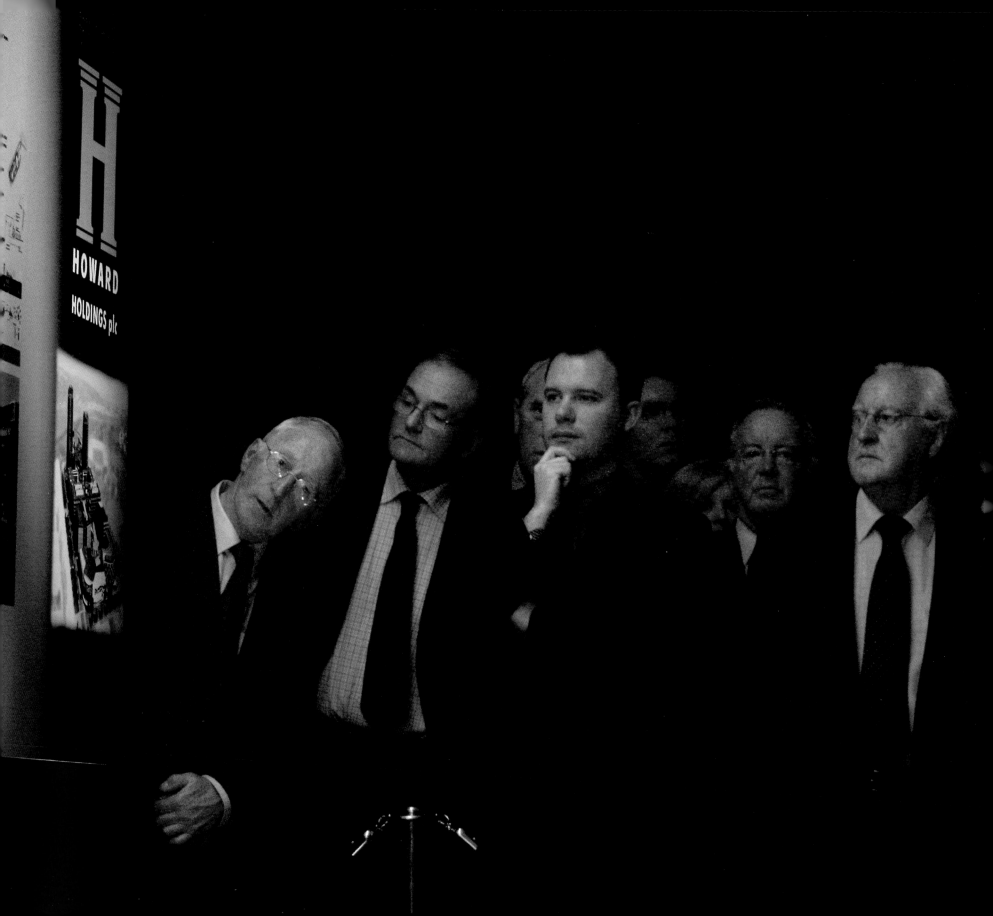

Above: ESB worker Neil Higgins, flanked by the original dials and switches that once controlled the power generators.

Opposite: Paul Watts surveys the old and new chimney stacks at the ESB power plant on the Marina.

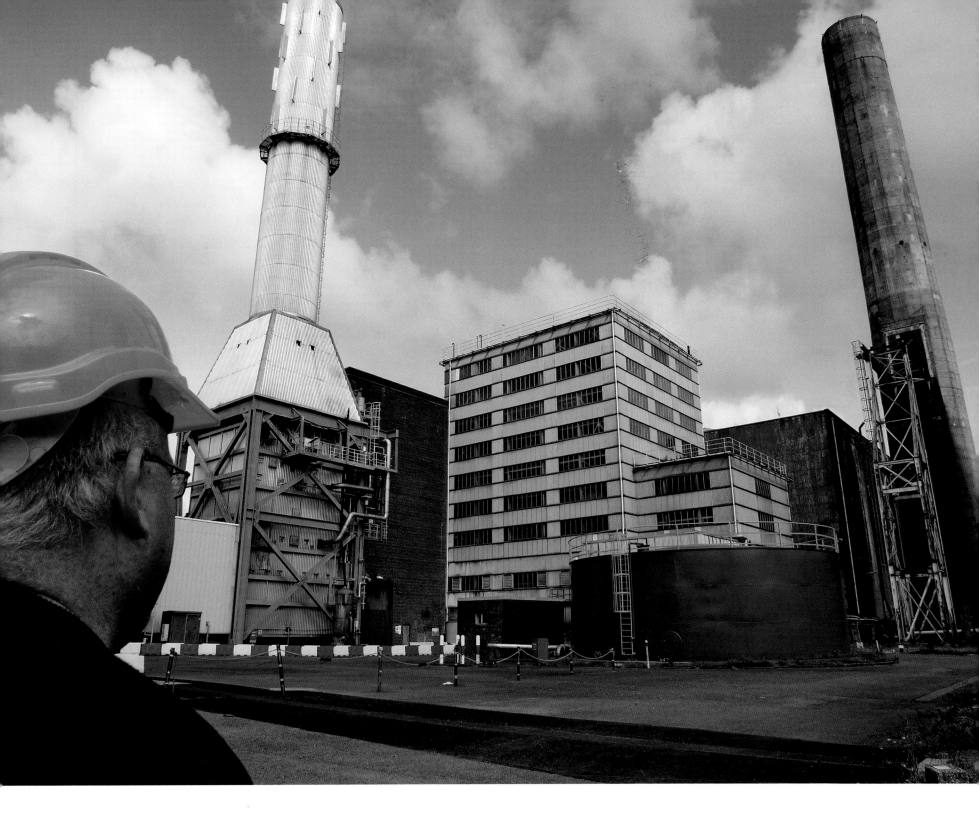

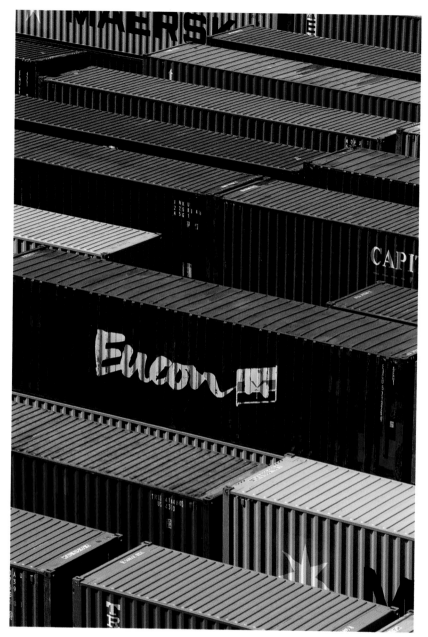

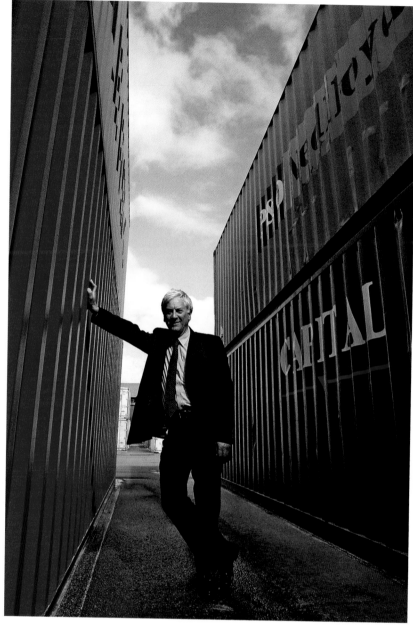

Above: (right) Gerard Deegan stands between the stacked containers at Tivoli Container Terminal.

Opposite: Insect-like straddle carriers shuffle the giant containers as they are loaded and unloaded from the ships at Tivoli.

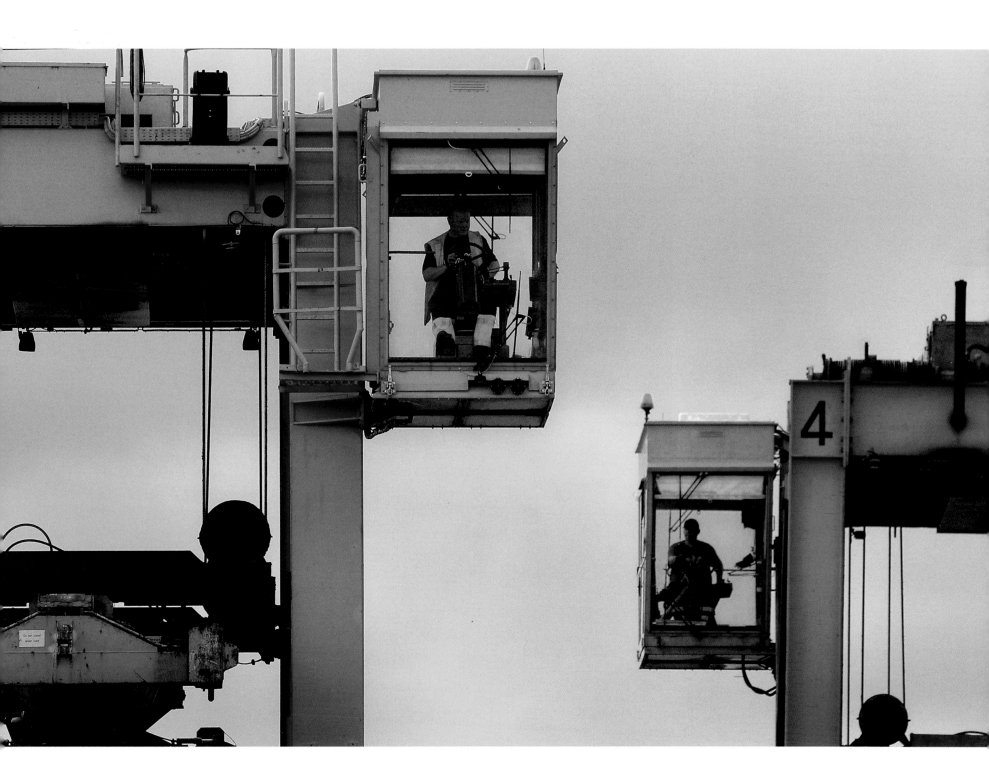

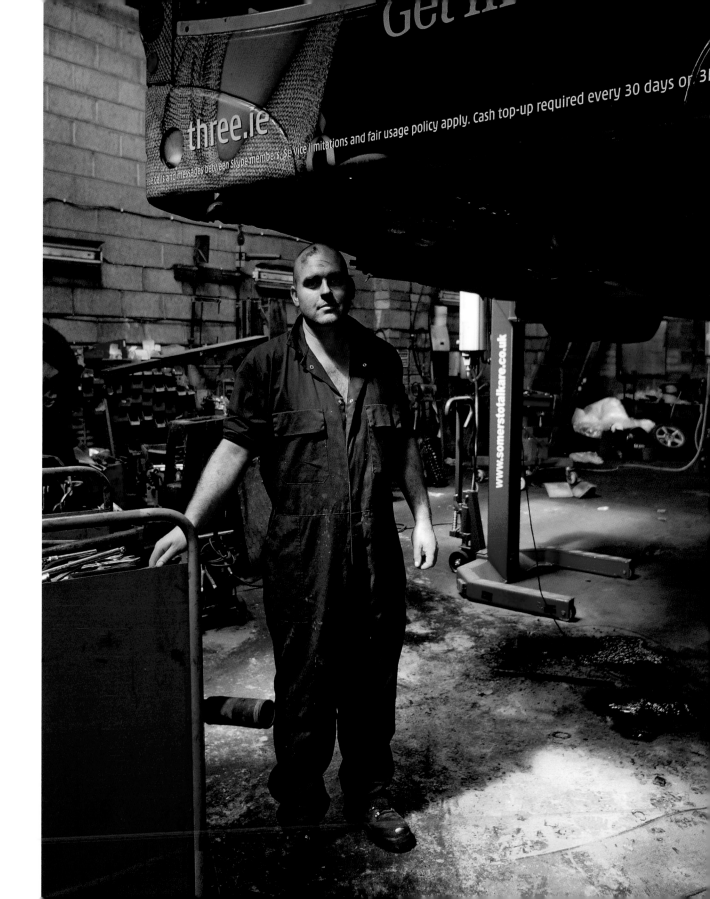

Right: Joe Guilfoyle at Pat Deasy's mechanical workshop repairs a CIE bus.

Opposite: (left) A visiting Russian ship docks on South Jetties; (right) Frank Brady gathers spilled coal.

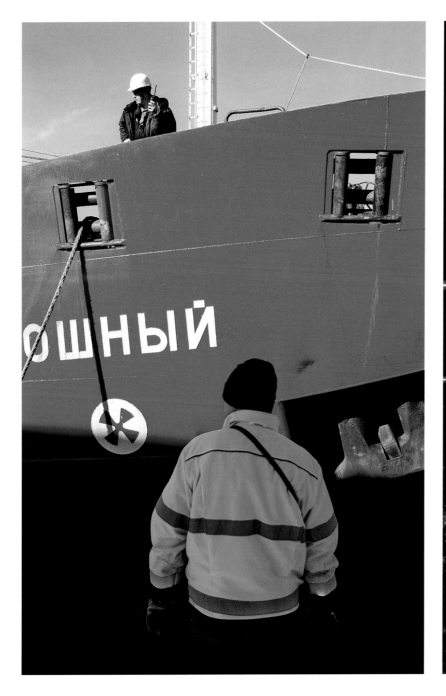

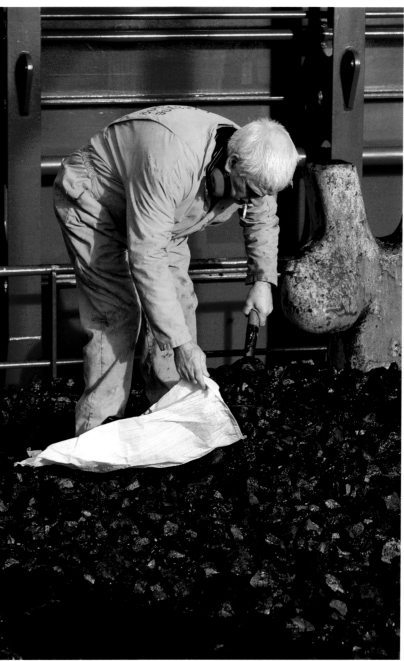

The serrated roof of the old
Ford plant which is now home
to many small businesses
(taken with a pinhole camera).

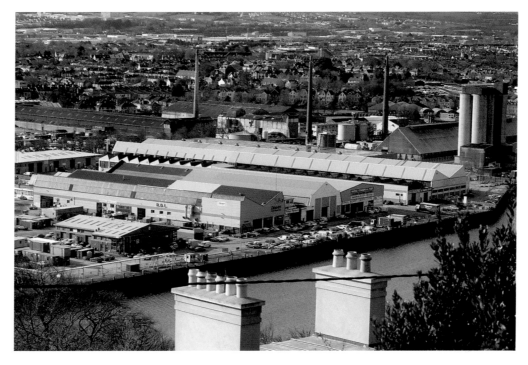

(top) An aerial view across the Ford plant, the chimney stacks of Goulding Fertilisers and the southern suburbs; (bottom) ESB Marina Generating Station on Centre Park Road.

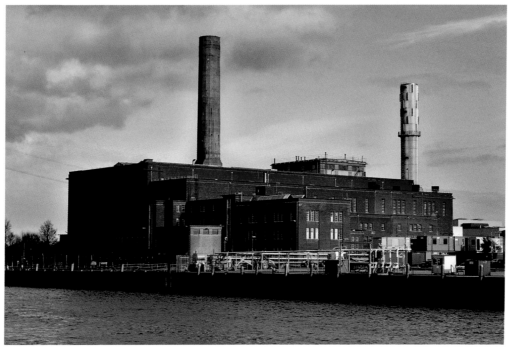

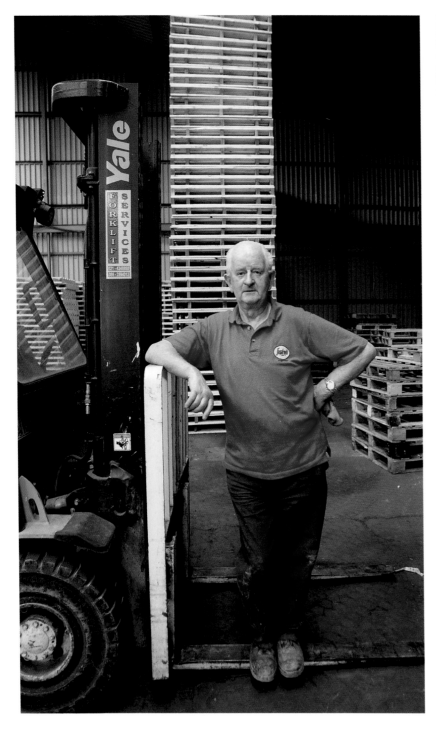
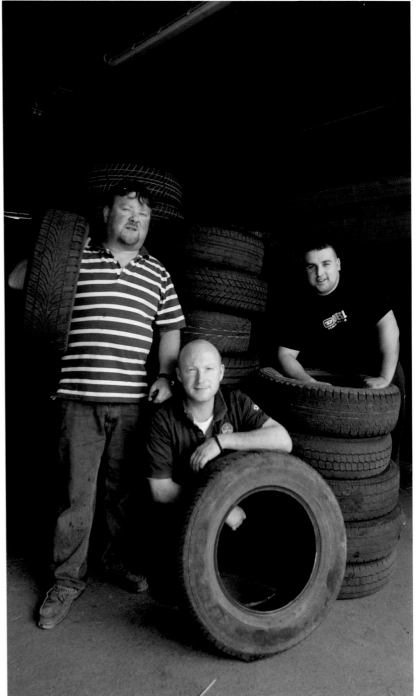

138

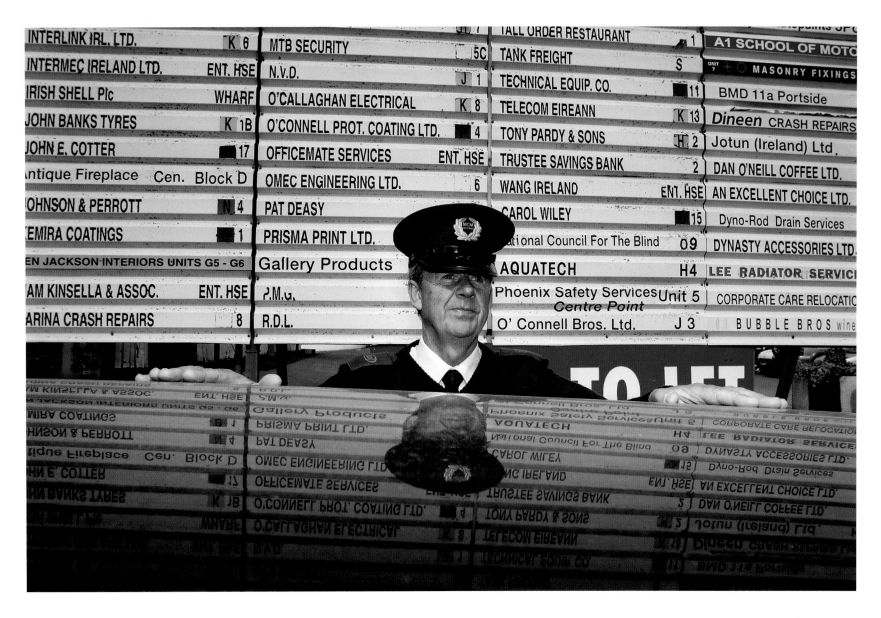

Opposite: (left) Eddie Collins has worked on the Dunlop site for fifty-three of his seventy-four years; (right) Jim Decourcey, Gavin Hill and Adrian O'Driscoll of South Link Tyres.

Above: 'In this job I work with a range of people, from tradesmen to artists,' Denis Creedon, security guard, Marina Commercial Park.

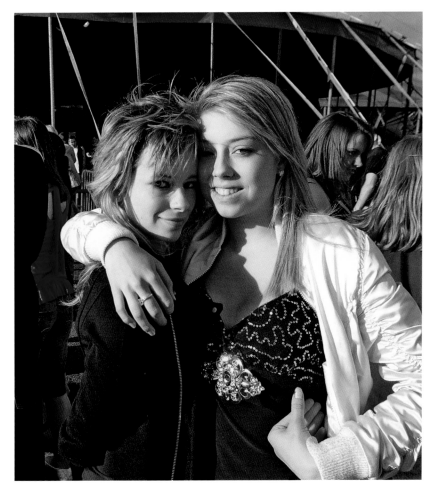

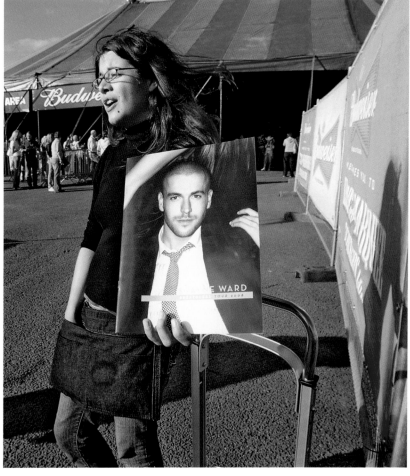

Previous: Lime trees on
Centre Park Road form a
canopy in winter and summer.

Opposite and above:
The young flock to the
Marquee to see performing
artists and musicians.

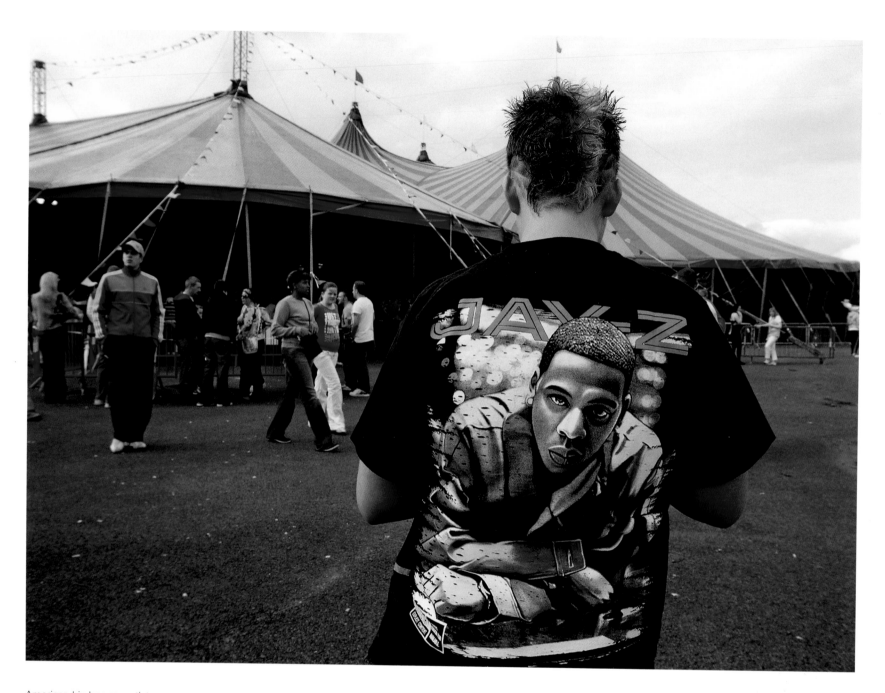

American hip-hop rap artist
Jay-Z plays the Marquee
in June.

144

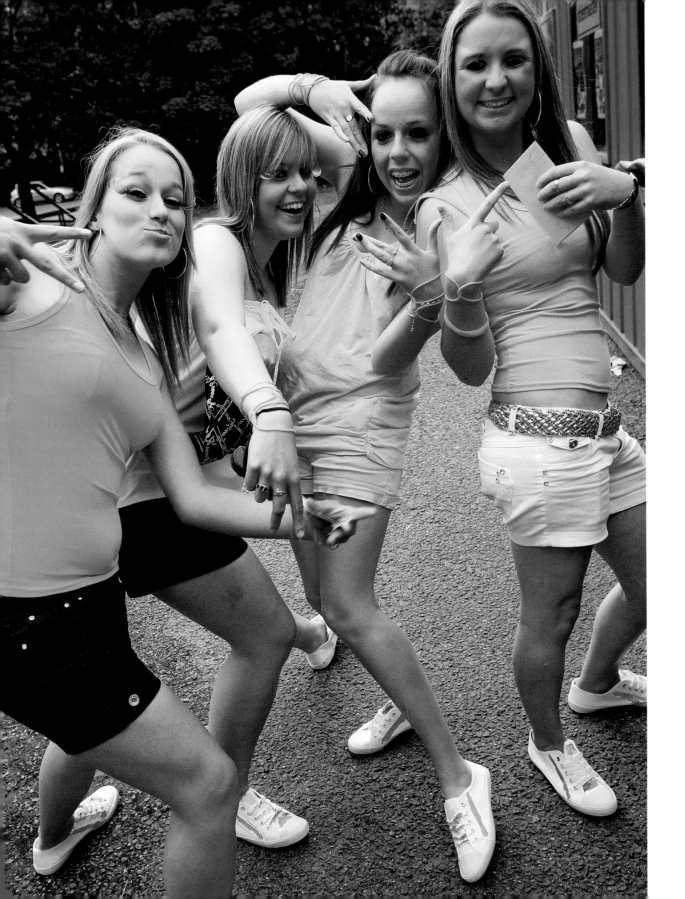

Colourful fans strike a pose.

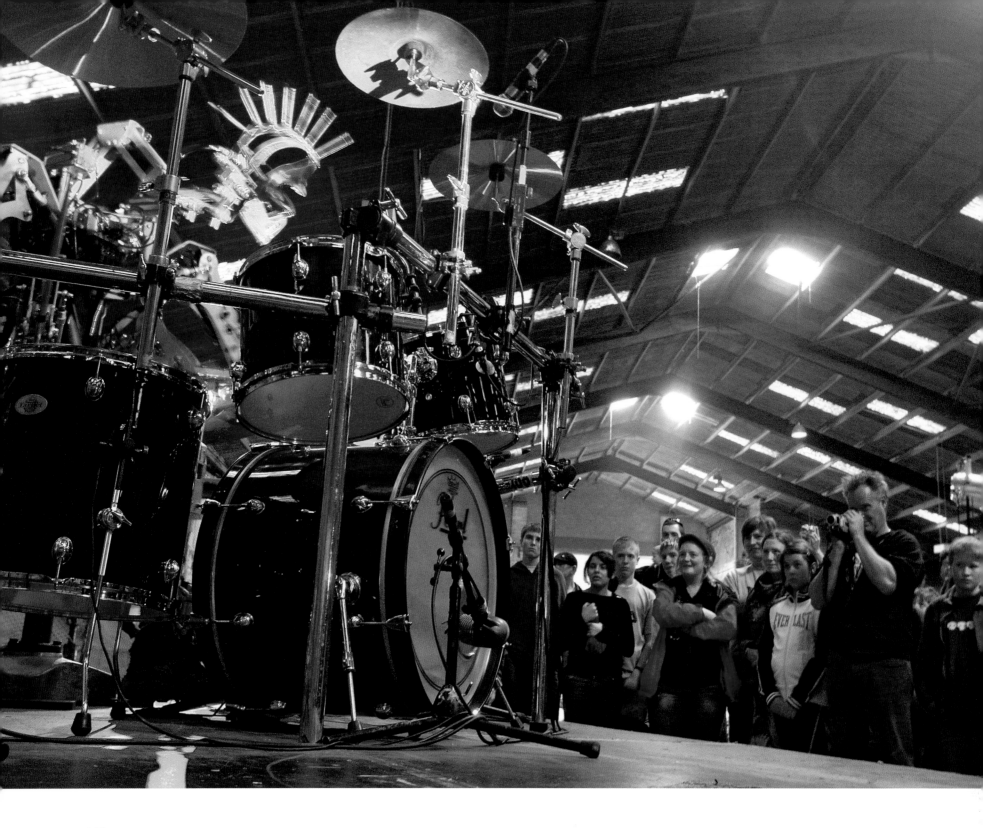

Opposite: A robotic drummer from the *Robodock* theatre show, part of the Cork Midsummer Festival, in the IAWS warehouse.

Above: (left) Kenny 'Mr Music' Lee has been involved in the music scene in Cork for decades; (right) Technical effects man for Corcadorca, Don Humphreys.

Right: Paka plays a central part in the hi-tech performance of *Robodock*.

Opposite: A scene from Corcadorca's performance of Eugene O'Neill's *The Hairy Ape* held in the old Southern Fruit Warehouse, June 2008.

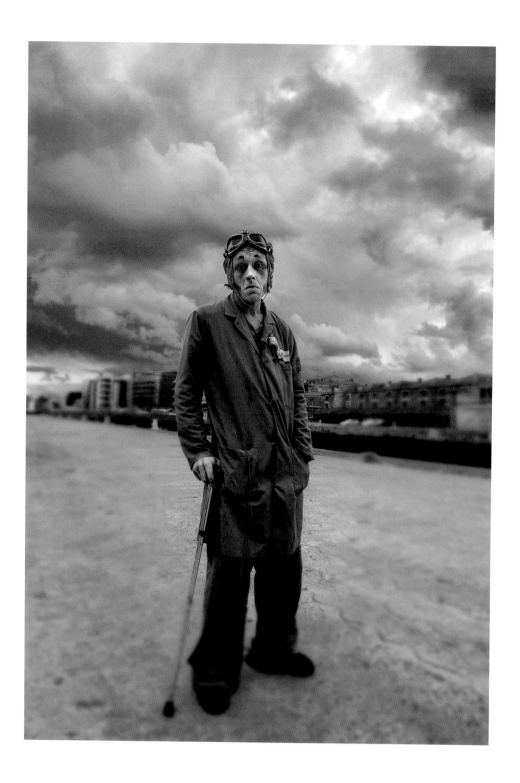

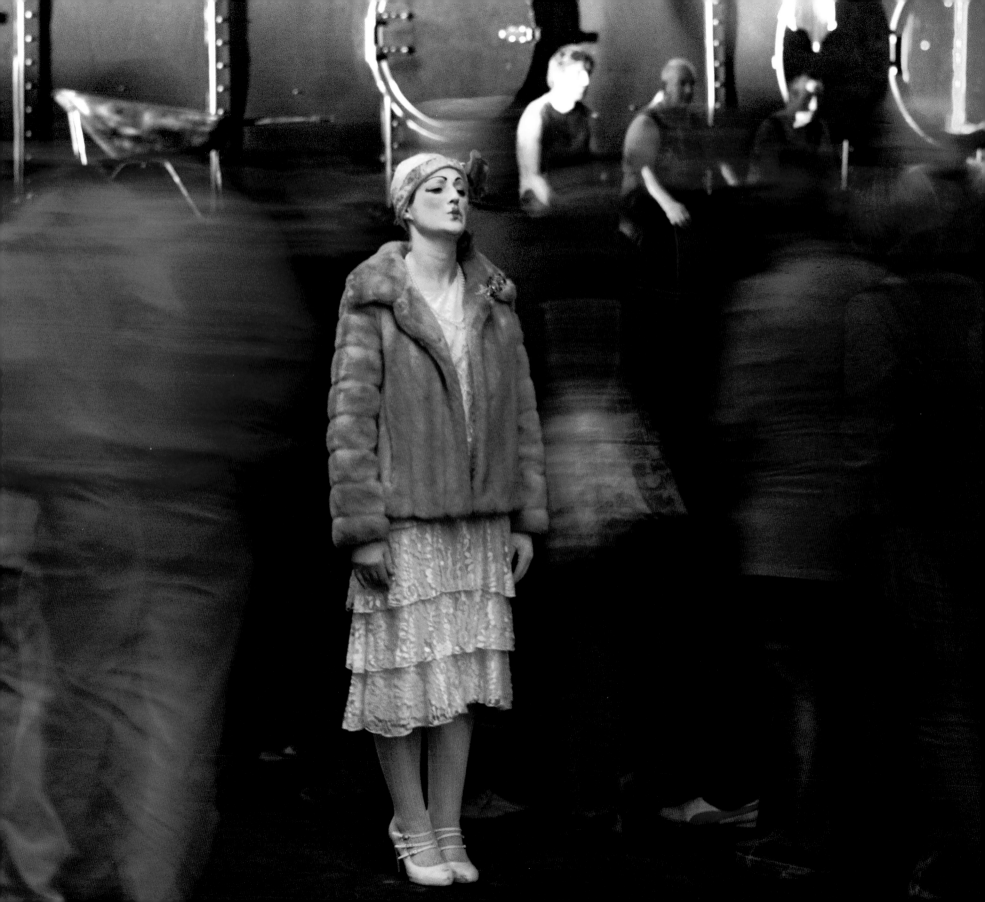

'The Hairy Ape' stands in front of the Arkady Feed silos.

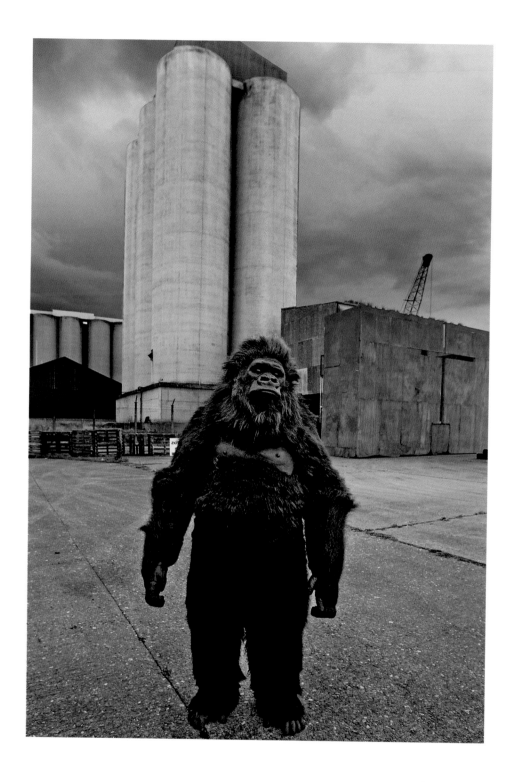

WEST

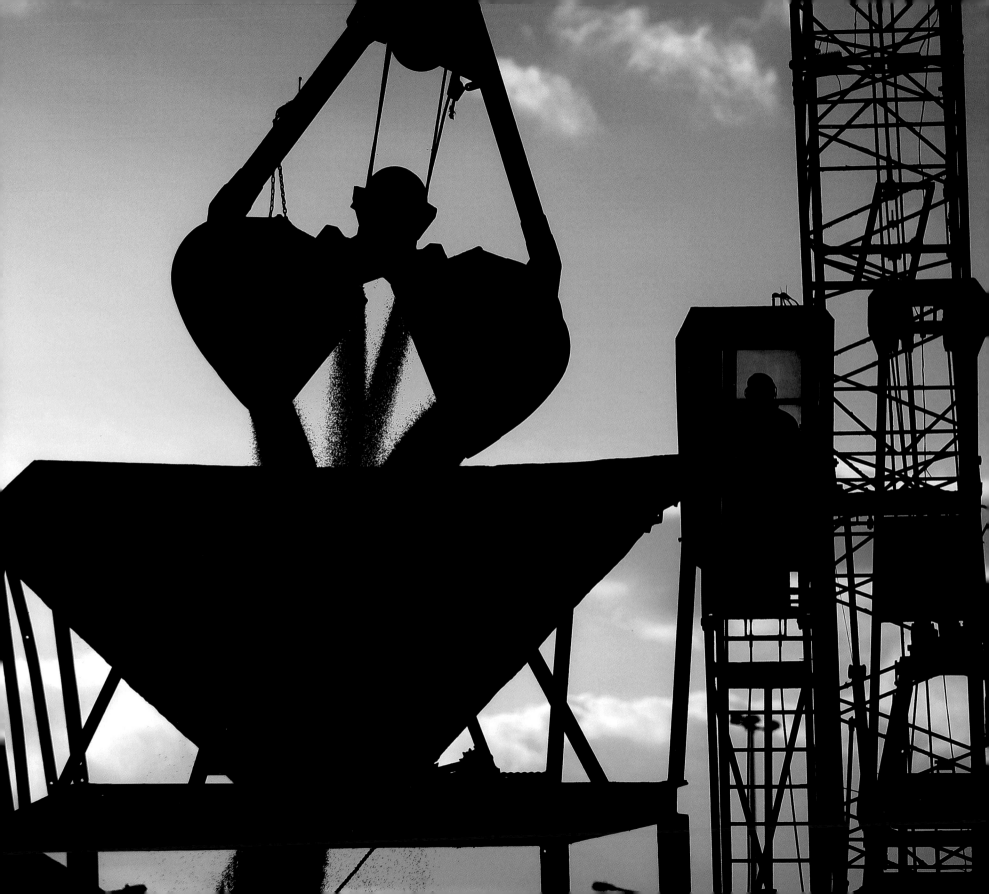

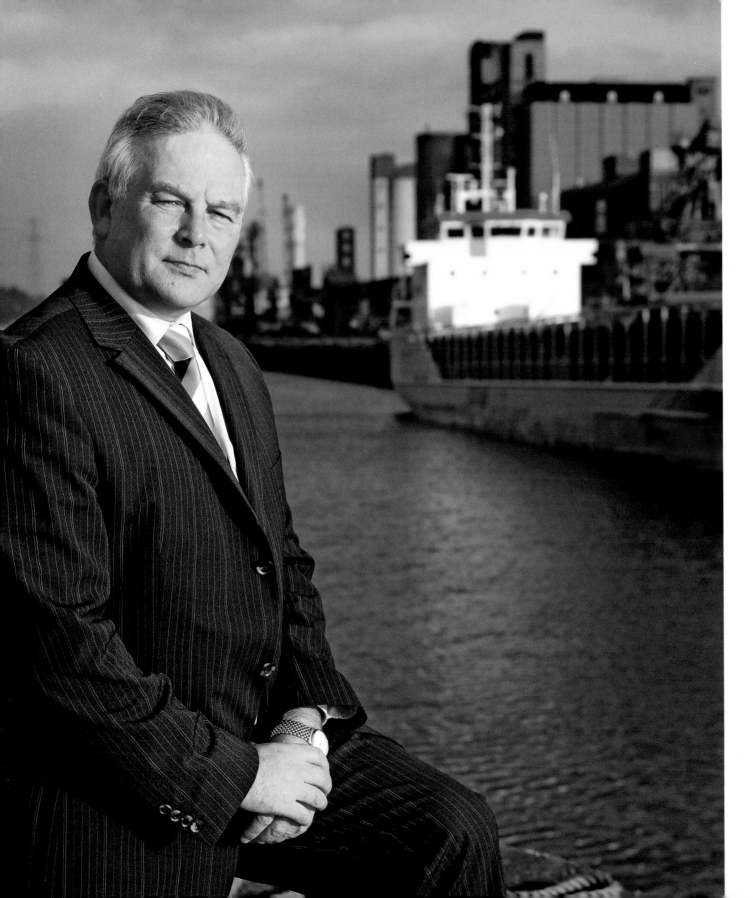

Opposite: Unloading magnesite on the South Jetties.

Left: Brendan Keating, CEO of the Port of Cork Company, is a vocal supporter of the Docklands redevelopment project.

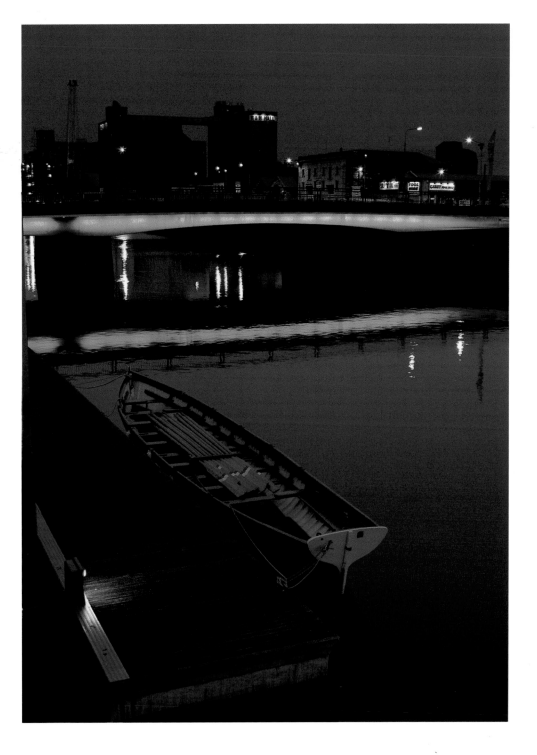

Opposite: Joe Gavin, Cork City Manager.

Left: A coastal rowing long boat tied up at Lapp's Quay.

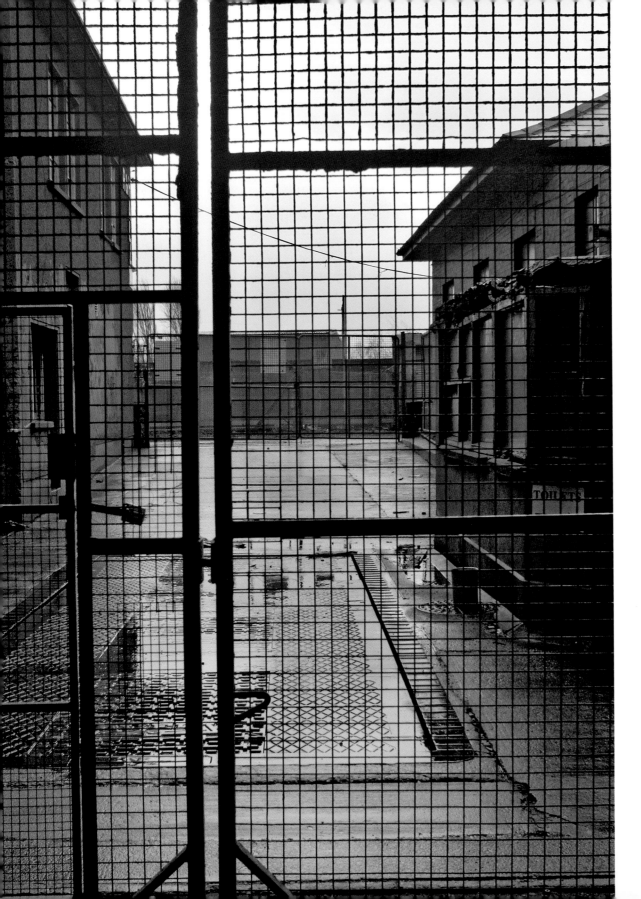

Opposite: Ships docking at the wharfs show signs of wear and tear from their travels on the high seas.

Left: Locked gates secure a disused weighbridge on the South Jetties.

157

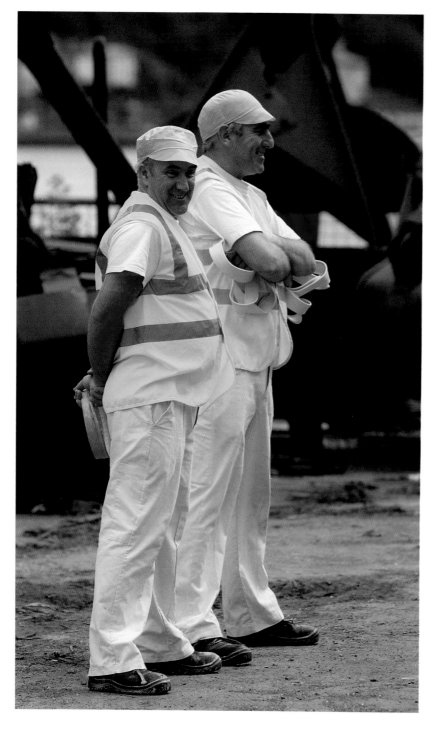

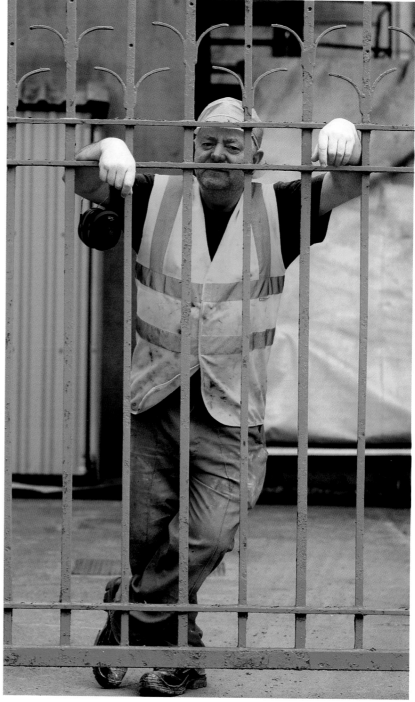

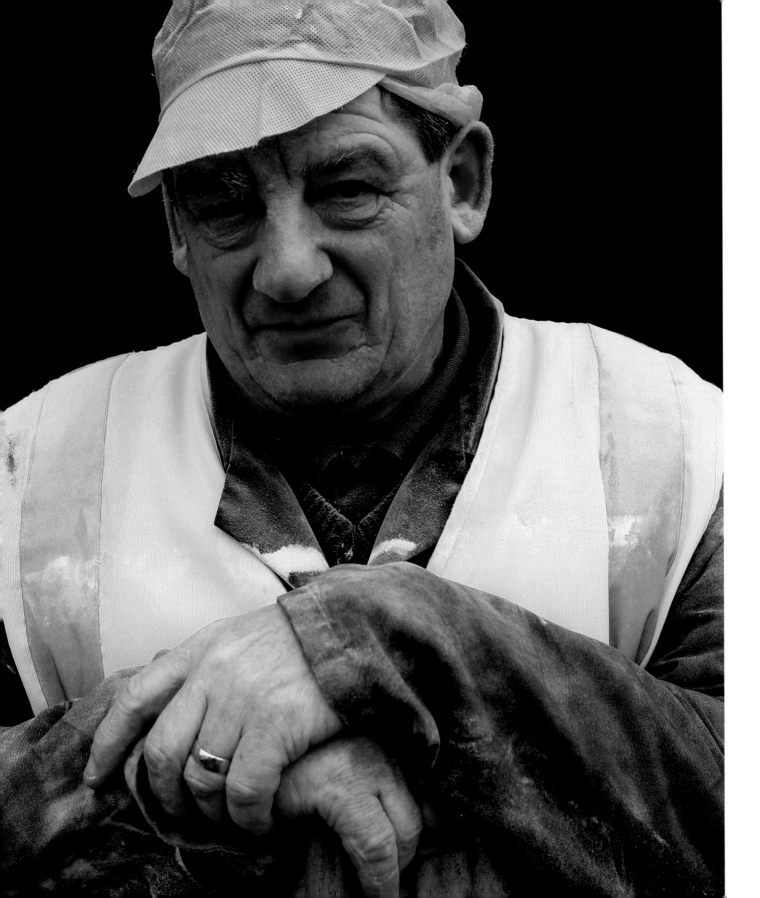

Opposite: (left) Robert Kerrigan and Eugene Murphy, millers, Odlums; (right) Pat O'Connell, miller, Odlums.

Left: Odlums workers, like Joe Barrett, are unsure of how the redevelopment will affect their jobs.

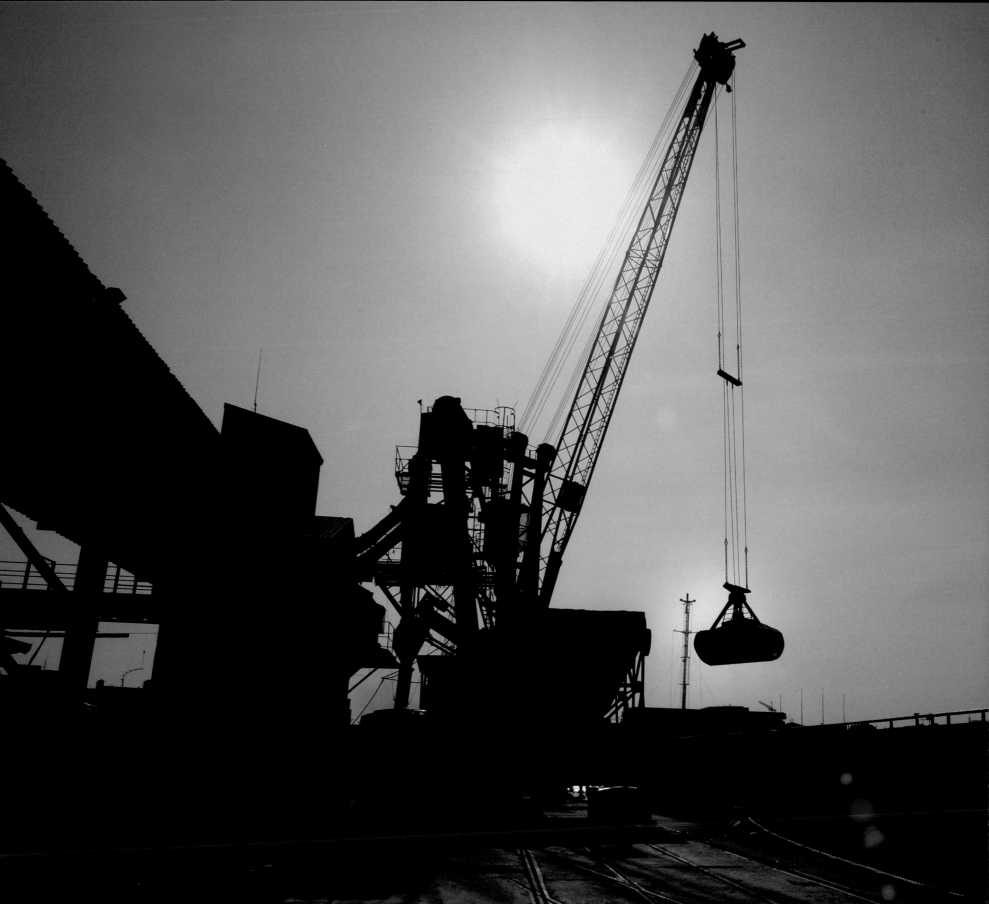

Fine weather makes unloading
loose cargo, like fertiliser
pellets and animal feed, a
smooth operation.

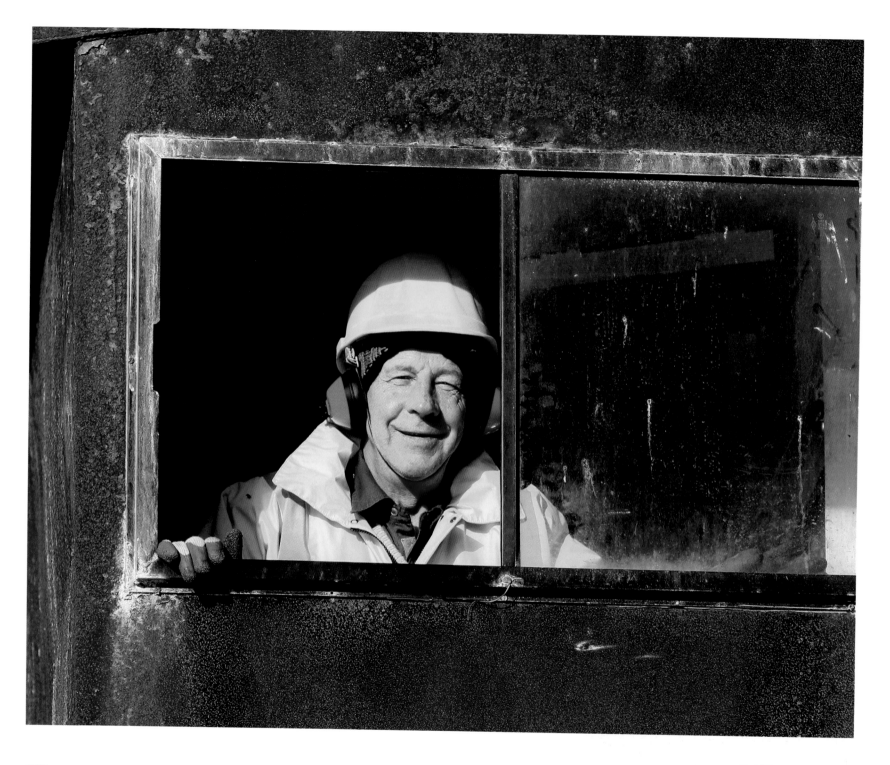

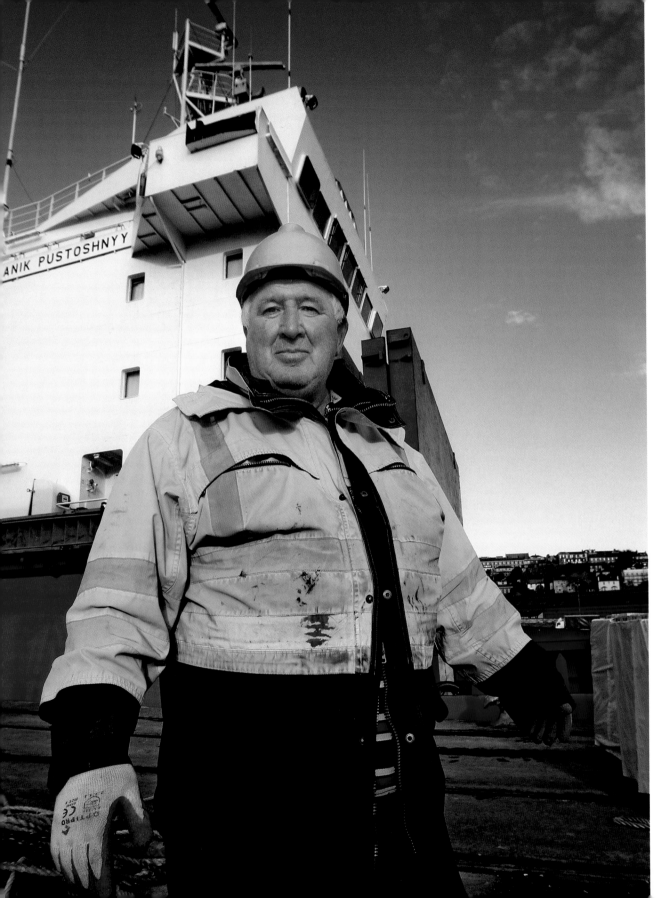

Opposite: John Hayes, docker, loads trucks from the hopper.

Left: 'The men who did this job fifty years ago were hard as steel,' Patsy Quilligan, docker.

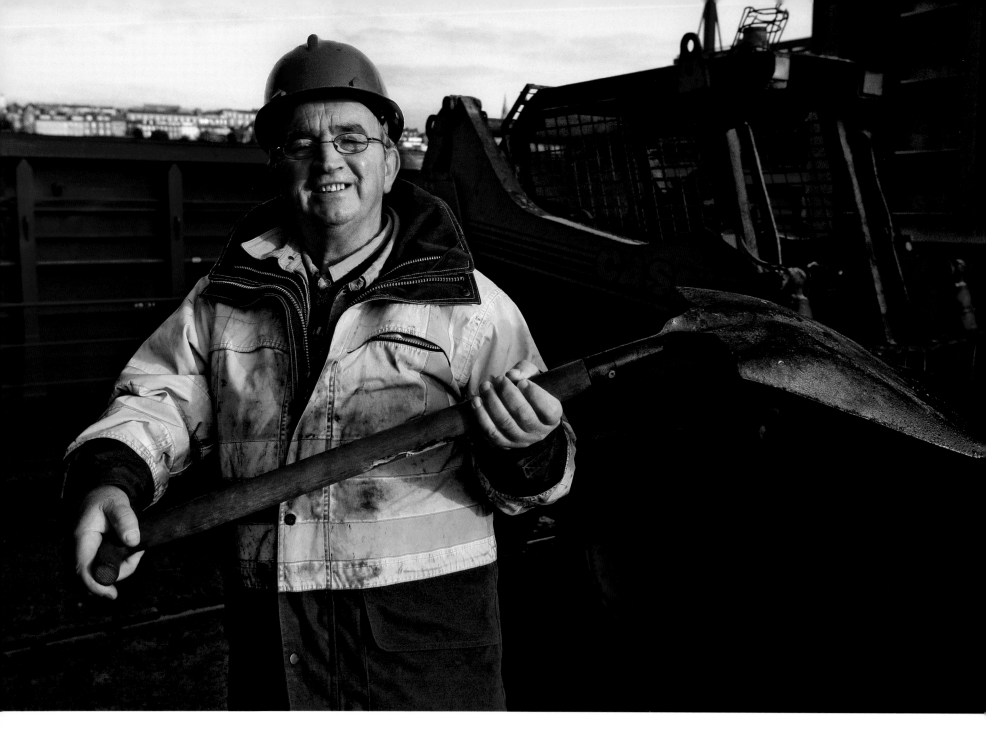

Above: William 'The Wiser' O'Sullivan comes from a long line of dockers.

Opposite: (left) Dave Anderson covers up from the dust in the ship's hold; (right) Patsy Salmon, docker.

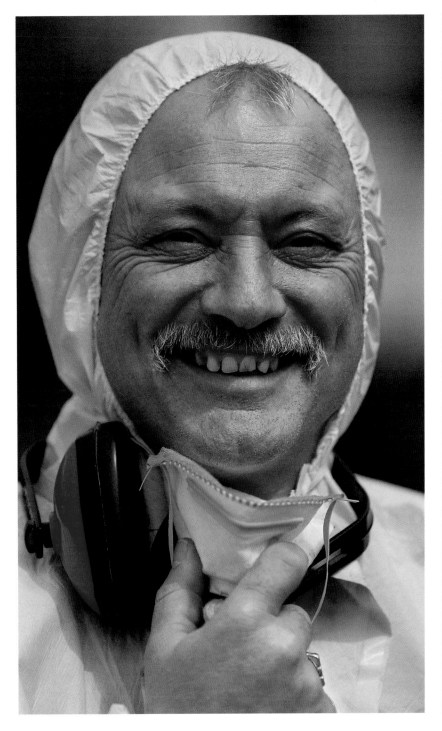

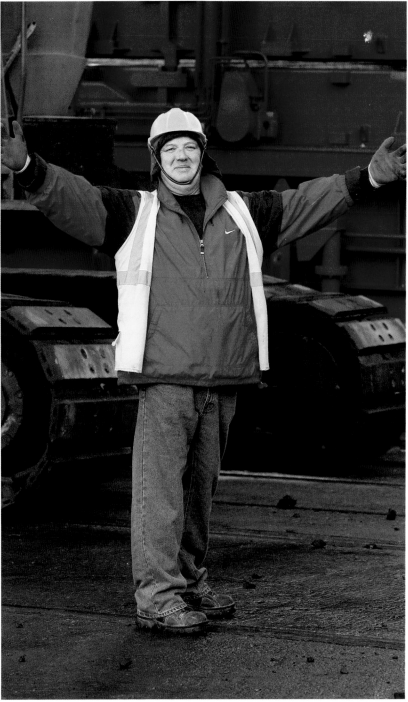

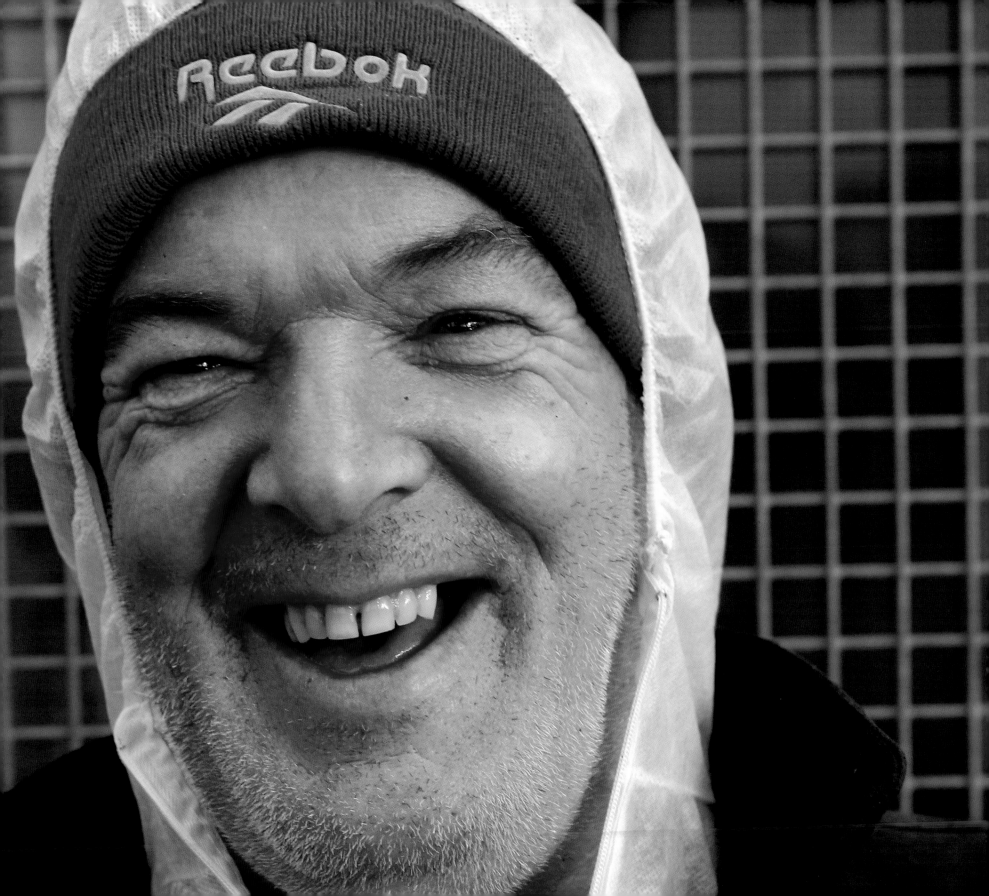

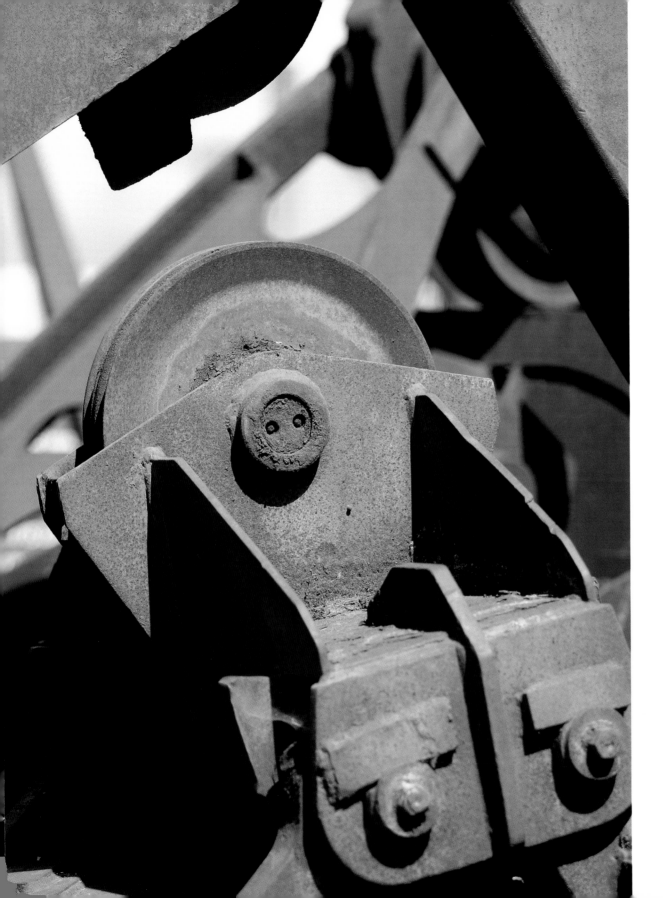

Opposite: Ger 'Mac the Gatler' MacCarthy's father was the 'top docker' back in the 1970s.

Left: Heavy lifting machinery rusts in the elements.

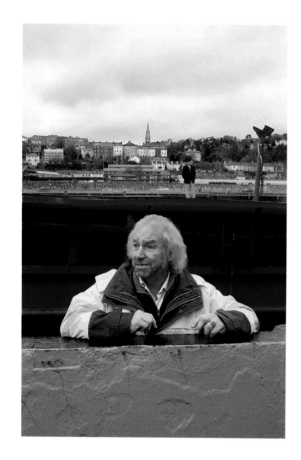 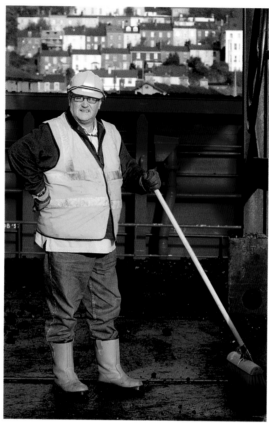 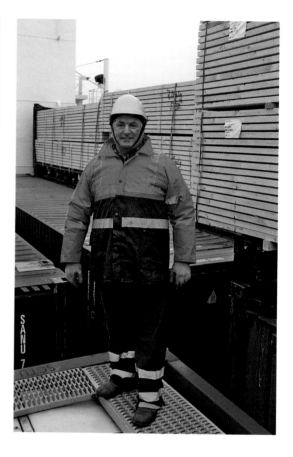

(left to right) John 'Suzie'
Murphy, Steve 'The Wazzie'
Hogan, and Connie Raymond.

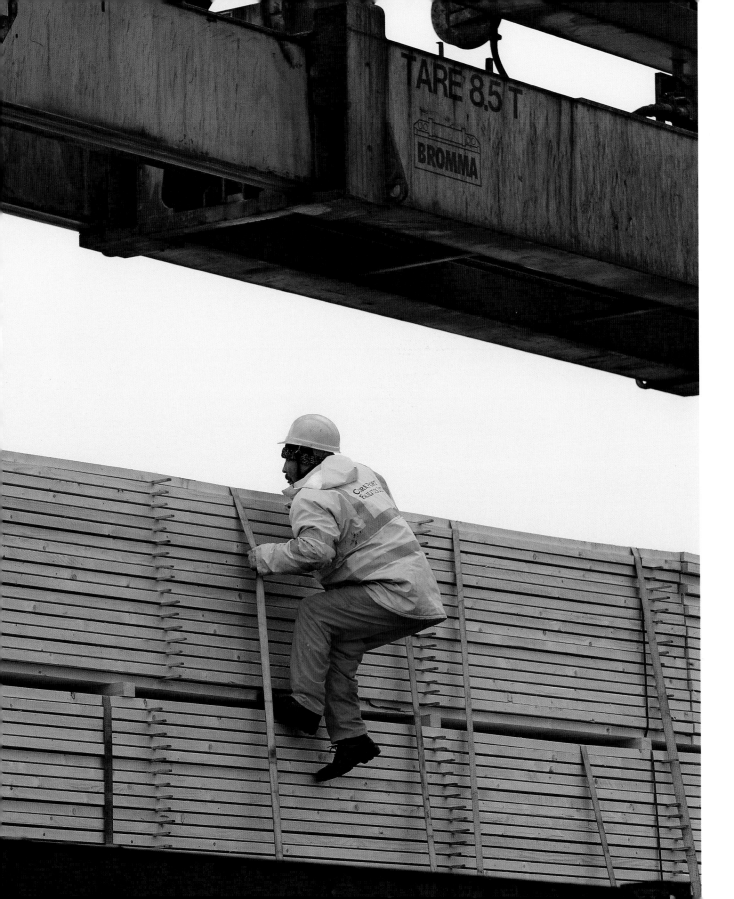

Preparing bundles of timber
for transportation requires
agility and strength.

169

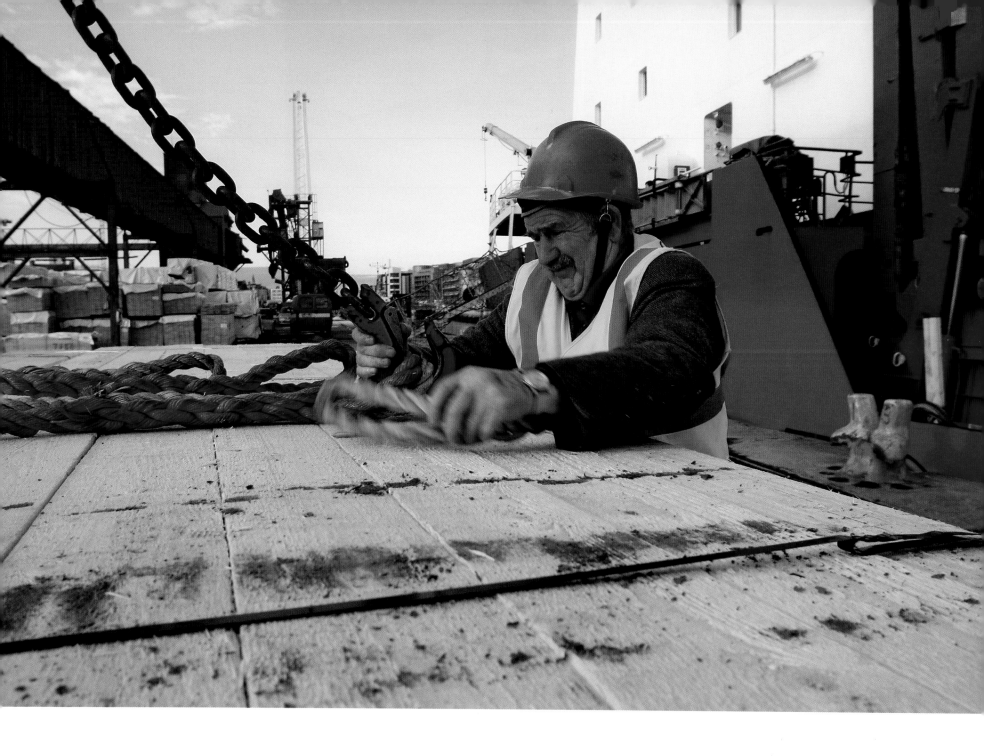

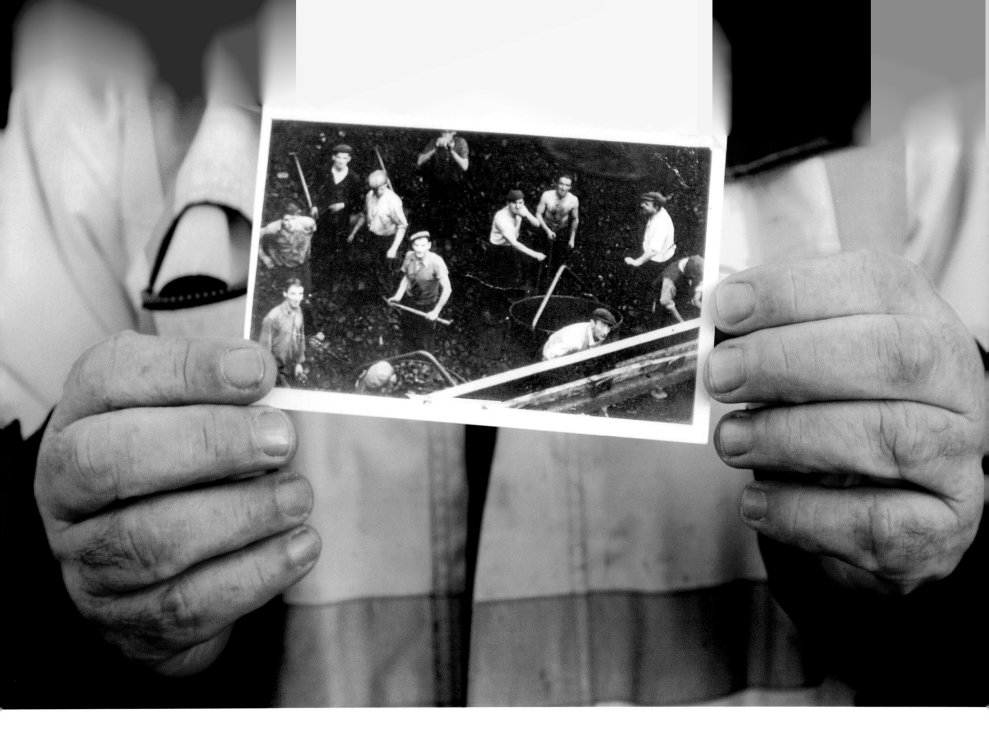

Opposite: Frankie Casey removes harnesses from a shipment of pine.

Above: Jimmy Ross carries a photograph taken in the 1950s, showing dockers unloading coal using simple shovels and buckets. Gangs were made up of as many as twelve men, when now they are only four.

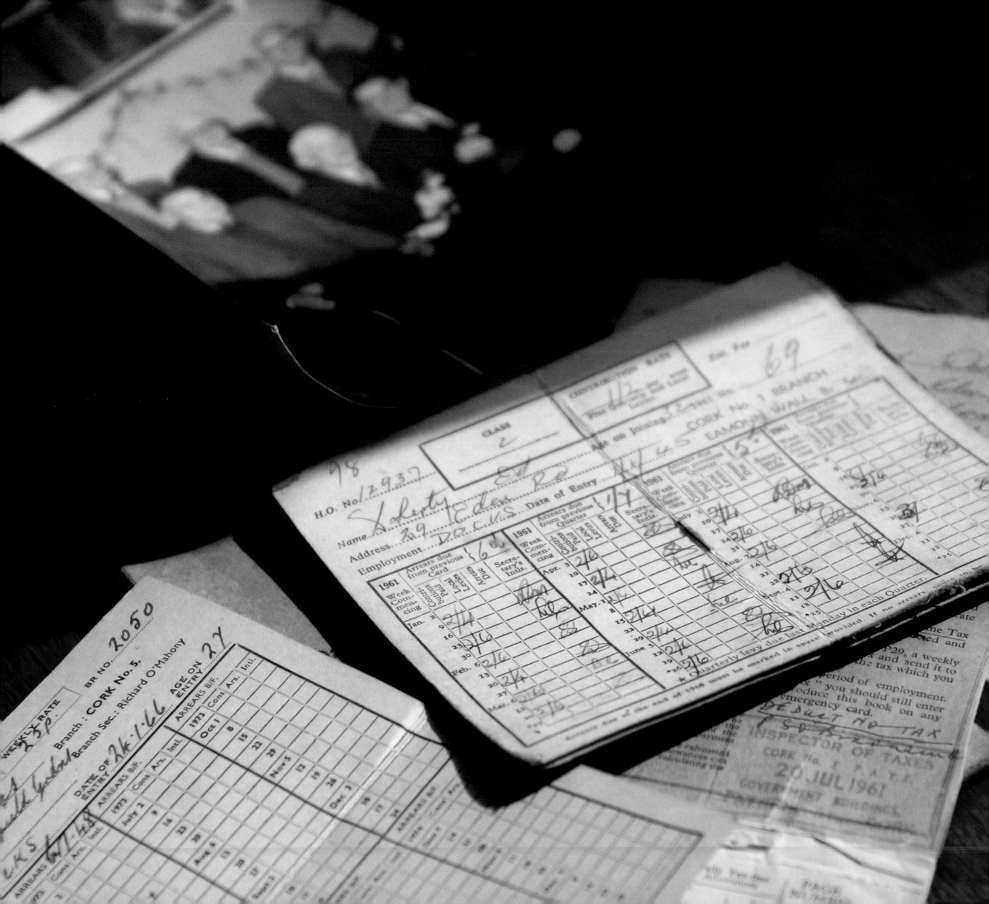

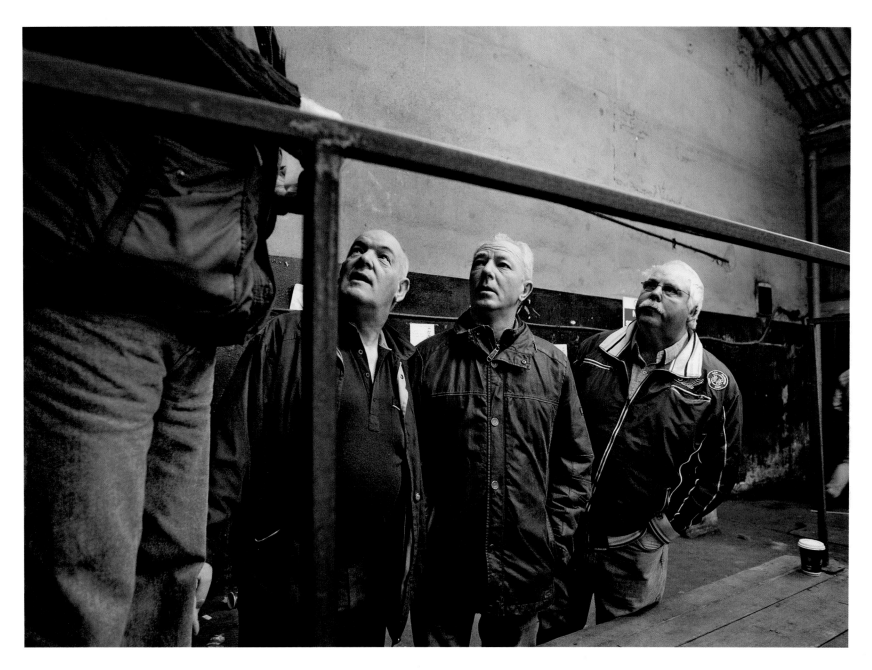

Opposite: Old paperwork records the payment of union fees and taxes.

Above: Doyle's workers listen to the foreman selecting men for a shift. On this day, there is plenty of work to go around.

Right: (top) Laddy Coad decides who will work the boats at Doyle's stores on Collins Street; (bottom) John Rourke of Tedcastles selects a handful of men to unload a newly arrived coal ship from Poland.

Opposite: The River Lee meets again at Customs House Quay.

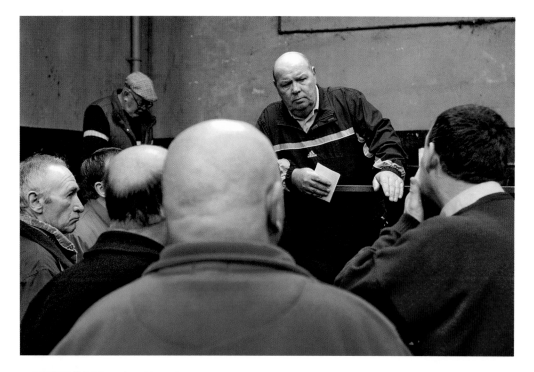

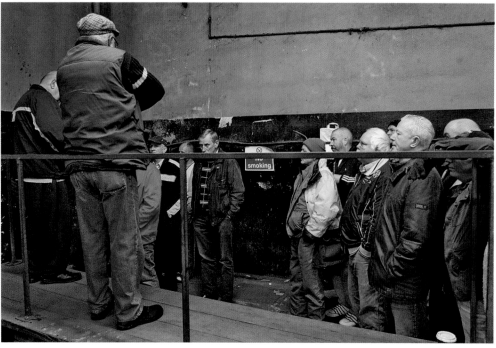

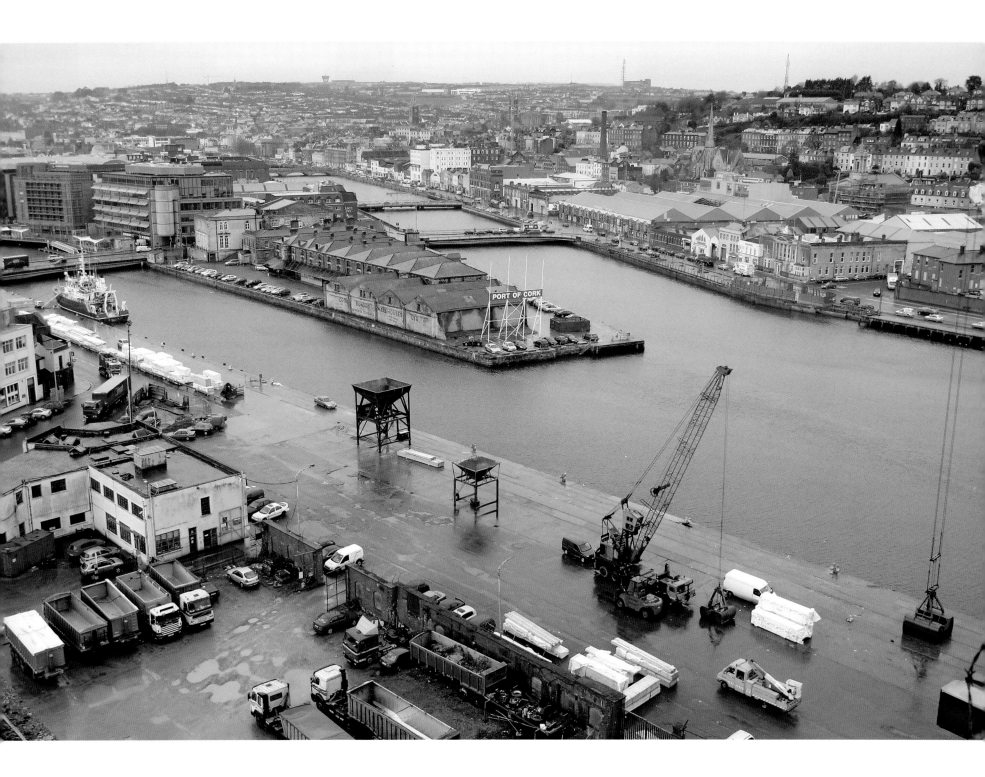

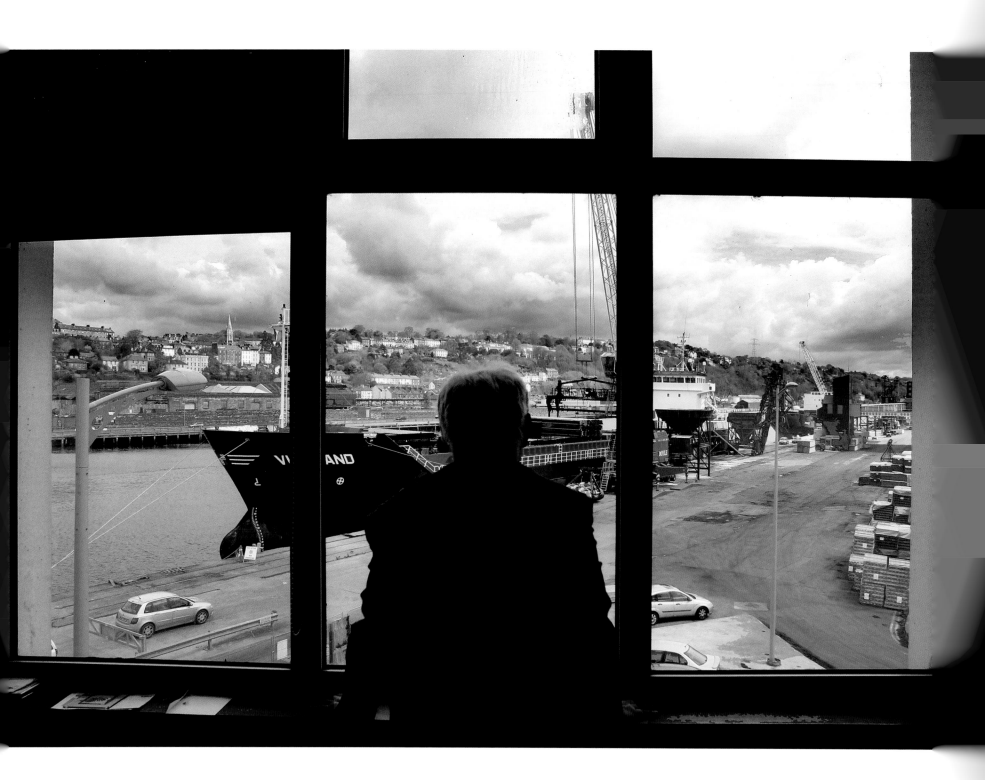

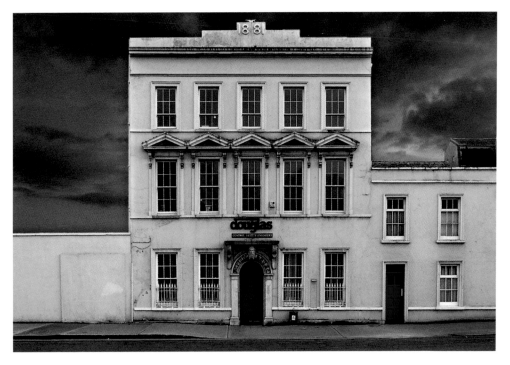

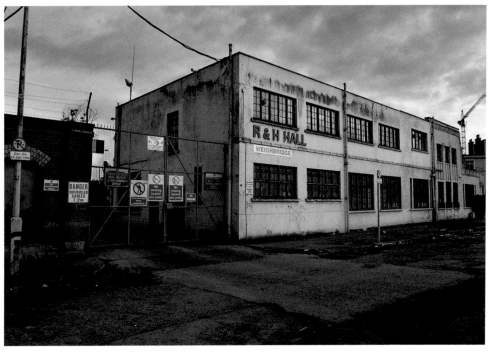

Opposite: Frank Doyle keeps an eye on ship movements from his office window. Doyle's family has run the shipping group since 1886.

Left: (top) Neptune House on Victoria Road; (bottom) R & H Hall's weighbridge on Kennedy Quay.

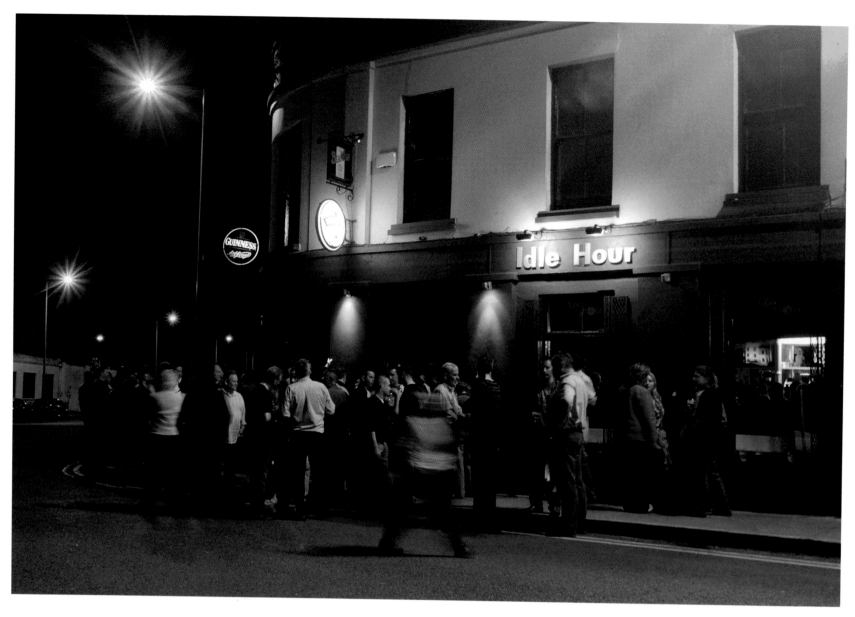

Above: The Idle Hour on Albert Quay was once called the Silo Bar. It was a favourite with the dockers and now attracts concert-goers from the summer music festivals.

Opposite: John O'Connor, owner, the Idle Hour.

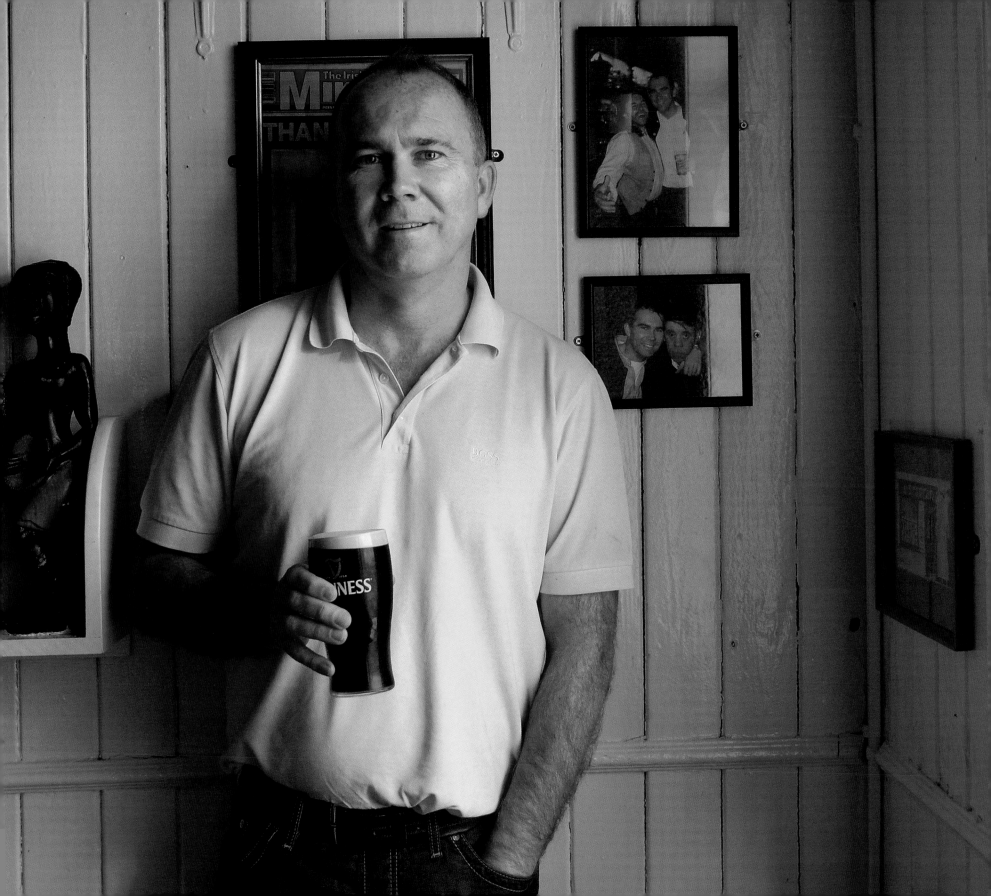

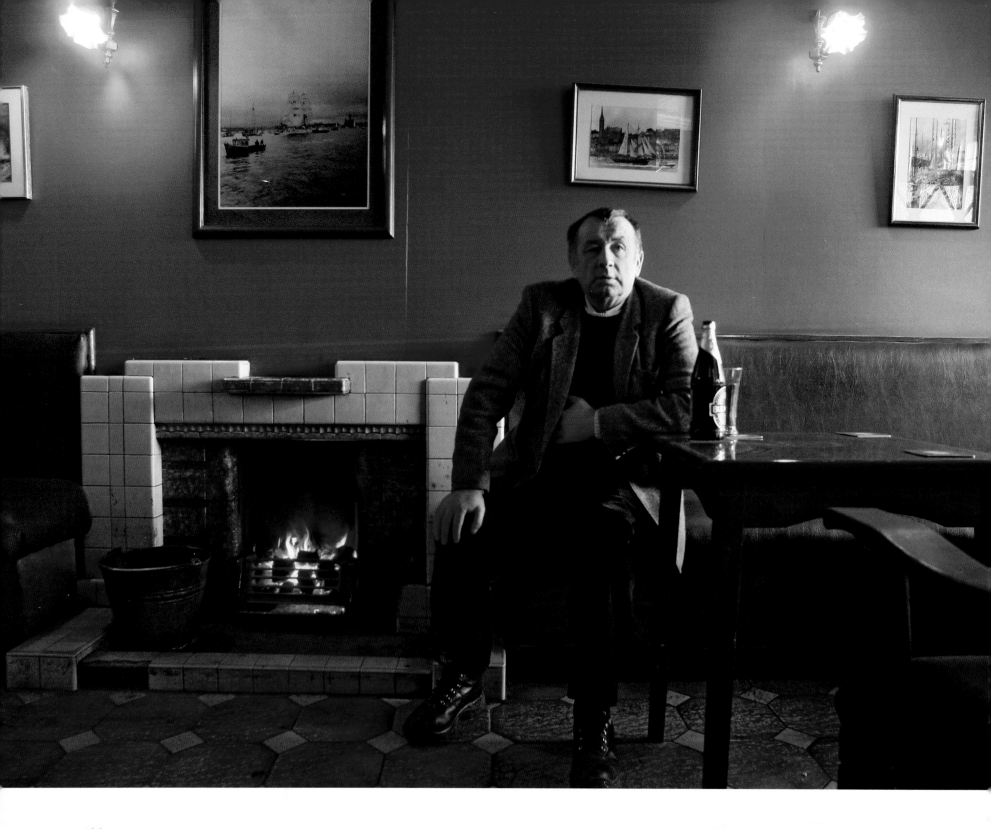

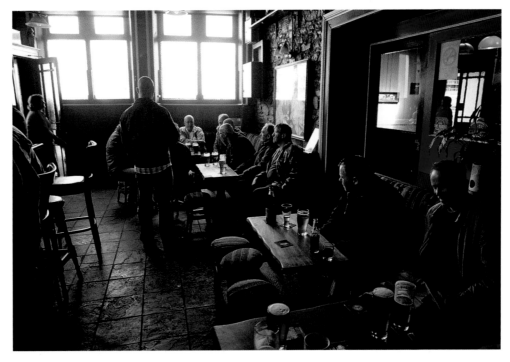

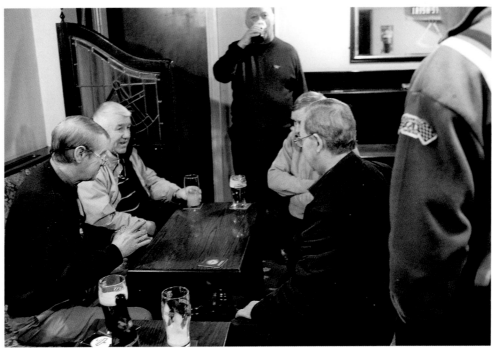

Opposite: Richard Sullivan, docker, drinks at the Port Bar on Victoria Road.

Left: (top) Afternoon pints at The Sextant Bar; (bottom) Don card players keep the tradition going during a weekly competition at The Sextant Bar.

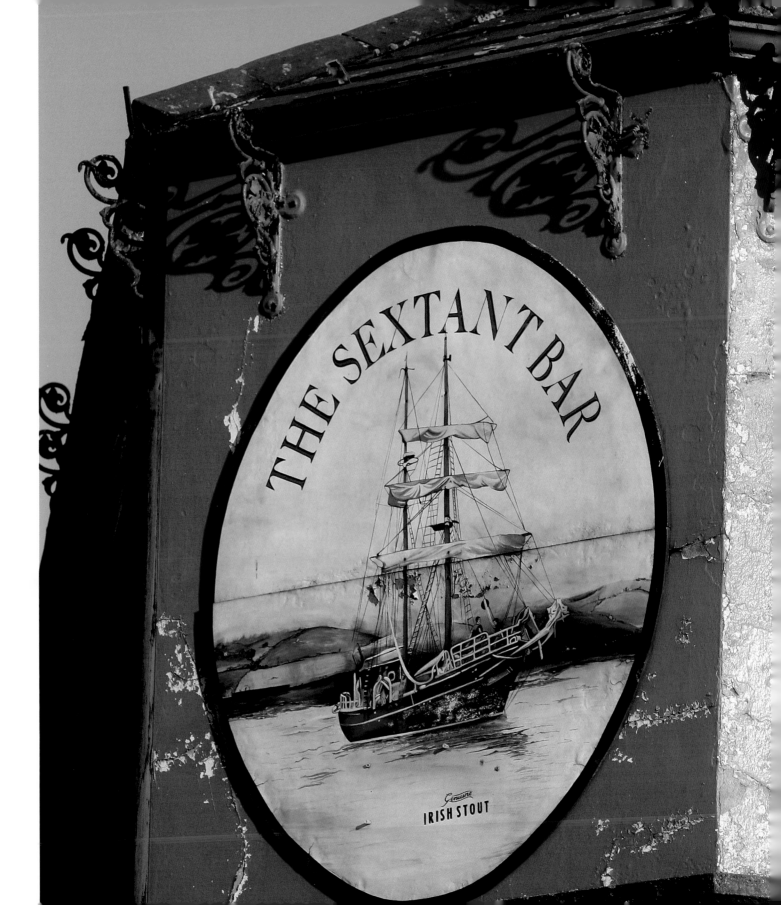

Right: The Sextant Bar.

Opposite: Faces from The Sextant Bar: (clockwise from top left) Siobhan Egan, John Madigan, Patsy Riordan and Dave O'Callaghan.

182

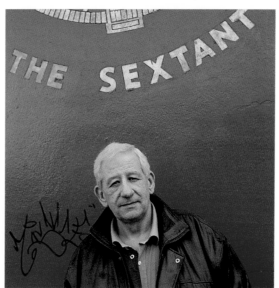

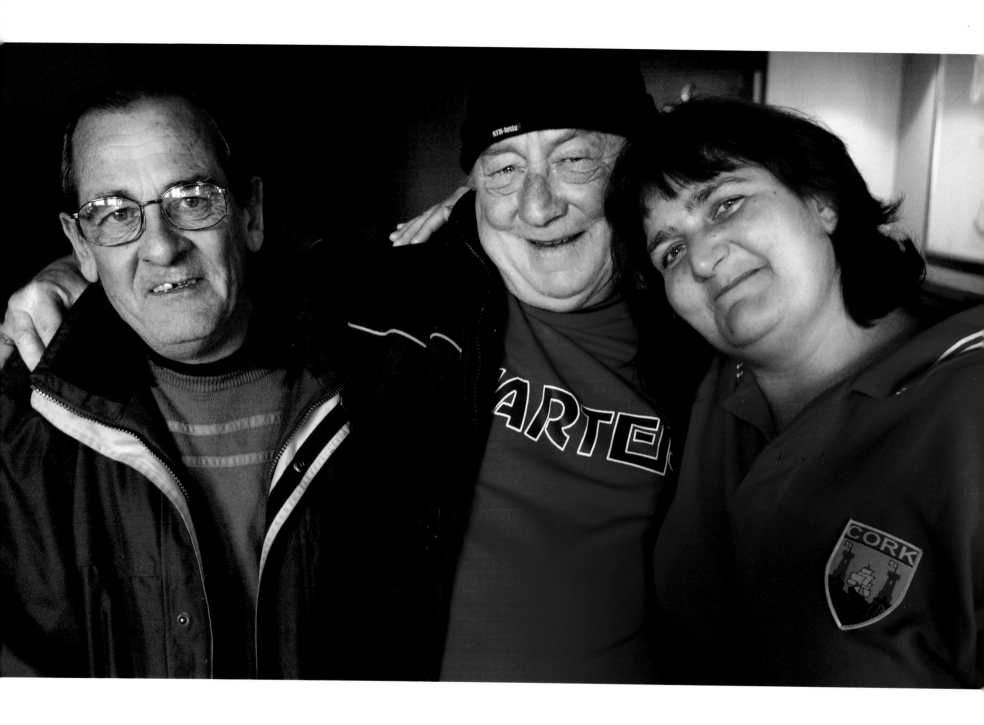

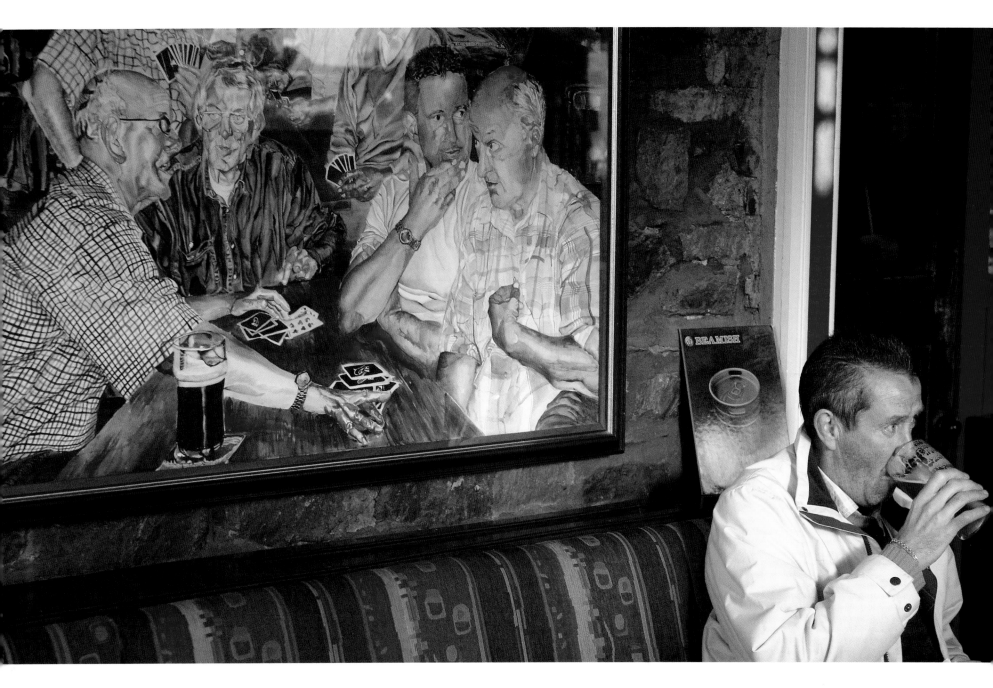

Opposite: (from left) Sextant
regulars, John 'The Scotsman' Johns,
Tommy Burns and Mary O'Brien.

Above: Christie Curran enjoys
a quiet pint in front of a painting
of the Sextant Don team.

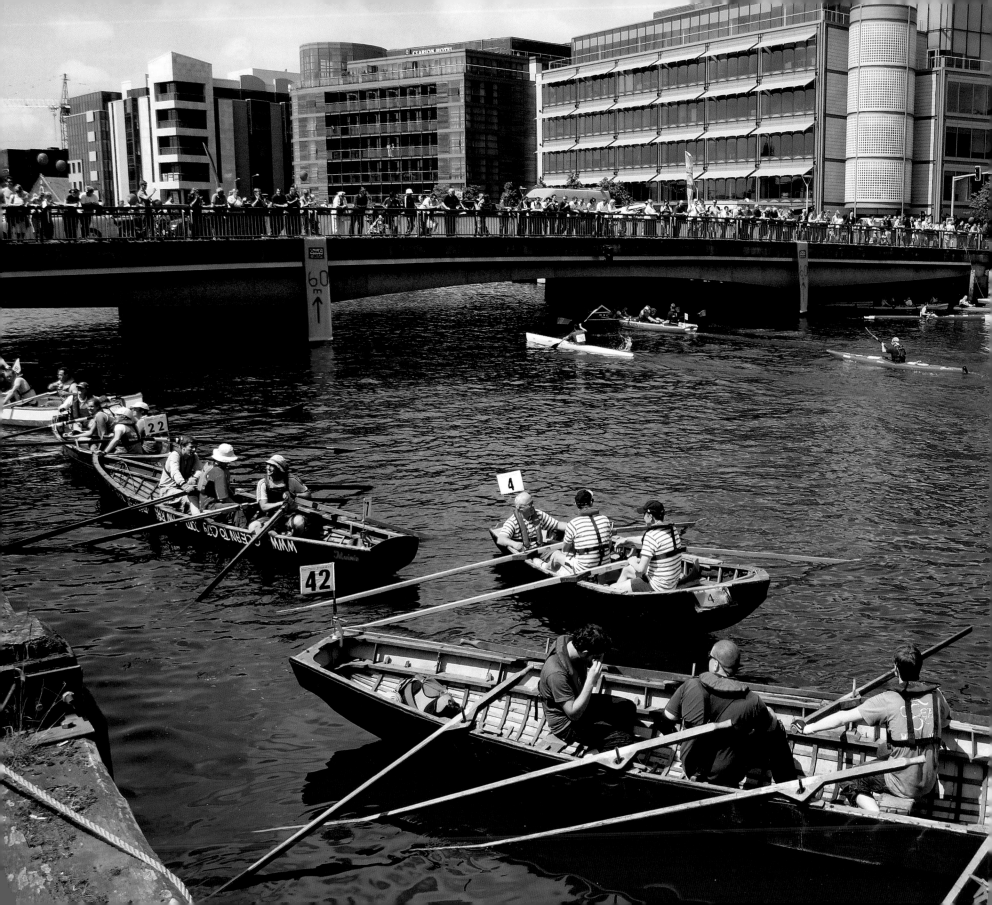

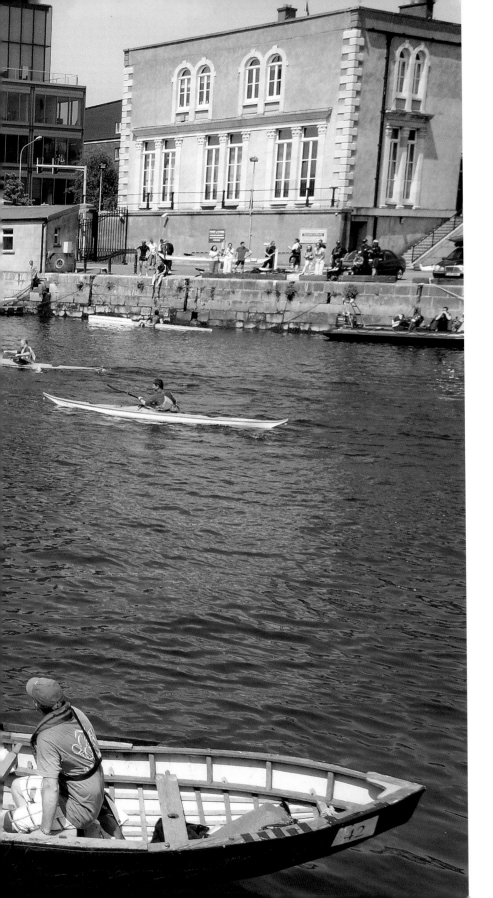

Rowers pass under the final bridge before the finish line in the annual Ocean to City rowing race that covers fifteen miles from the mouth of Cork Harbour to Lapp's Quay in the city centre.

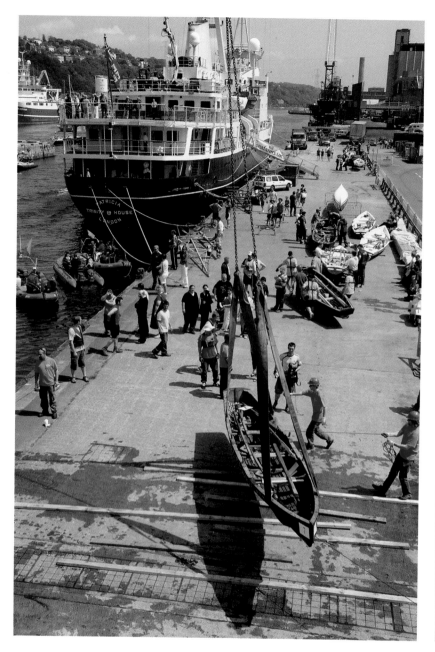

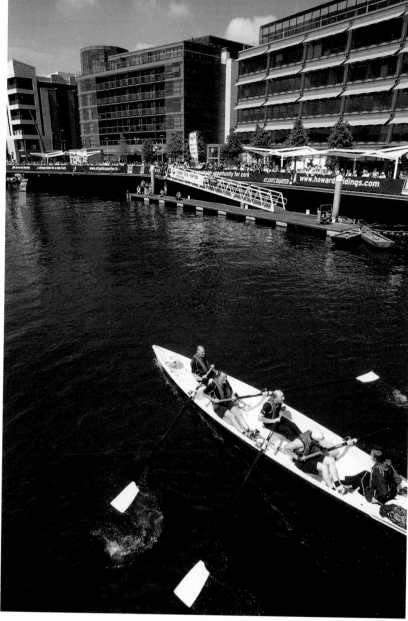

Above: (left) Cranes lift the long boats on to the wharfs after the race; (right) Crossing the finishing line at Lapp's Quay.

Opposite: Boats from the Naomhóga Chorcaí traditional boat rowers club.

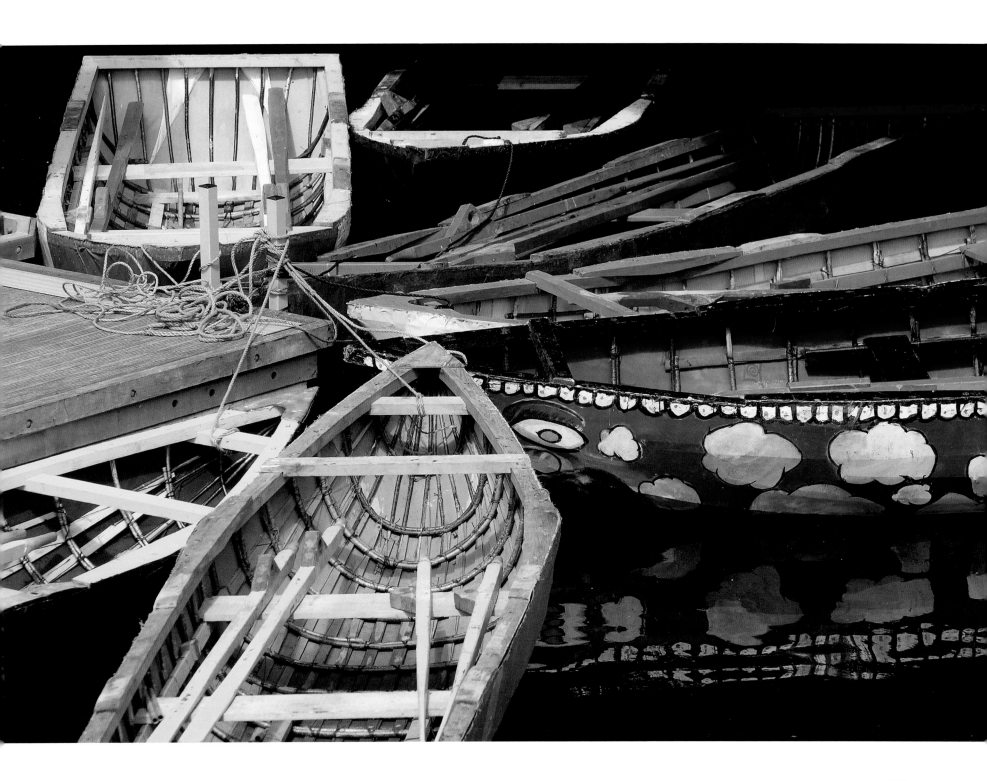

Swimmers in the annual
Lee Swim pass the Irish lights
ship *Granuaile* during their
two-kilometre ordeal.

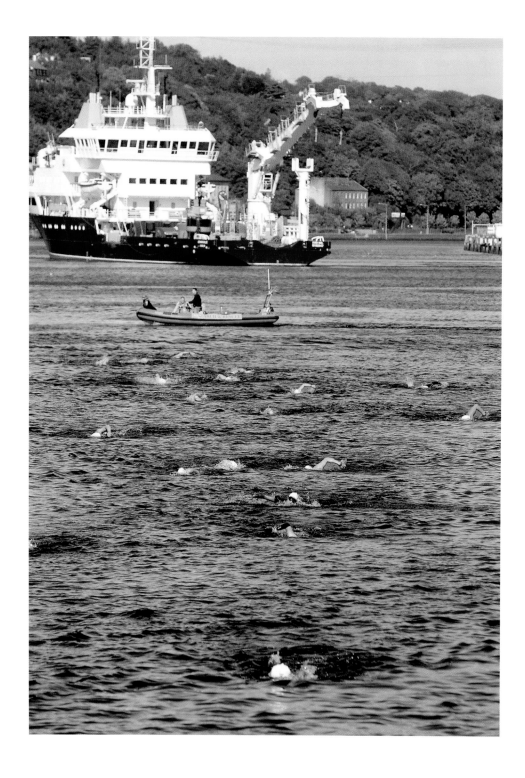

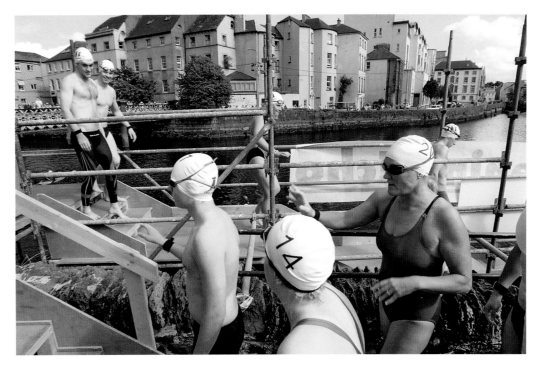

(top) Competitors prepare to enter the water at St Vincent's Bridge; (bottom) Crowds gather on Éamon de Valera Bridge to cheer home the swimmers.

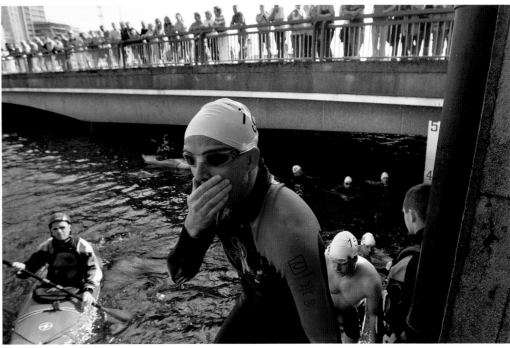

Right: Rinsing in fresh water.

Opposite: Chris Bryan, from County Clare, celebrates his win in the 2008 Lee Swim.

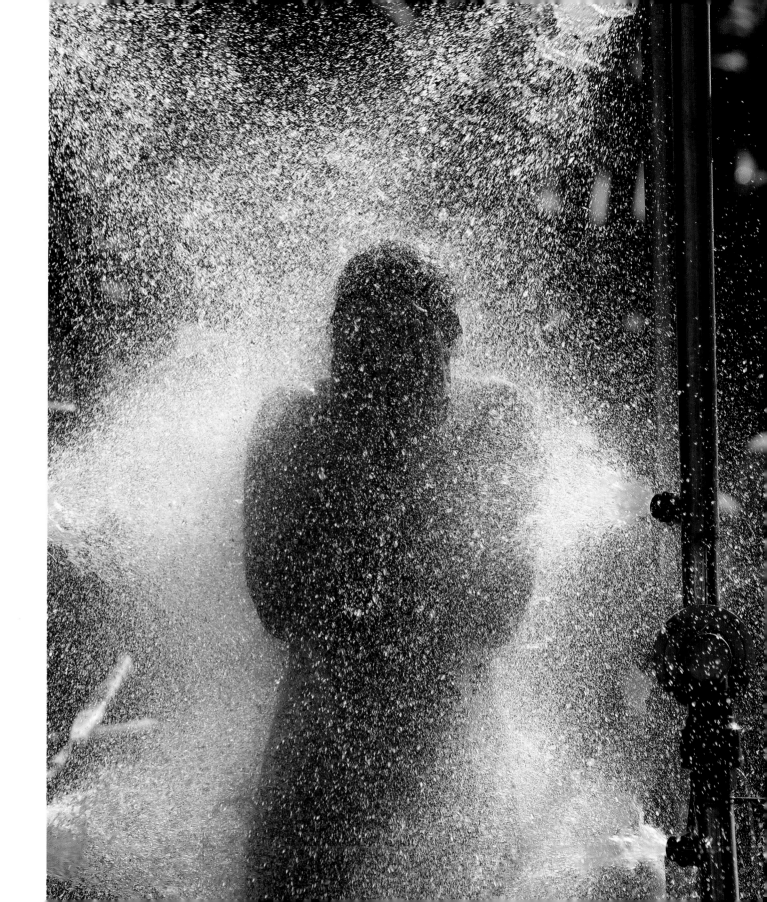